✓ KT-131-139

© 2009 by Rockport Publishers, Inc.

All rights reserved. No part of this book may be reproduced in any form without written permission of the copyright owners. All images in this book have been reproduced with the knowledge and prior consent of the artists concerned, and no responsibility is accepted by producer, publisher, or printer for any infringement of copyright or otherwise, arising from the contents of this publication. Every effort has been made to ensure that credits accurately comply with information supplied. We apologize for any inaccuracies that may have occurred and will resolve inaccurate or missing information in a subsequent reprinting of the book.

First published in the United States of America by Rockport Publishers, a member of Quayside Publishing Group 100 Cummings Center Suite 406-L Beverly, Massachusetts 01915-6101 Telephone: (978) 282-9590 Fax: (978) 283-2742 www.rockpub.com

Library of Congress Cataloging-in-Publication data available

ISBN-13: 978-1-59253-488-3 ISBN-10: 1-59253-488-0

10 9 8 7 6 5 4 3 2 1

Design: Jeffrey Everett of El Jefe Design

Printed in China

CLASS 746.92 EVE 159181 ACQ 1.09

JEFFREY EVERETT EL JEFE DESIGN THE WHO, WHAT, WEAR

1307 💬 🖂 🖸 🖸

BEVERLY MASSACHUSETTS

A Comprehensive Collection of Wearable Designs

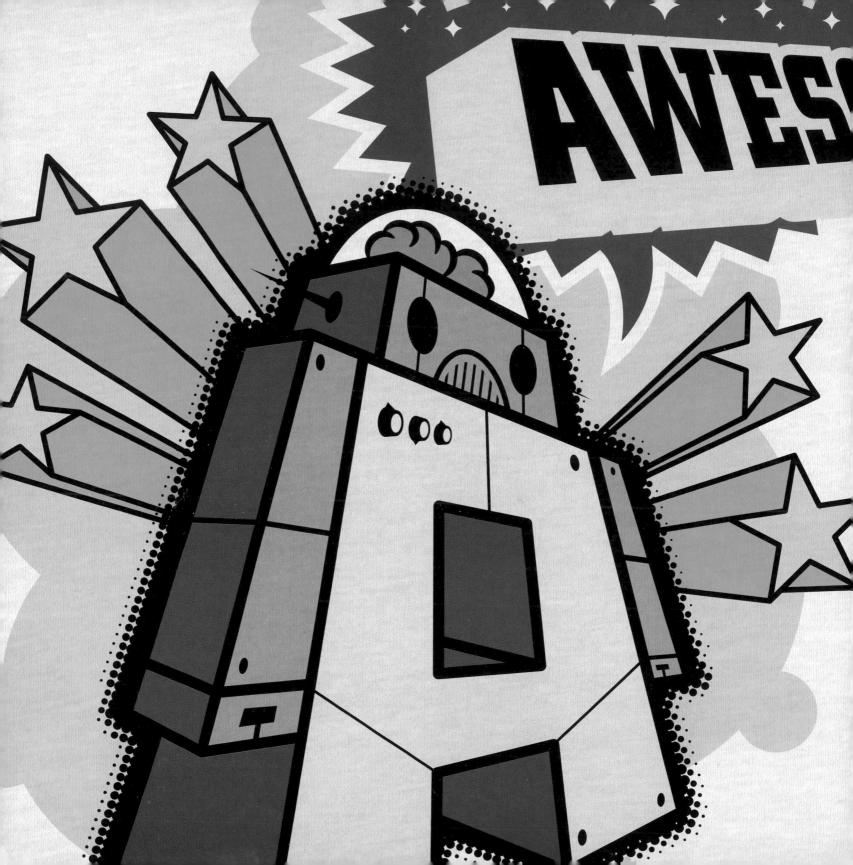

arments, and garment graphics in particular, are ubiquitous. On any given street you may see dozens-if not hundreds-of people wearing different patterns, images, and phrases on shirts, purses, shoes, coats, dresses, and much more. Most of the time these graphics tend to be bland and stale; landscape noise that fades into the mind's background as you tend

to your thoughts. Uninteresting doodles, generic logos, and mindless fluff arc put together haphazardly to appeal to the lowest common amoeba; filler to make a blank \$1 T-shirt worth \$3.

On occasion, though, there will be an image that makes you do a double take. The graphic will snap you out of your thoughts and make you smile, smirk, think, or just feel bewildered. The sensibility is proudly distinct, possibly using inside jokes, sarcasm, fringe culture iconography, painfully rendered type, or satire of a beloved idol. These graphics stand in stark contrast to the overwhelming homogenization and conservatism that characterize committee-created corporate products, which are cool only if you can poke fun at them.

This book is a unique collection of garments that bring a sparkle to the jaded eyes of the passerby. From around the world, the designers whose work is featured in this book have elevated garment graphics from a piece of cloth to be forgotten in a closet, to proud displays of personality and wit to be showcased like a heart on your sleeve.

> JEFFREY EVERETT EL JEFE DESIGN

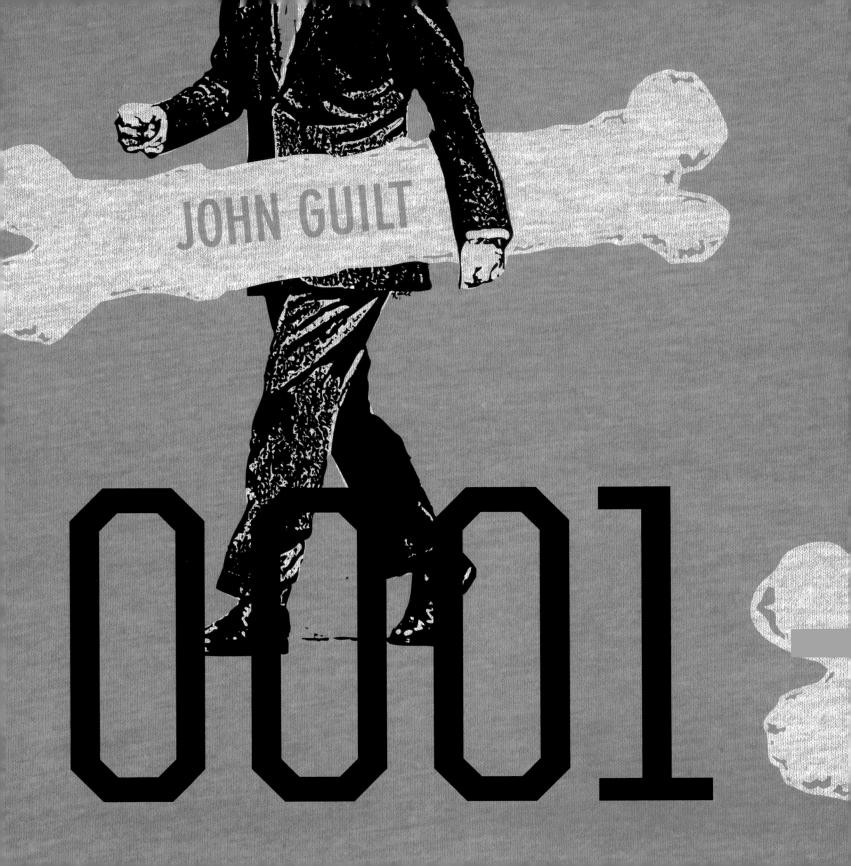

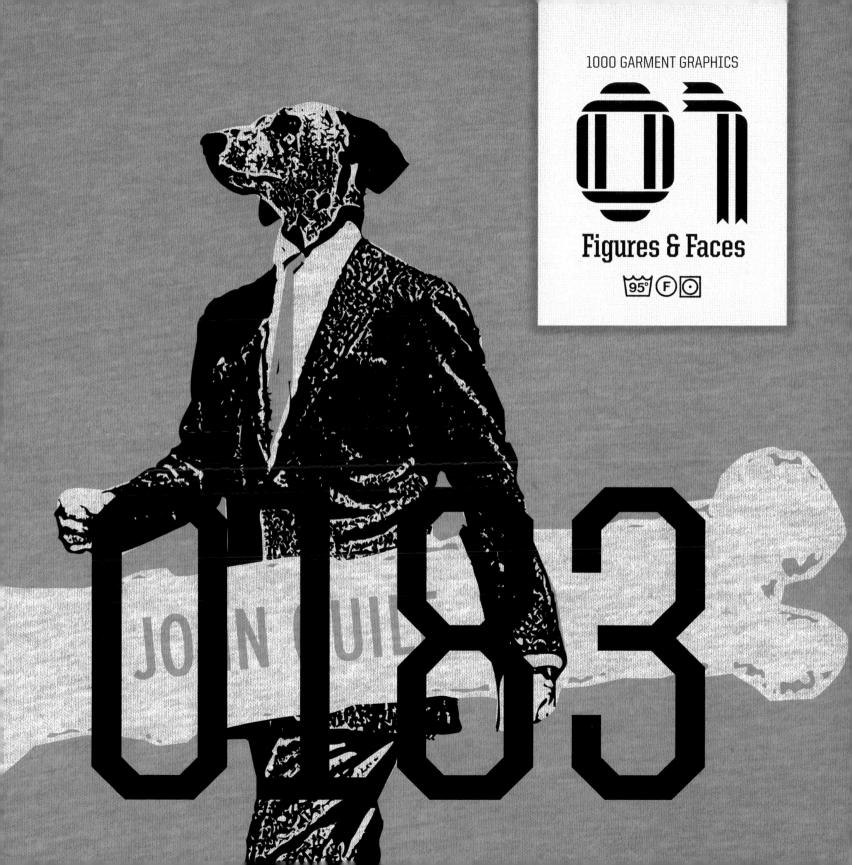

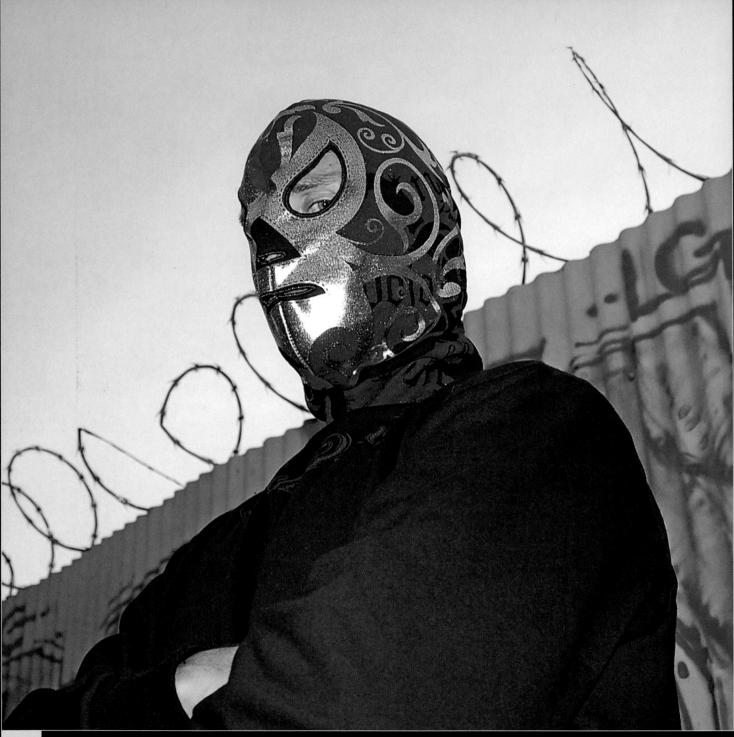

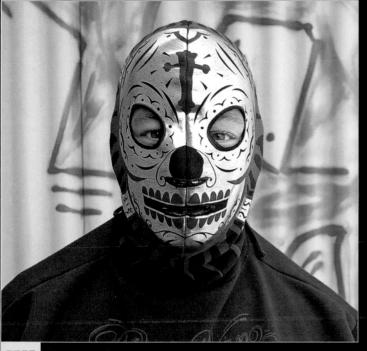

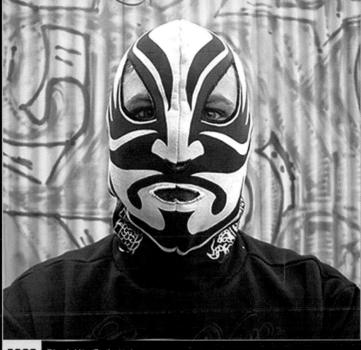

0002 Black Van Industries

0003 **Black Van Industries**

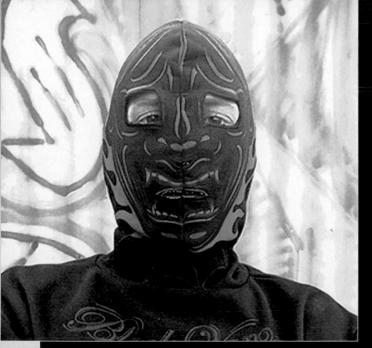

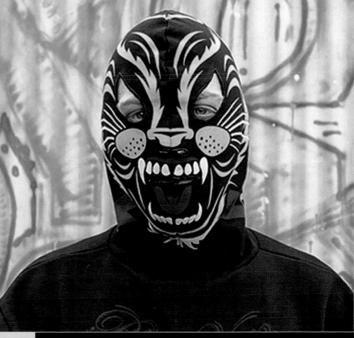

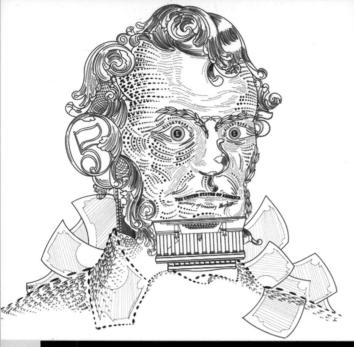

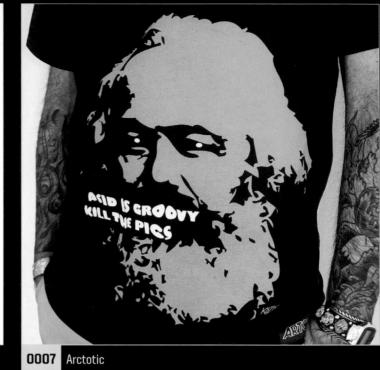

0006 Threadless

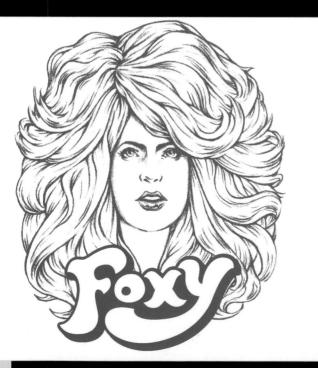

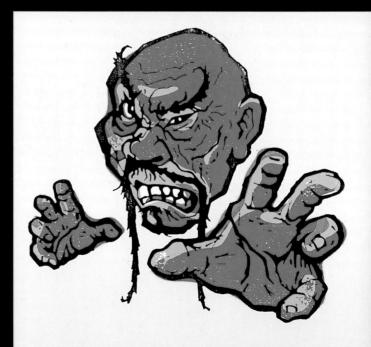

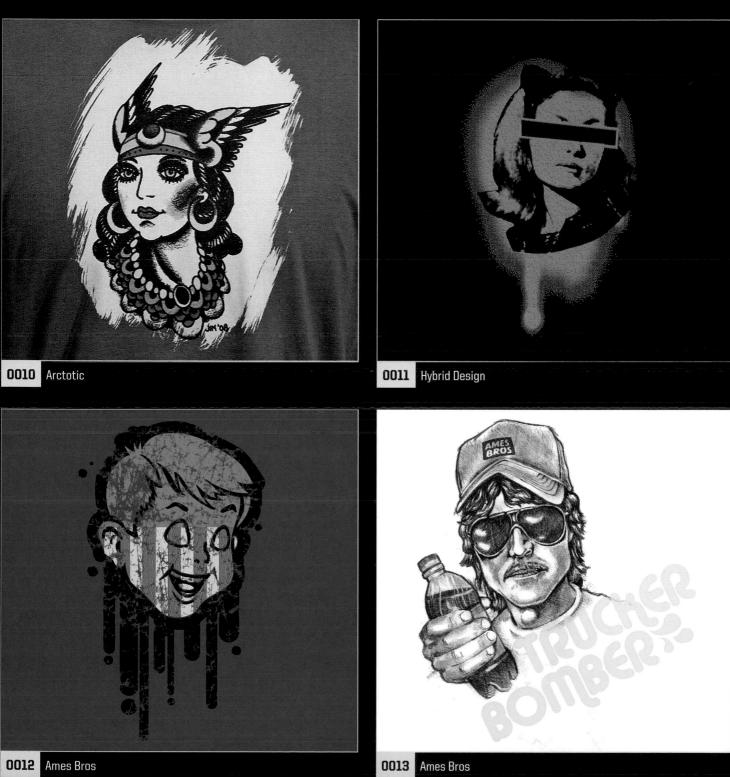

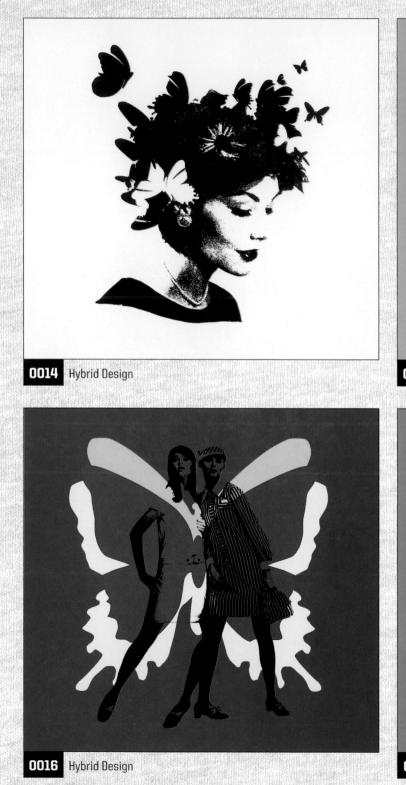

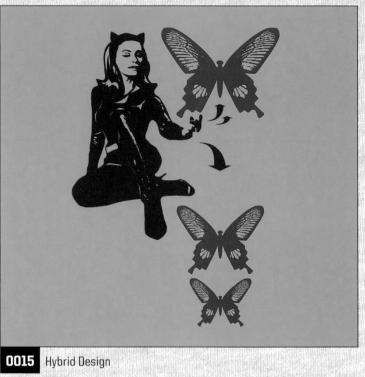

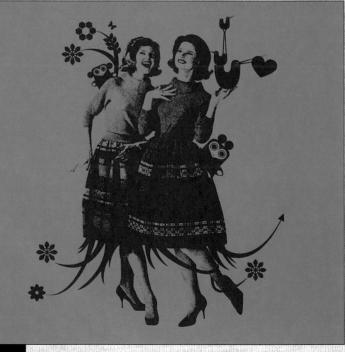

FIGURES & FACES | 15

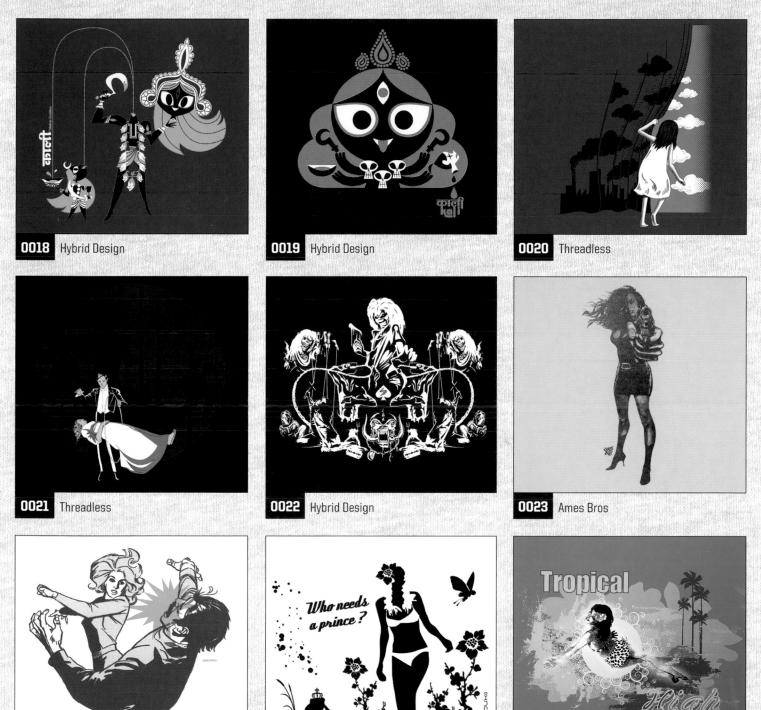

0024 Ames Bros

0025 Di Depux

0026 Hive Creative

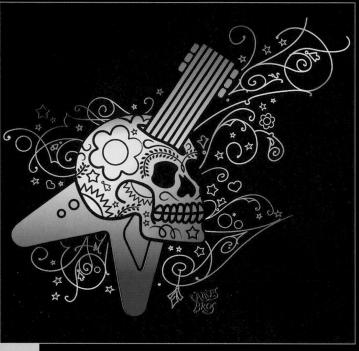

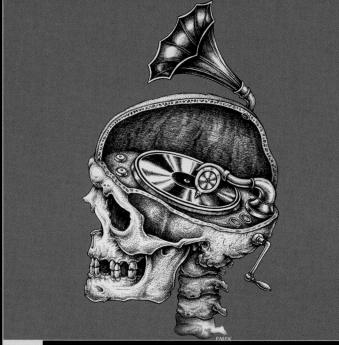

0027 Ames Bros

Aeroprojed

0028 The Faded Line Clothing Co.

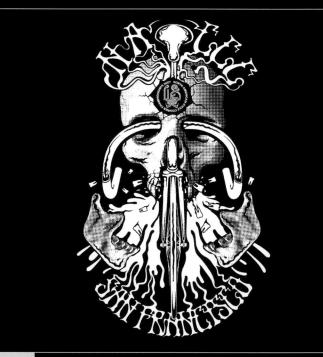

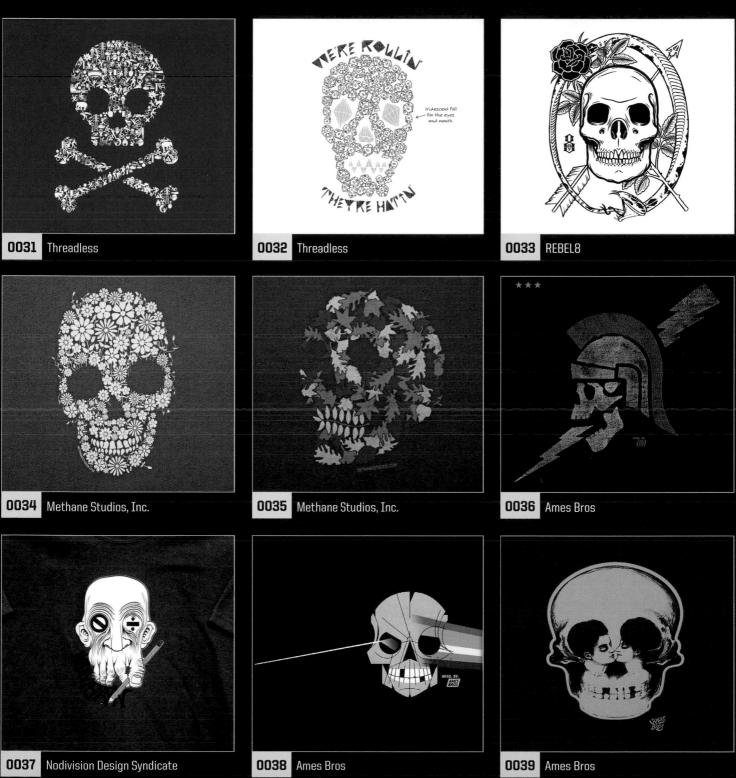

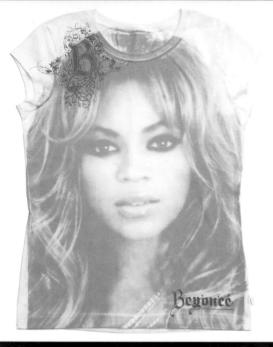

0040 DA Studios

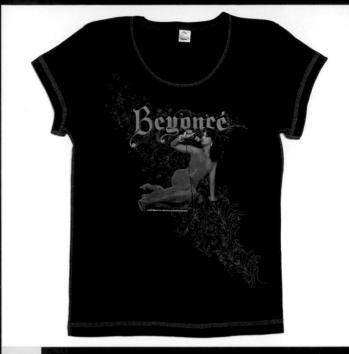

0041 DA Studios

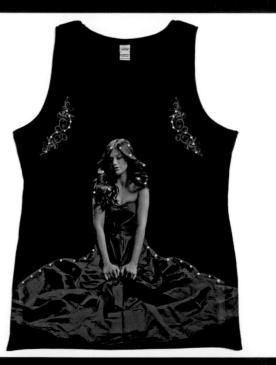

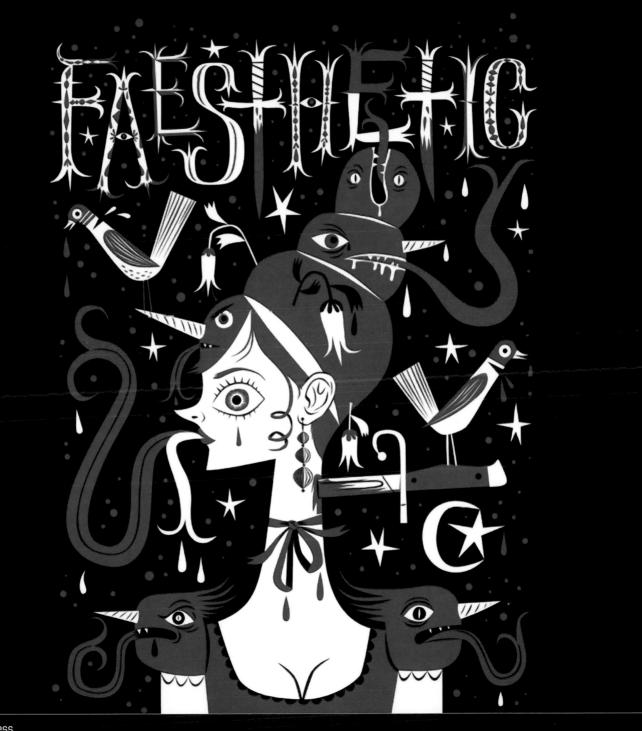

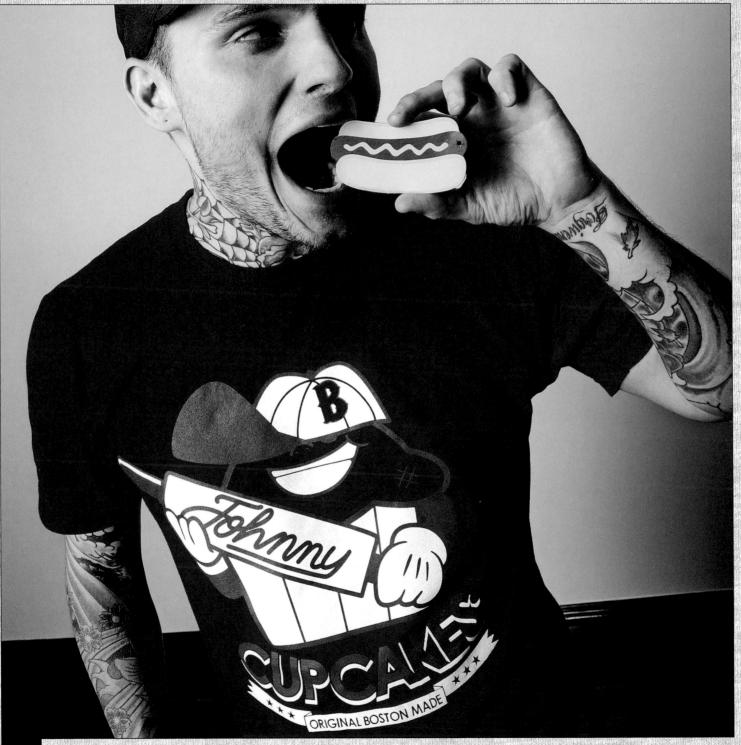

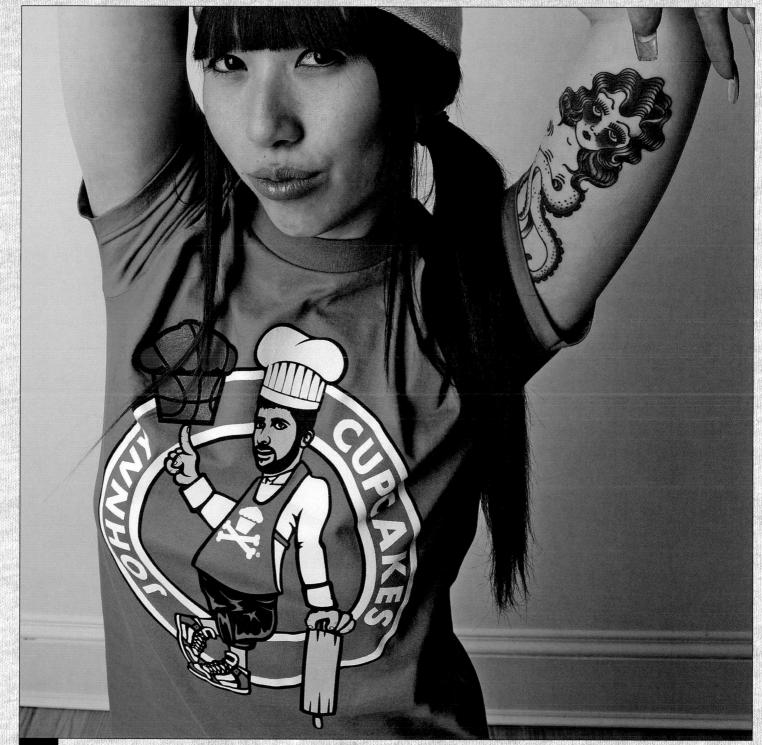

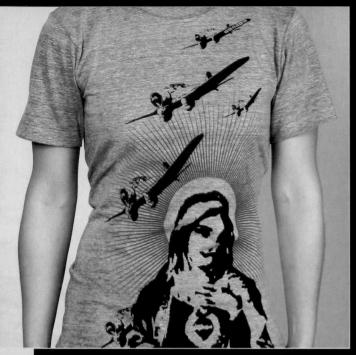

0047 De*Nada Design

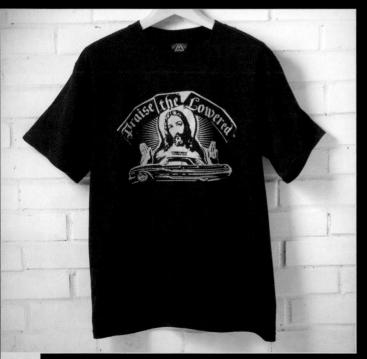

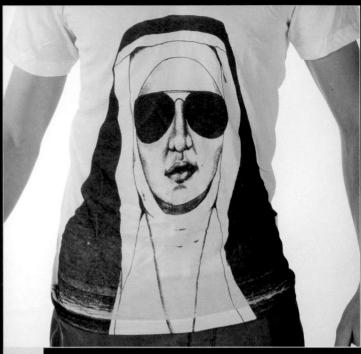

0048 Iskra Print Collective

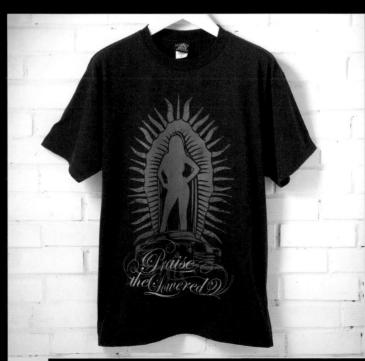

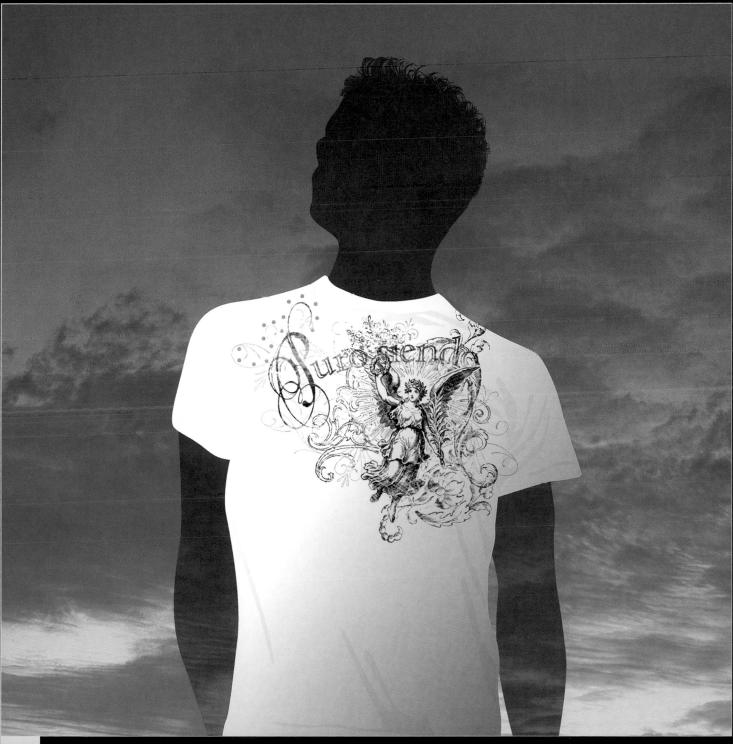

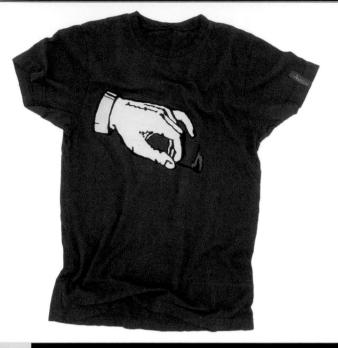

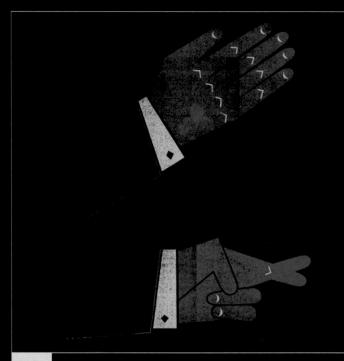

0052 Jonathon Wye, LLC

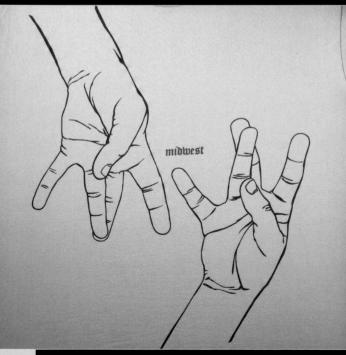

0053 Threadless

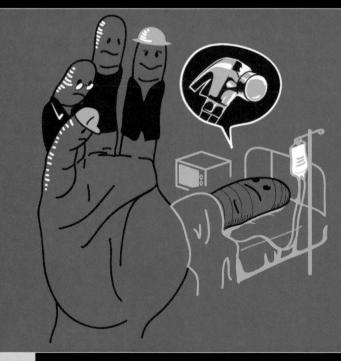

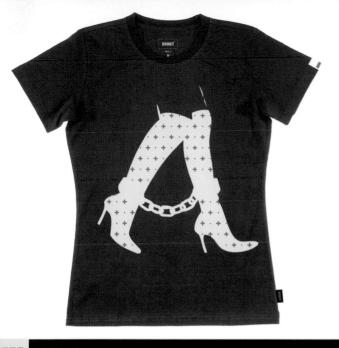

0056 Addict LTD

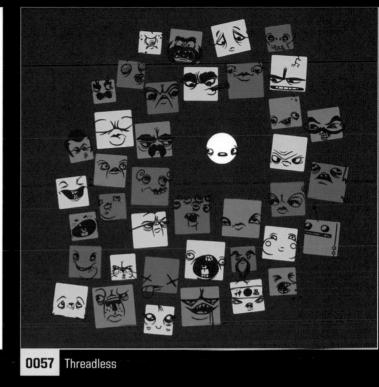

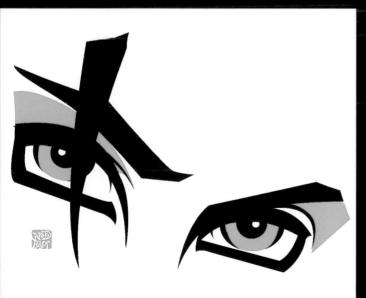

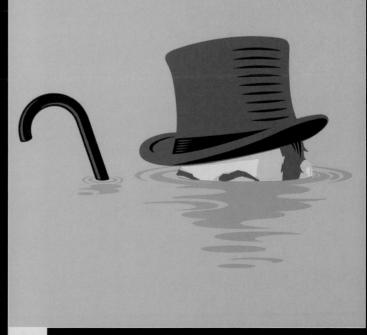

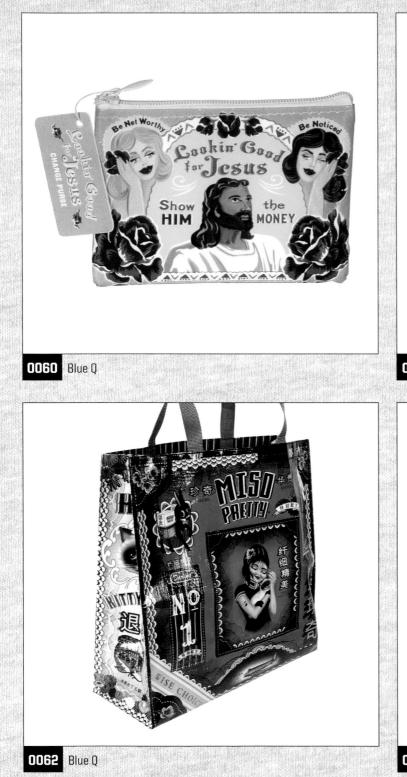

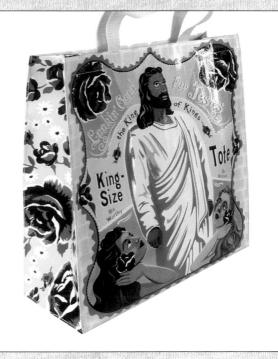

0061 Blue Q

OOGS Blue Q

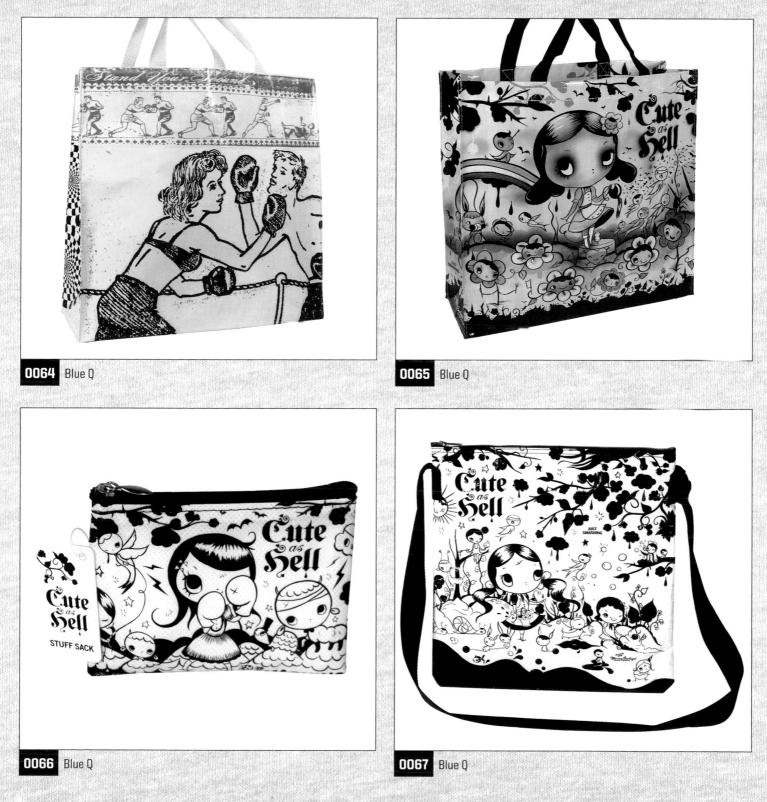

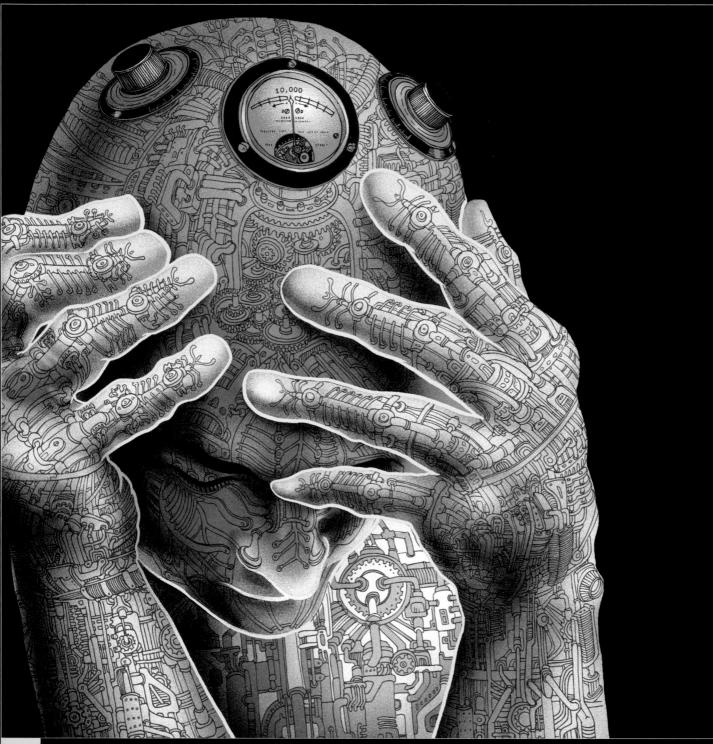

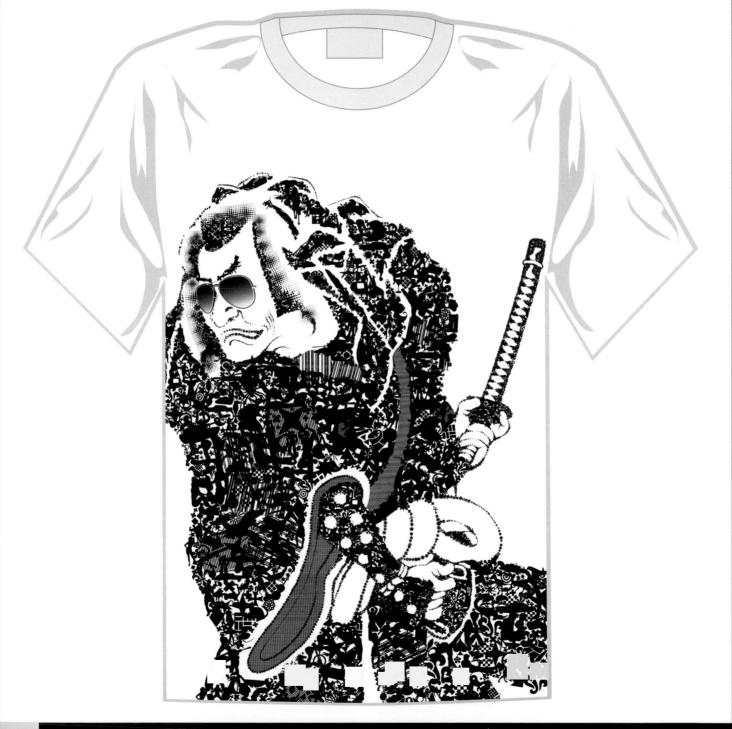

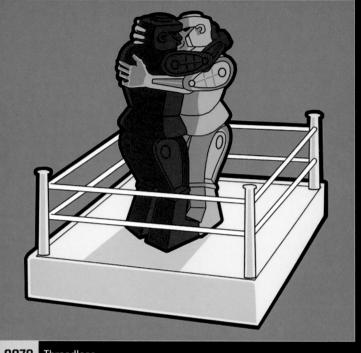

0070 Threadless

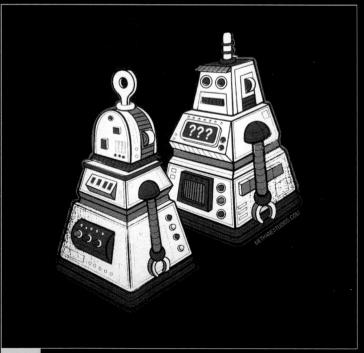

0071 Alphabet Arm Design

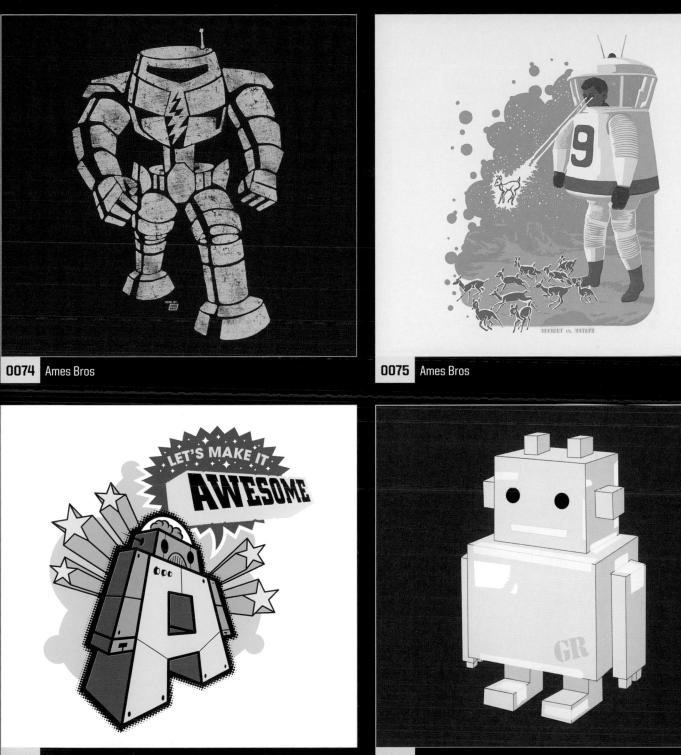

0077 Giant Robot

FIGURES & FACES | 35

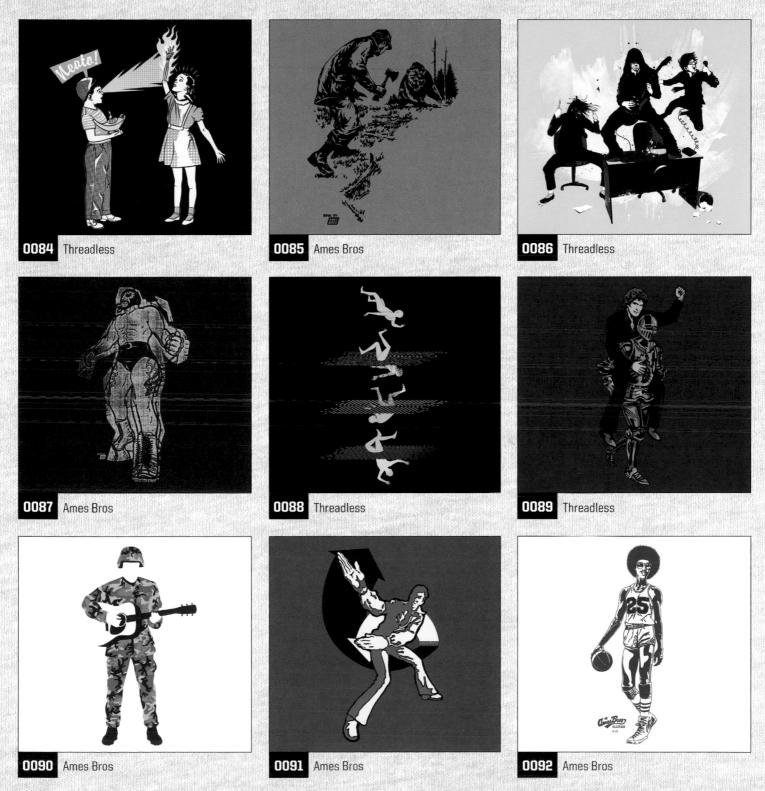

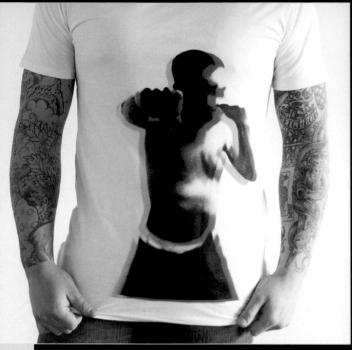

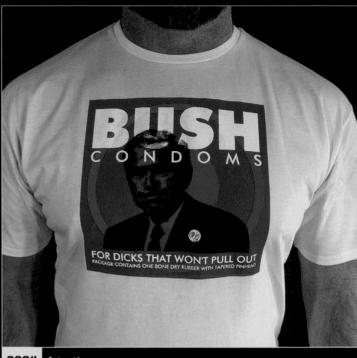

0093 Artcotic

0094 Artcotic

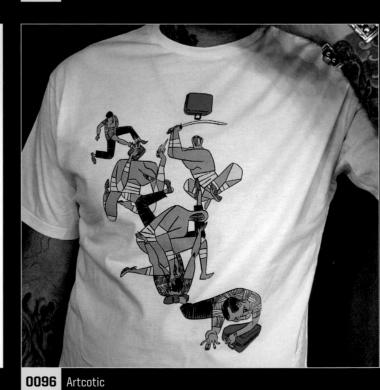

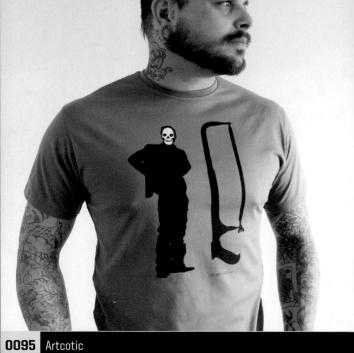

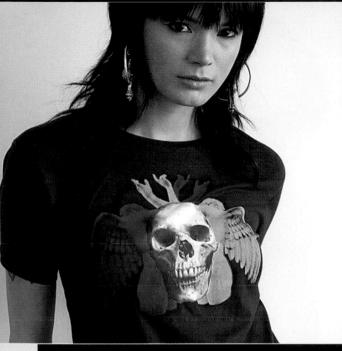

0097 Artcotic

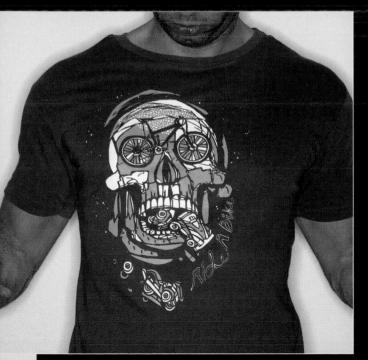

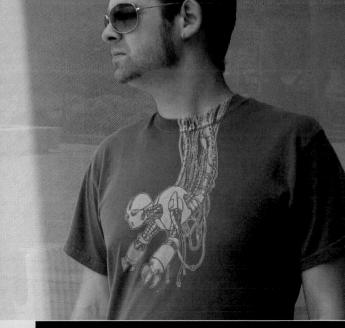

0098 Artcotic

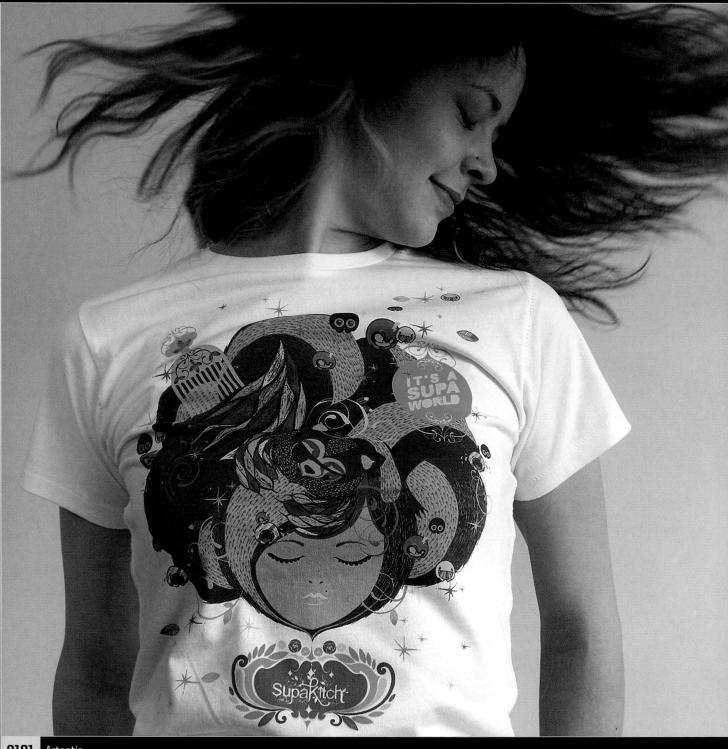

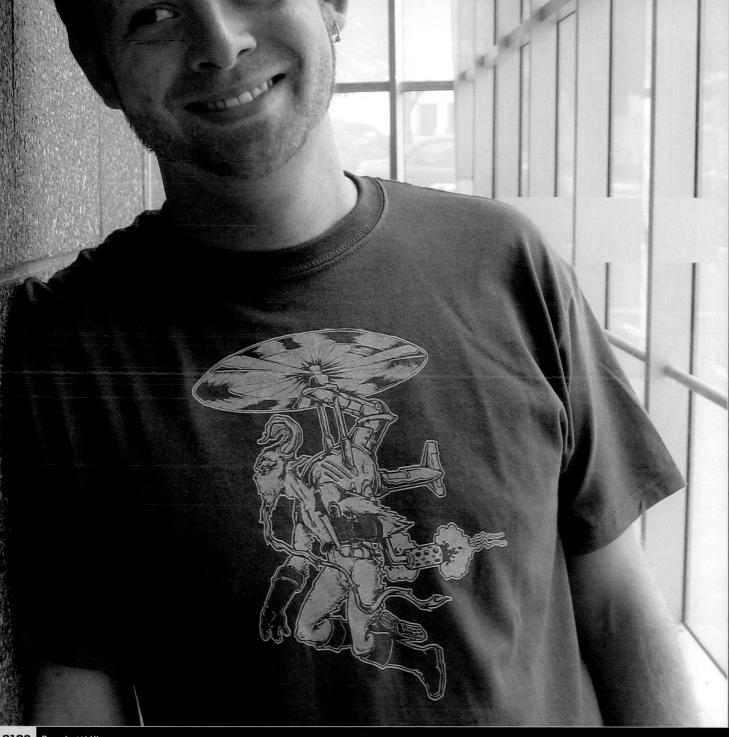

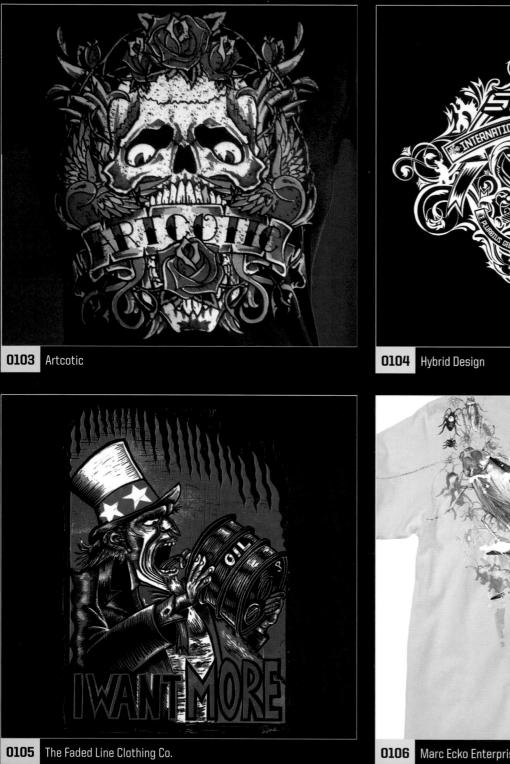

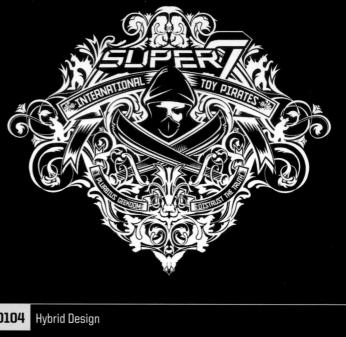

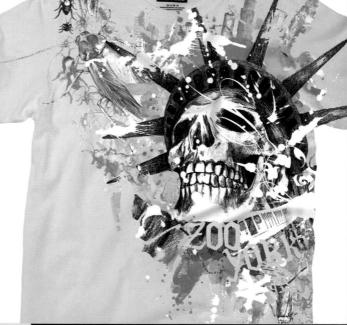

.

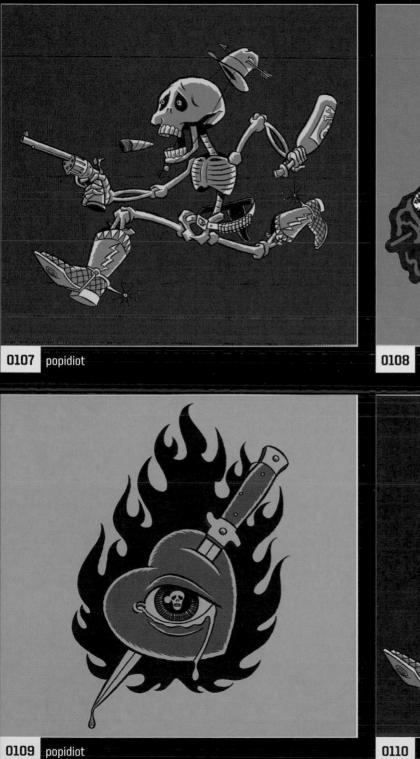

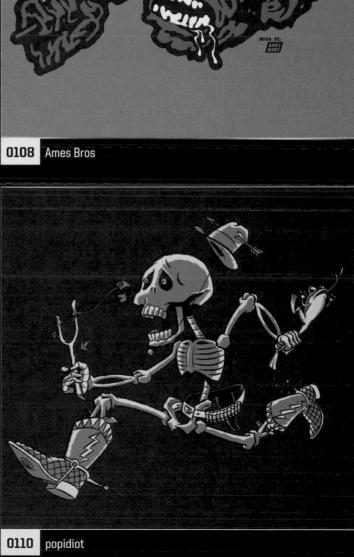

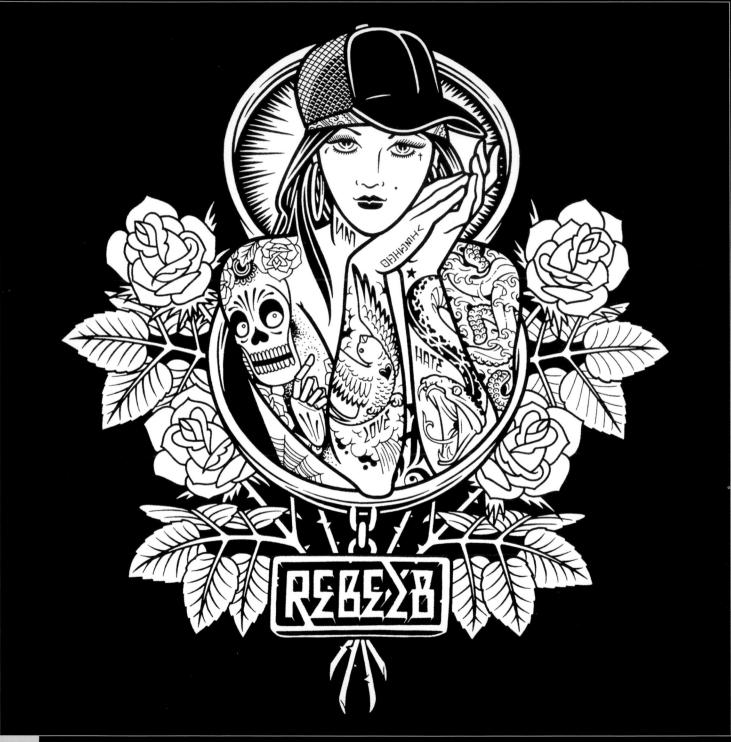

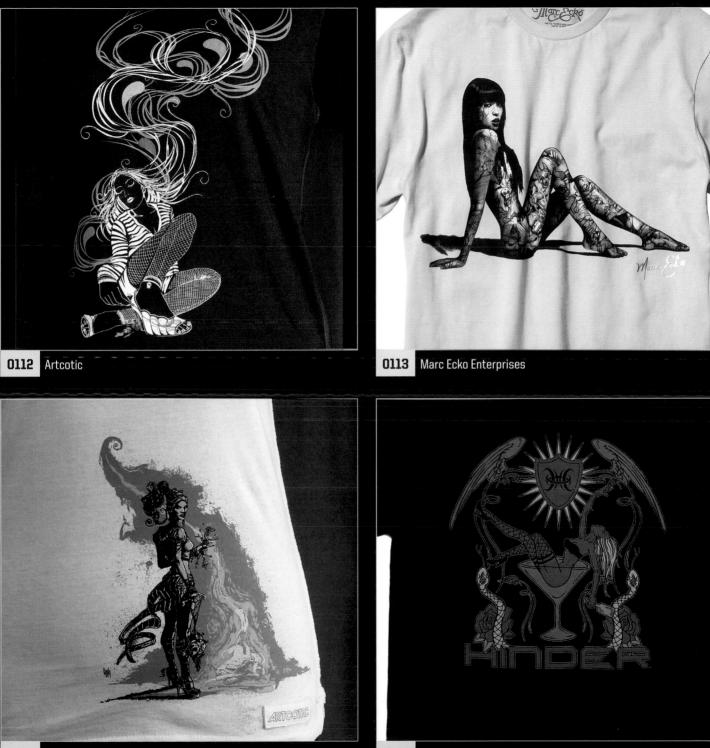

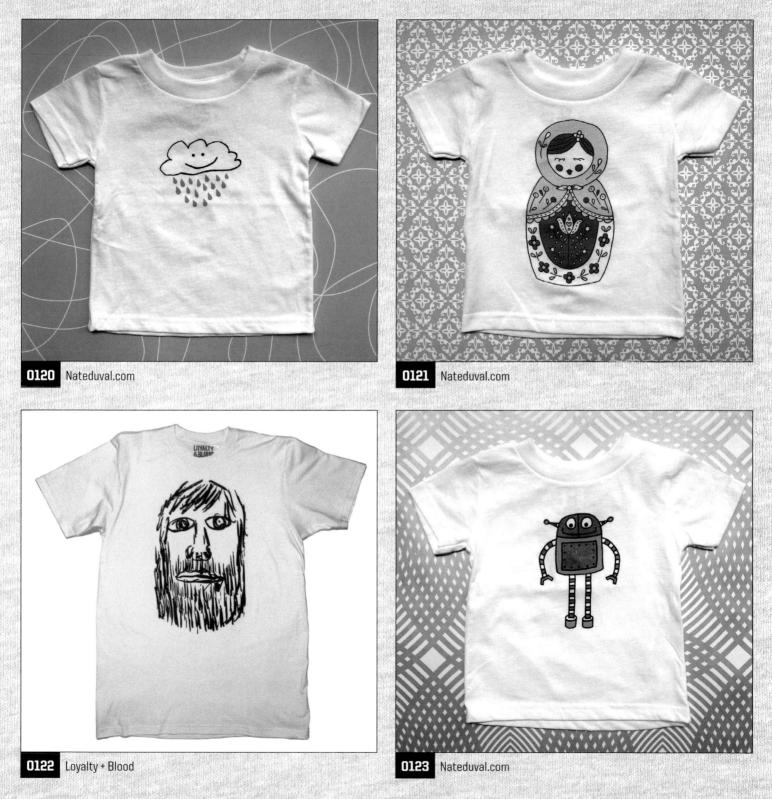

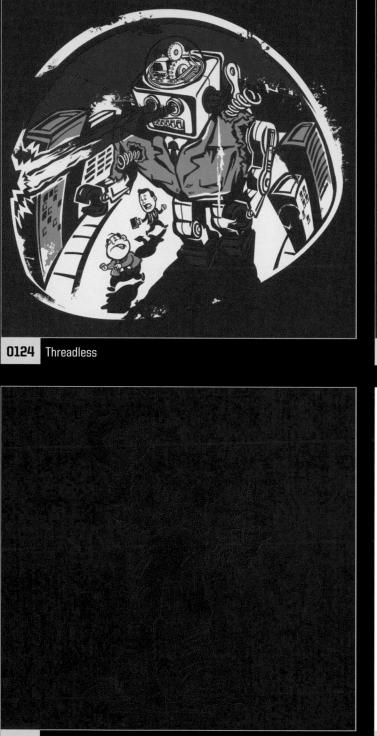

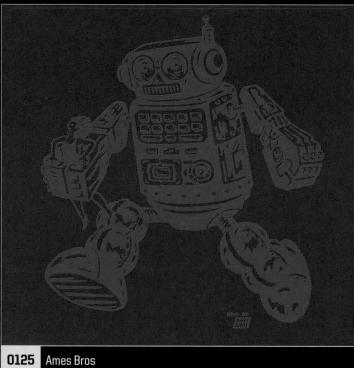

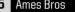

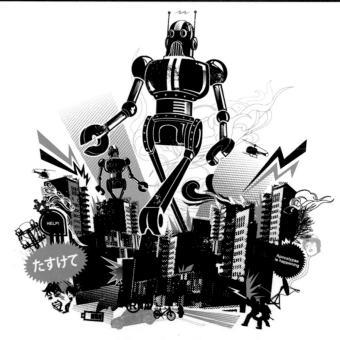

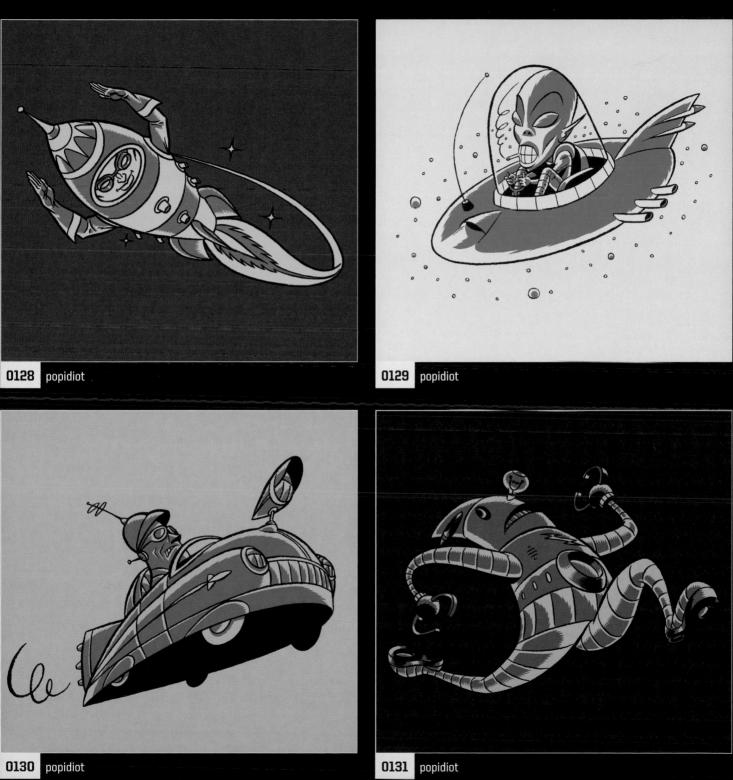

0132 christiansen : creative

0133 Alphabet Arm Design

0134 Alphabet Arm Design

0135 Alphabet Arm Design

0136 Iskra Print Collective

0137 Johnny Cupcakes

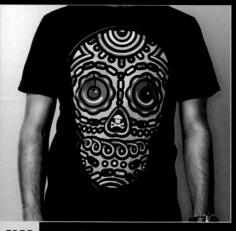

0138 Johnny Cupcakes

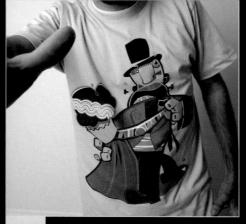

0139 Johnny Cupcakes

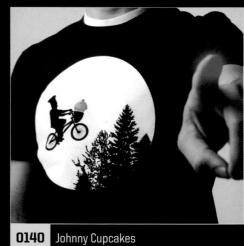

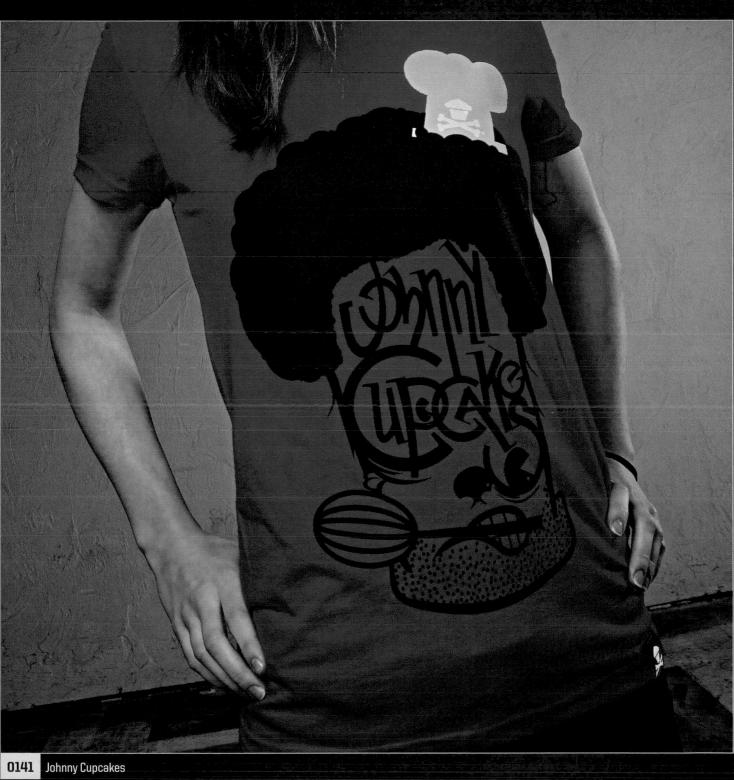

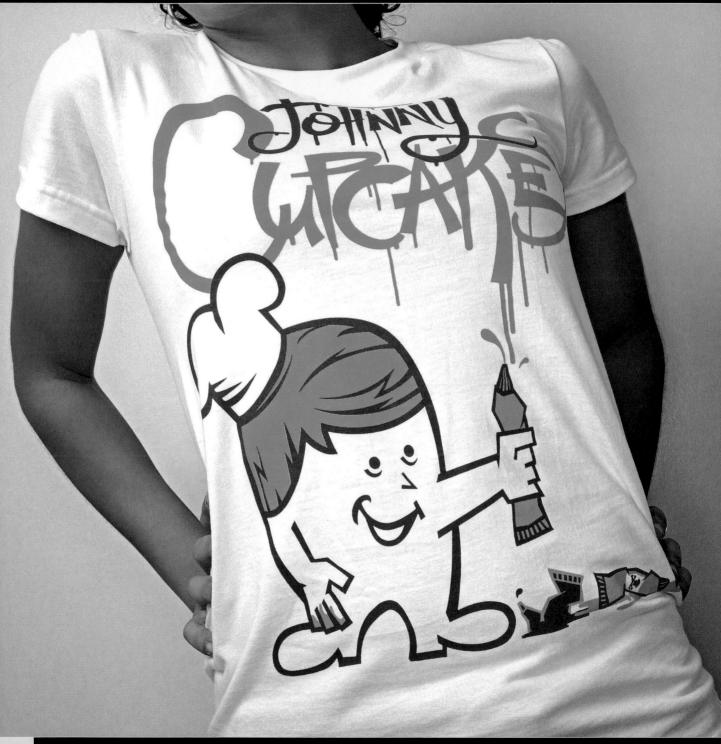

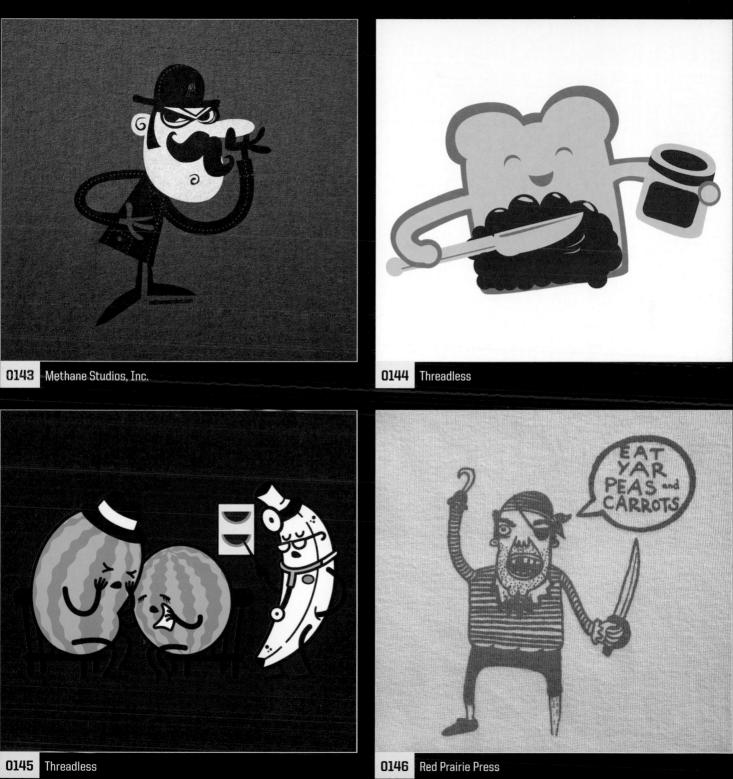

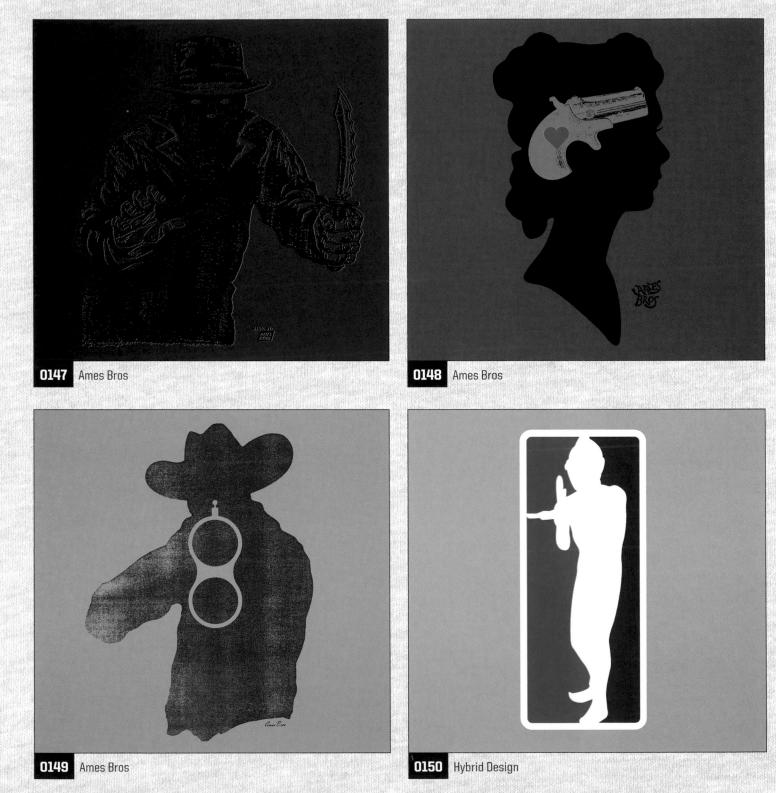

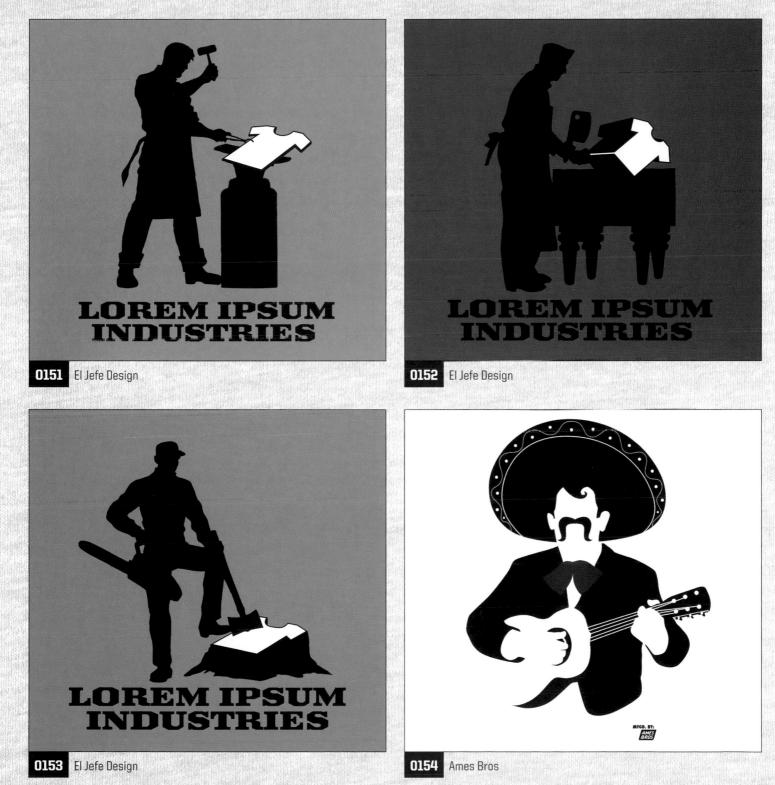

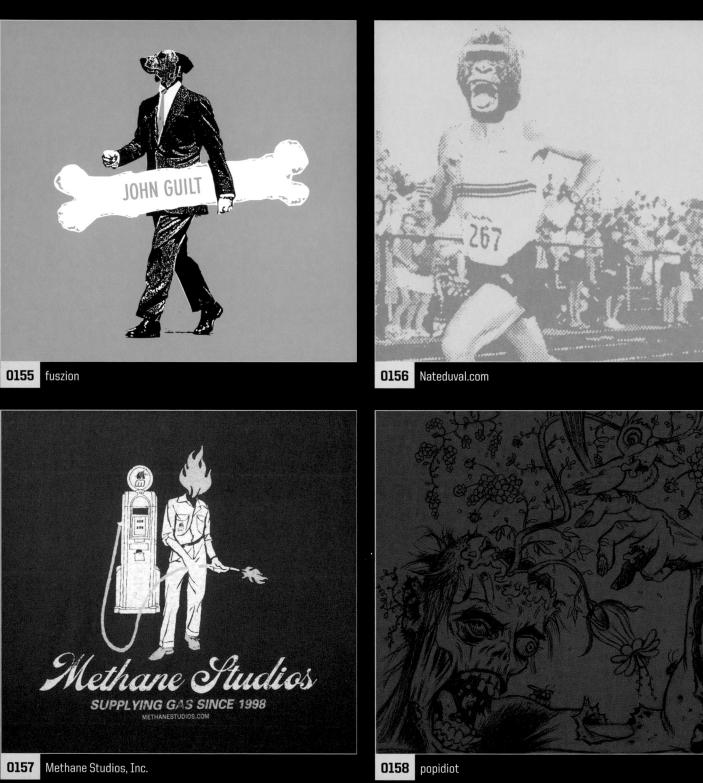

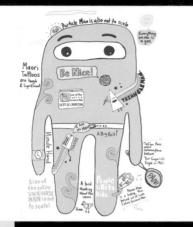

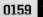

B Threadless

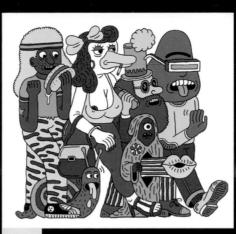

0160 Threadless

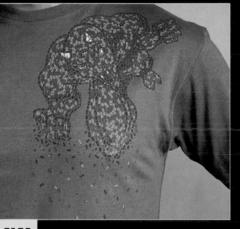

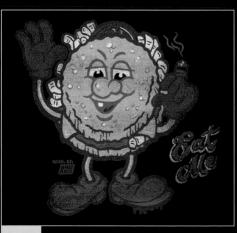

0163 Ames Bros

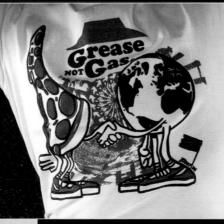

0166 The Faded Line Clothing Co.

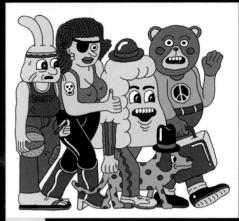

0161 Threadless

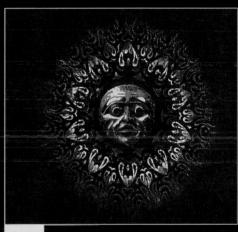

0164 The Faded Line Clothing Co.

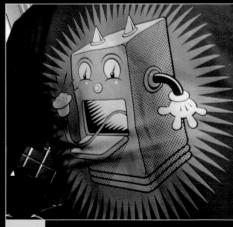

0167 Johnny Cupcakes

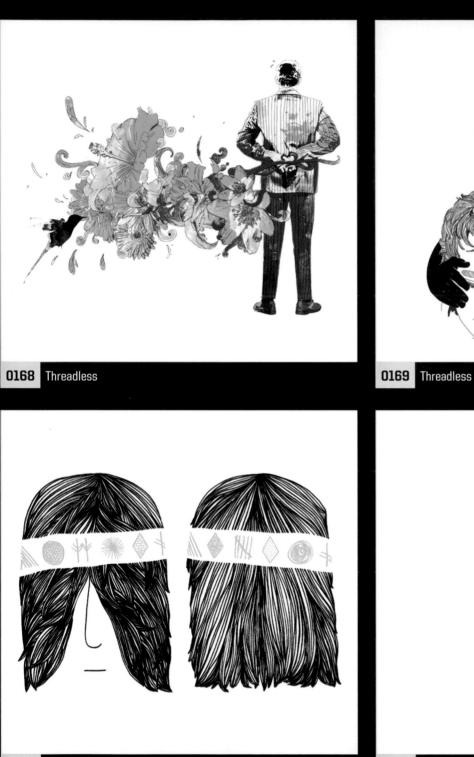

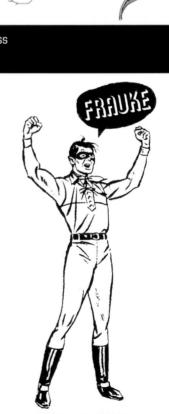

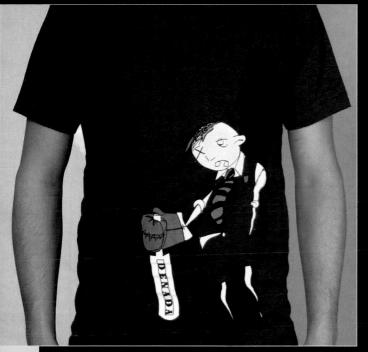

0172 De*Nada Design

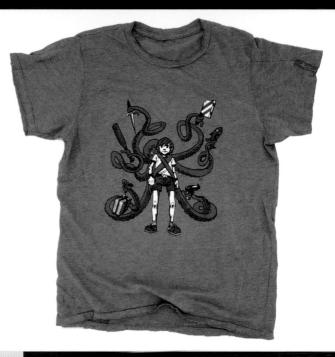

0173 Jonathon Wye, LLC

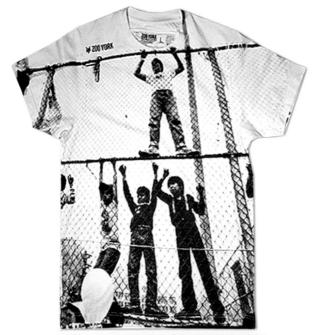

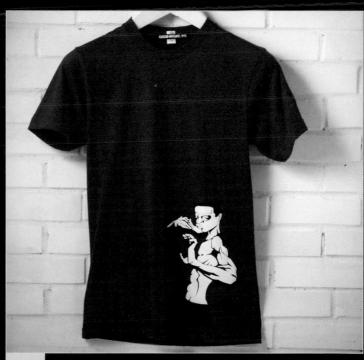

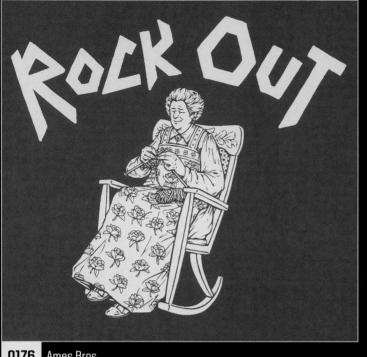

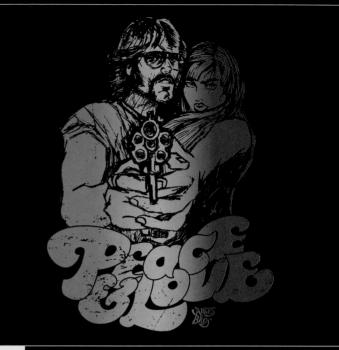

0176 Ames Bros

0177 Ames Bros

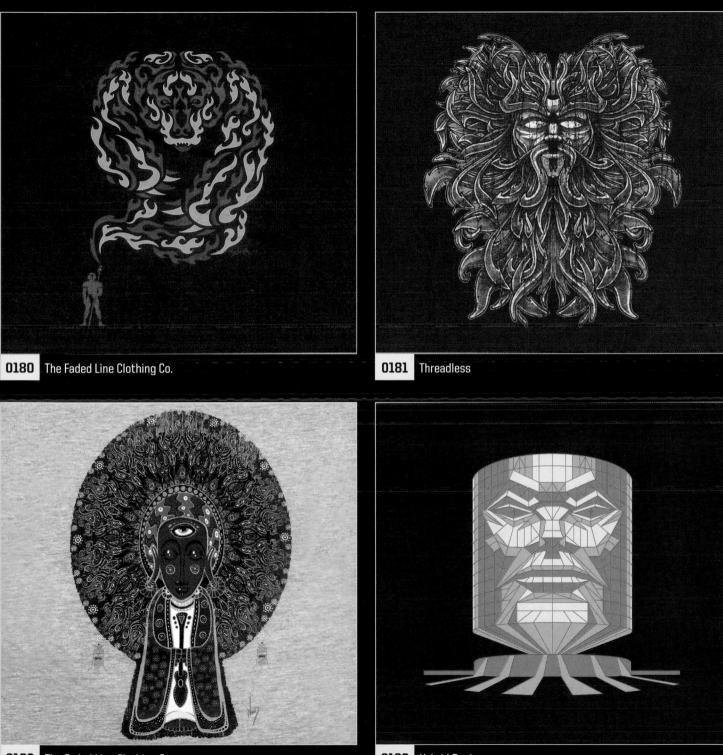

0183 Hybrid Design

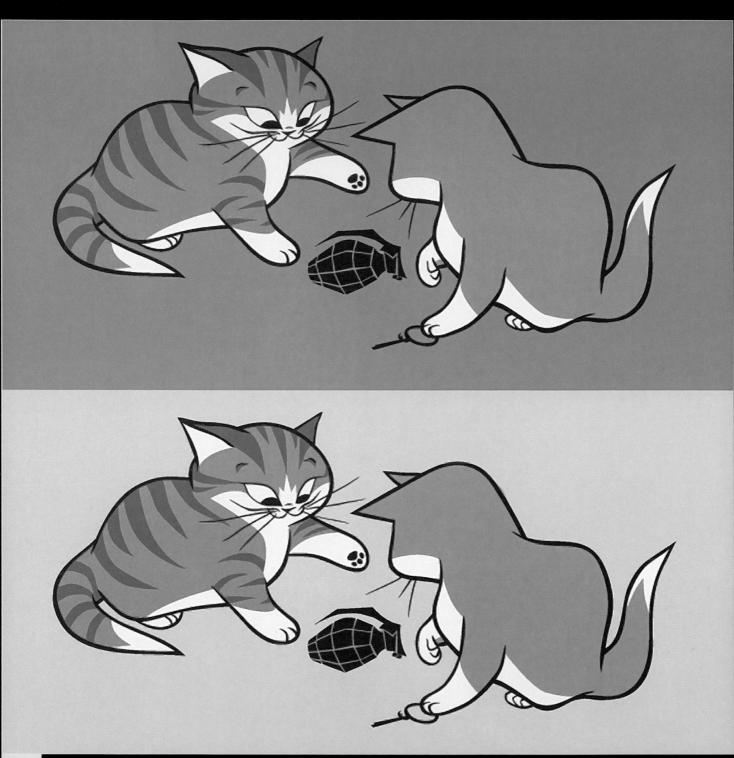

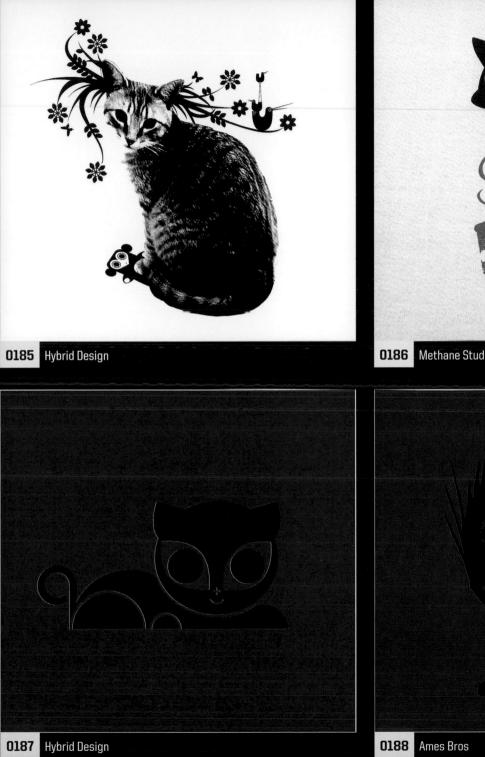

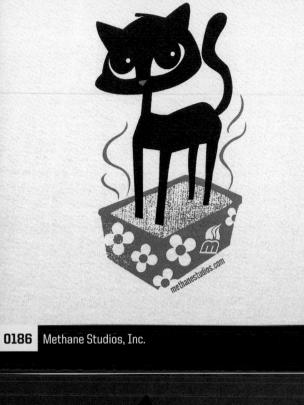

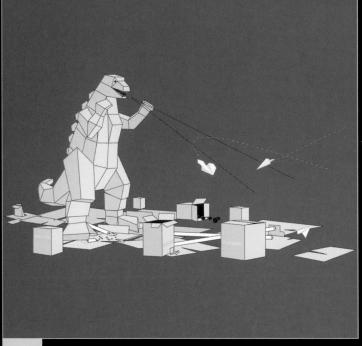

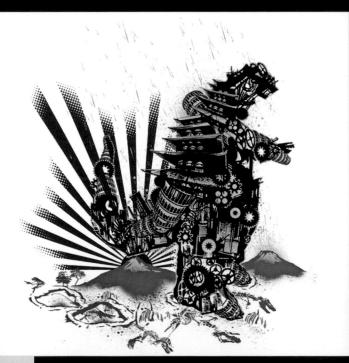

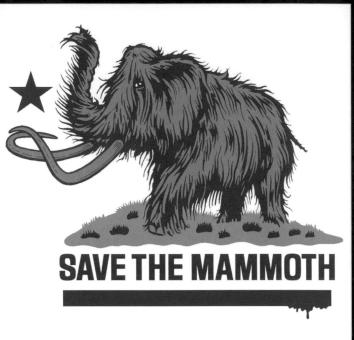

0190 Ames Bros

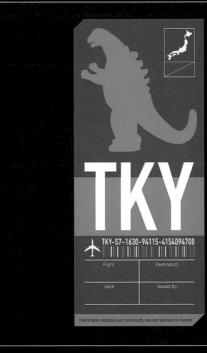

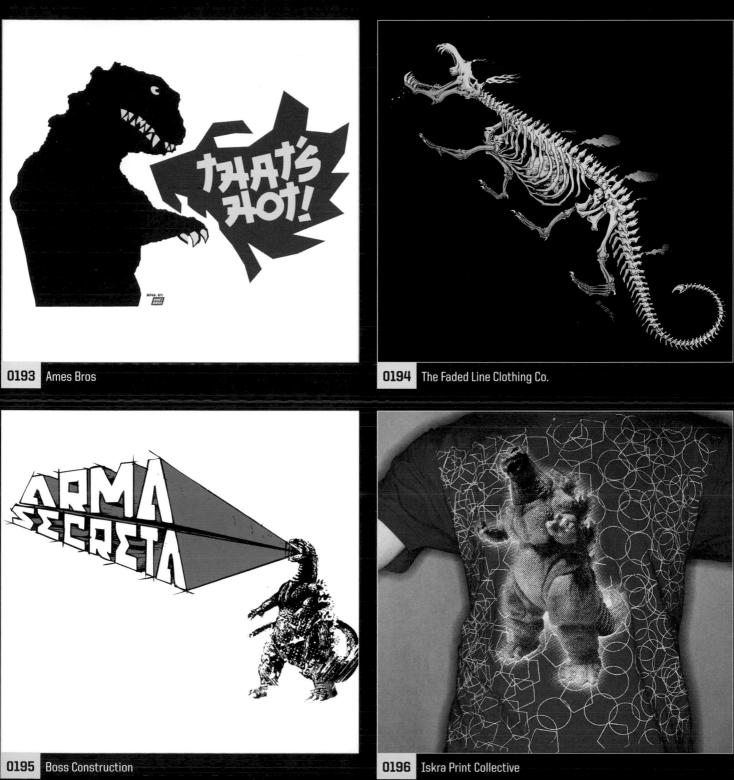

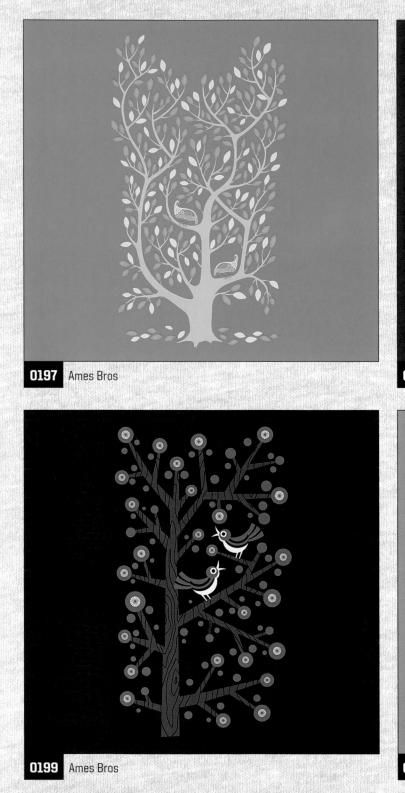

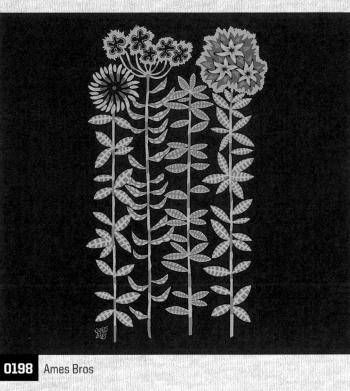

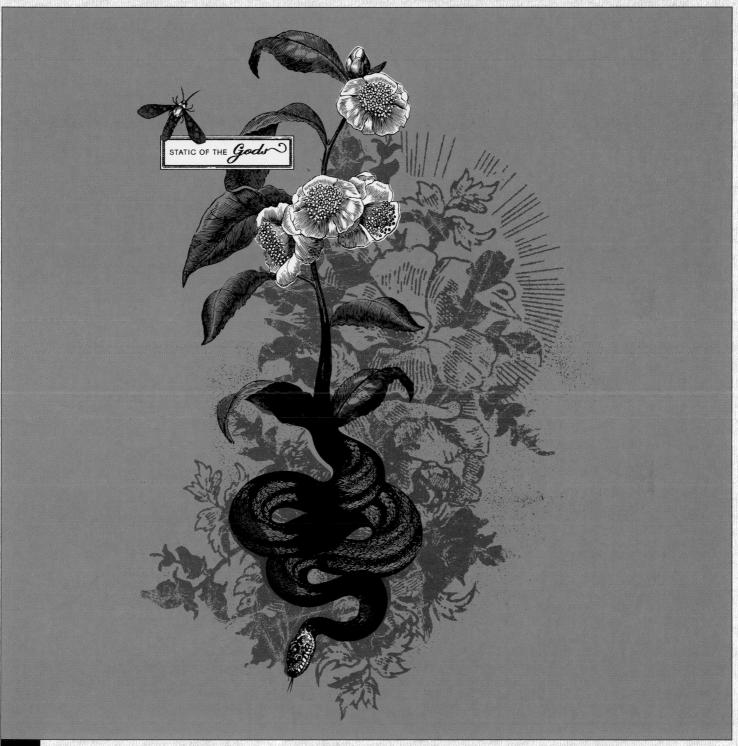

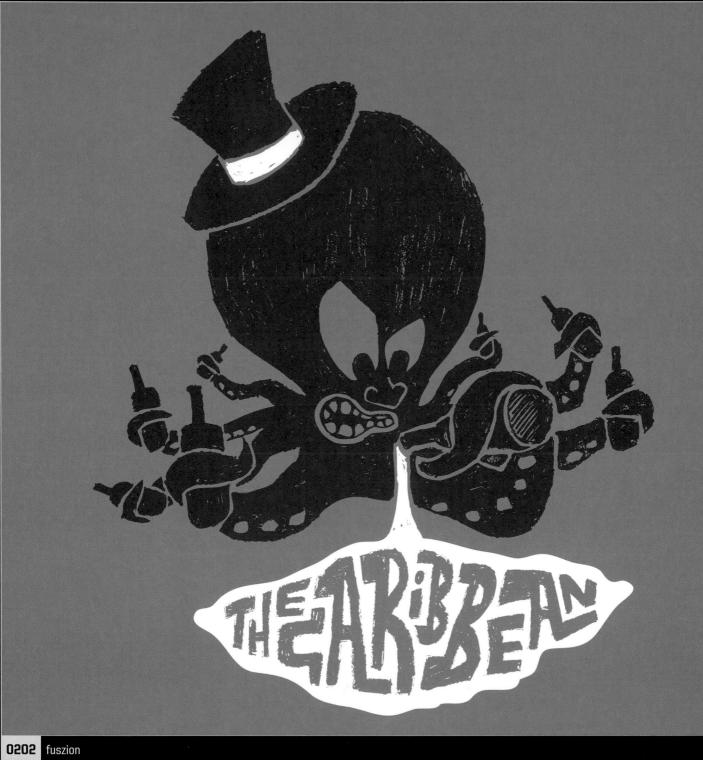

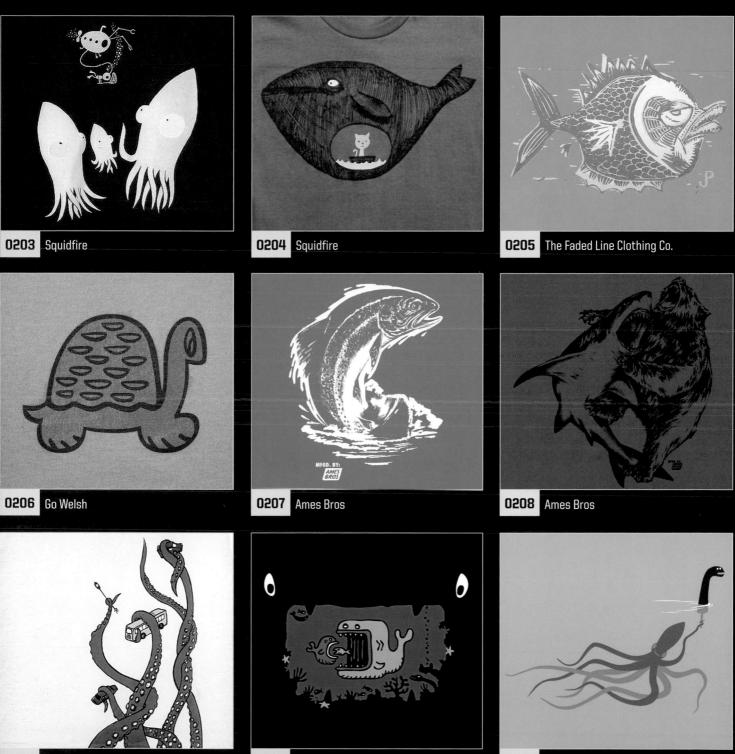

0209 Squidfire

0210 Threadless

0211 Threadless

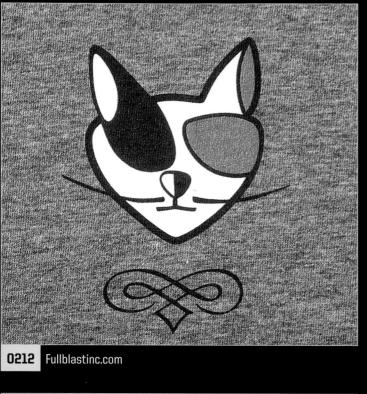

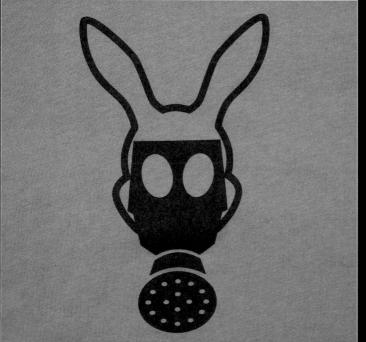

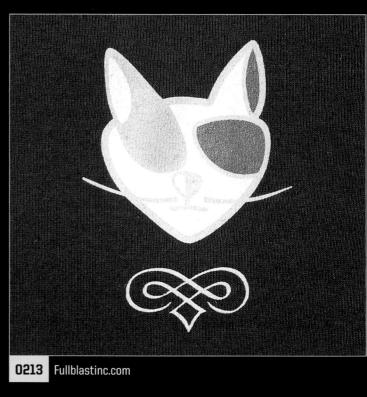

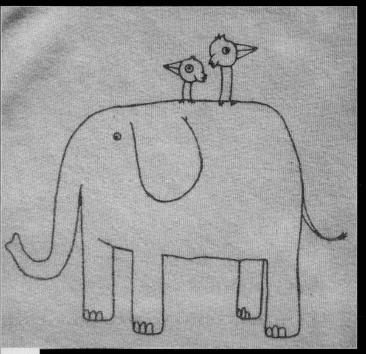

0218 Banker Wessel

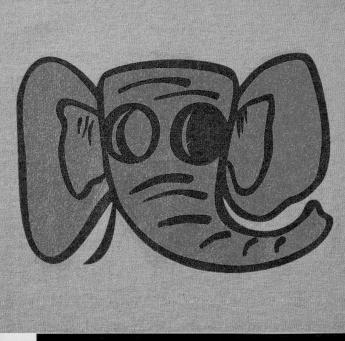

0217 Go Welsh

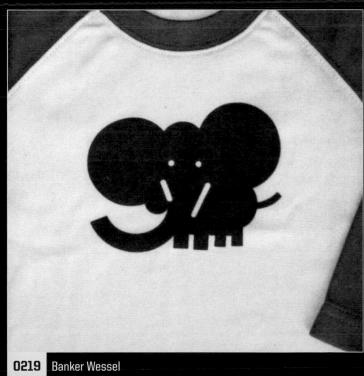

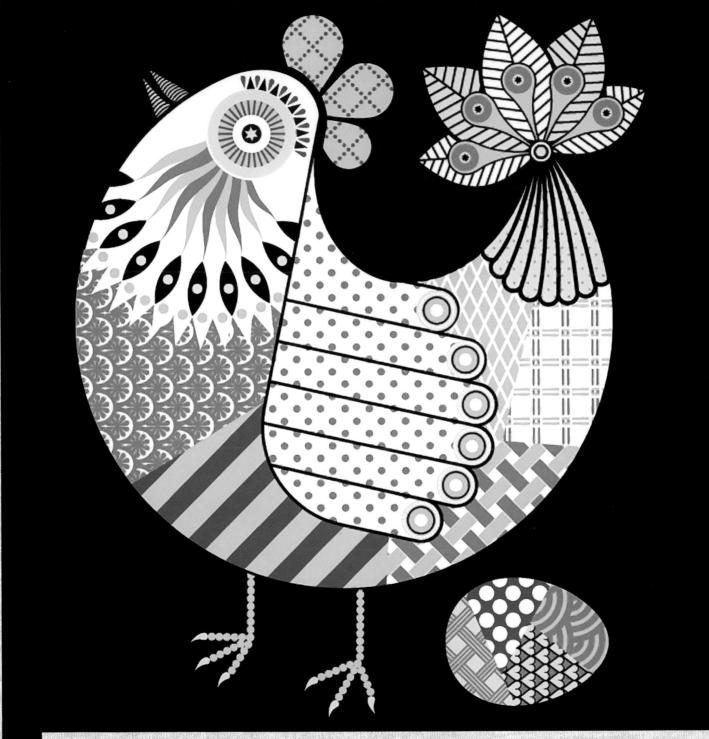

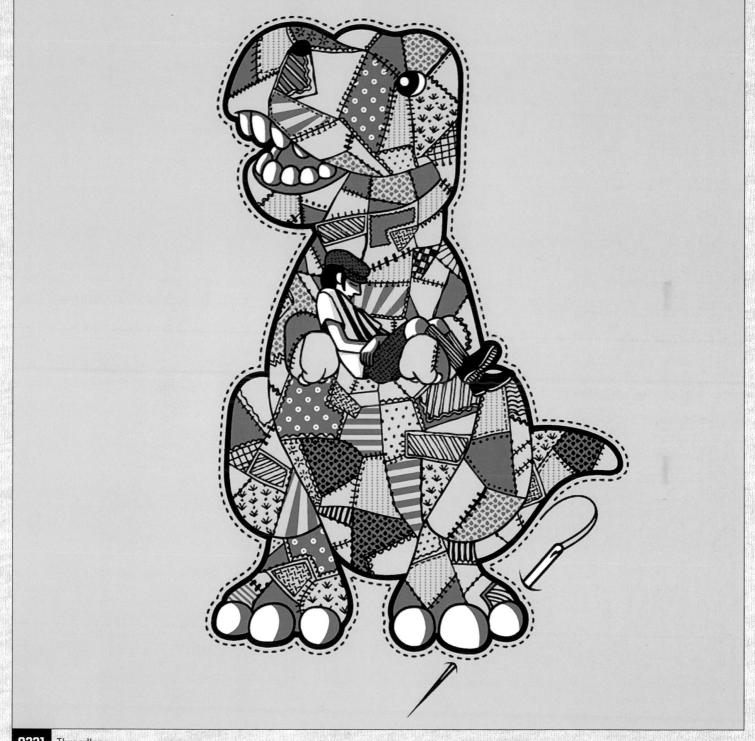

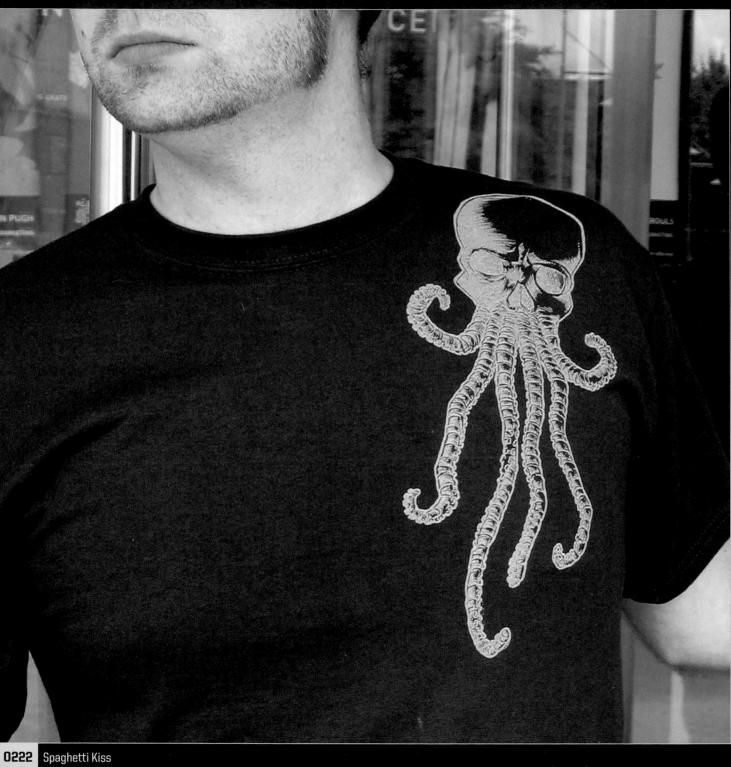

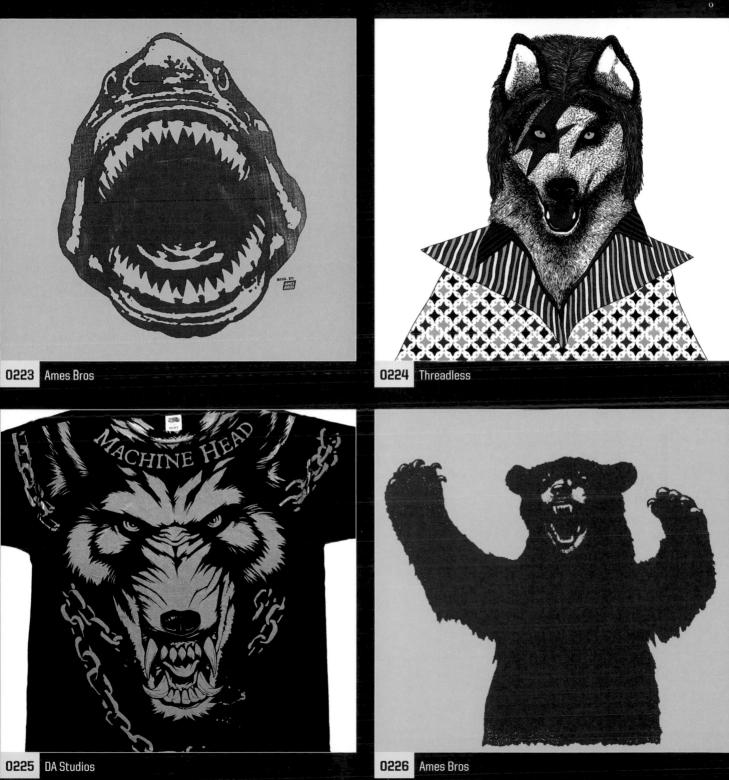

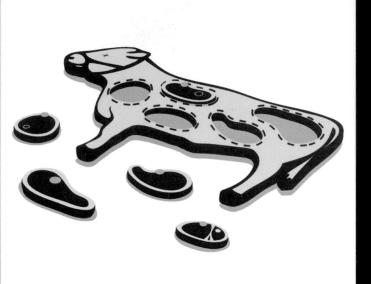

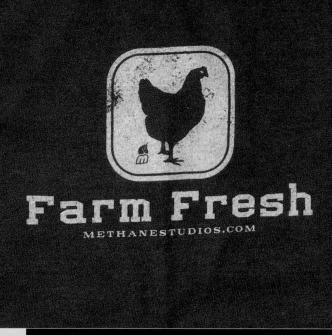

0227 Threadless

0228 Methane Studios, Inc.

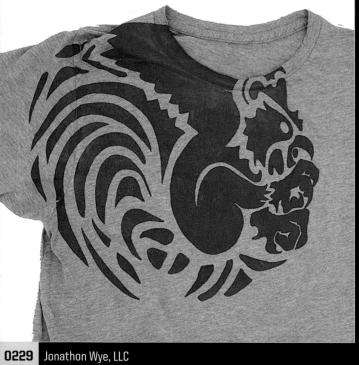

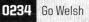

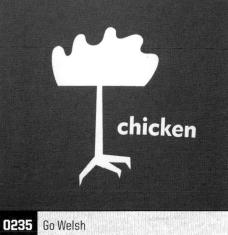

0238 Go Welsh

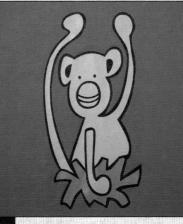

D241 Go Welsh

0242 Blue Q

0243 Blue Q

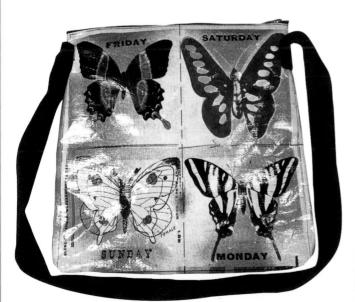

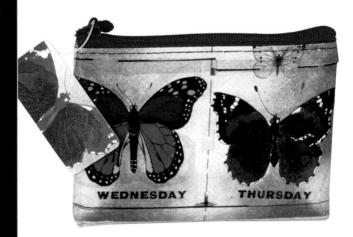

DOGS WE KNOW

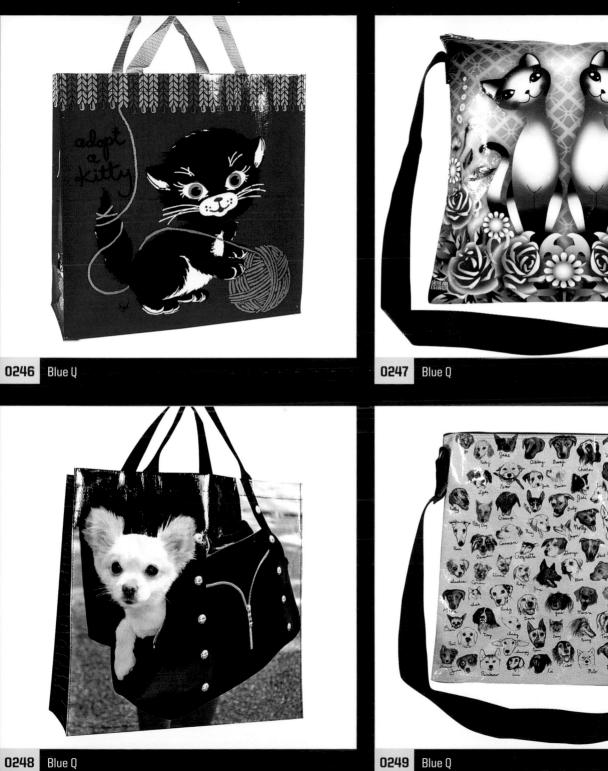

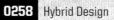

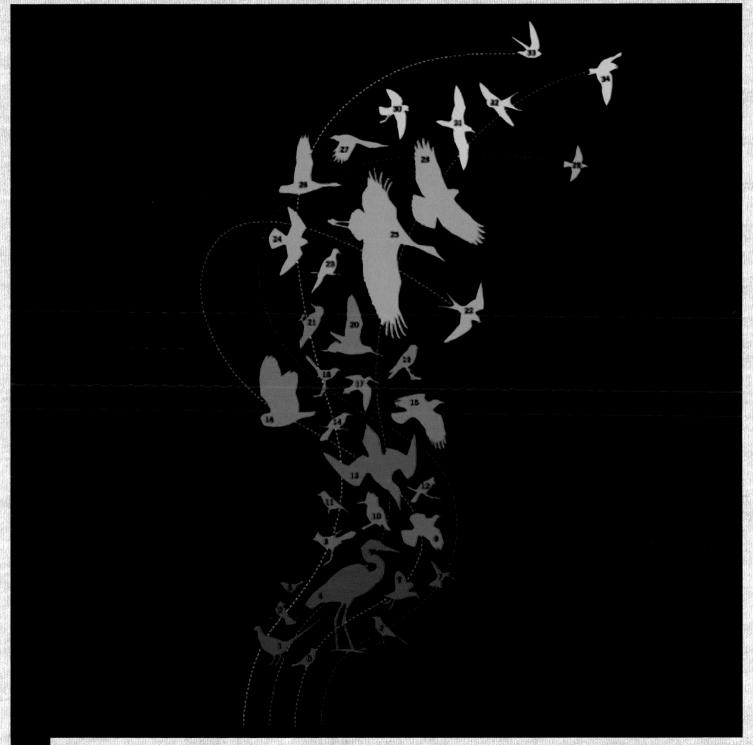

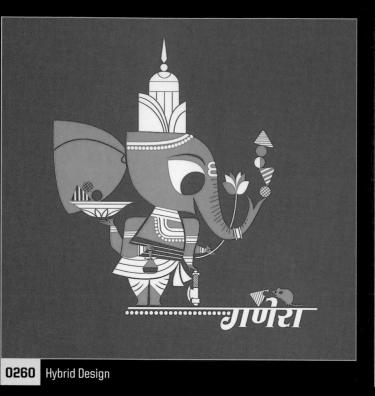

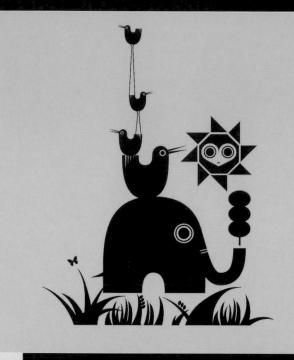

0261 Hybrid Design

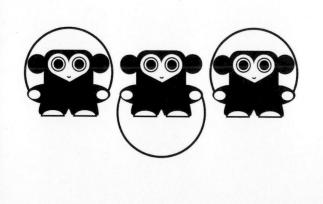

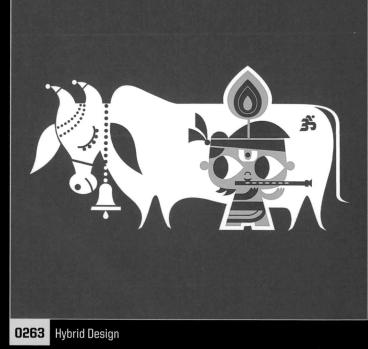

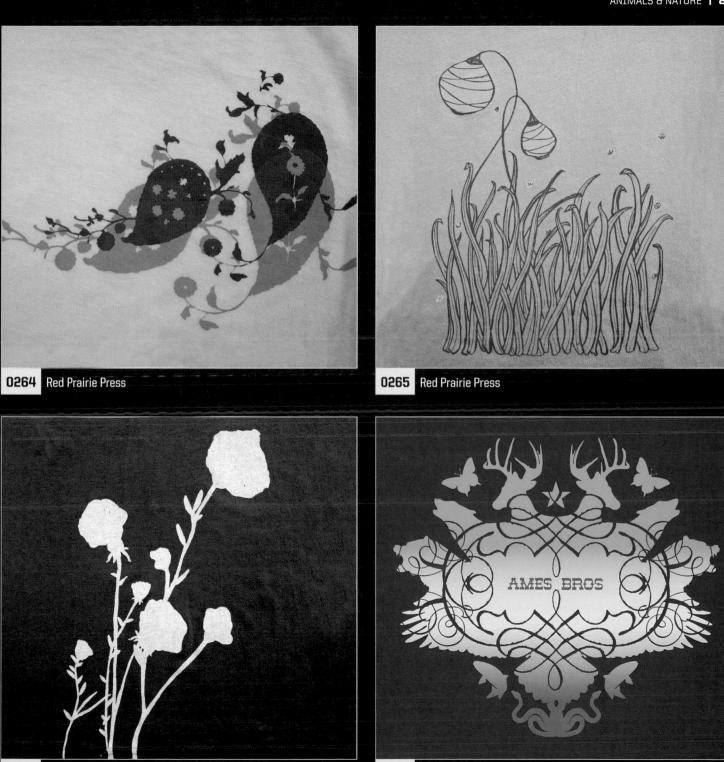

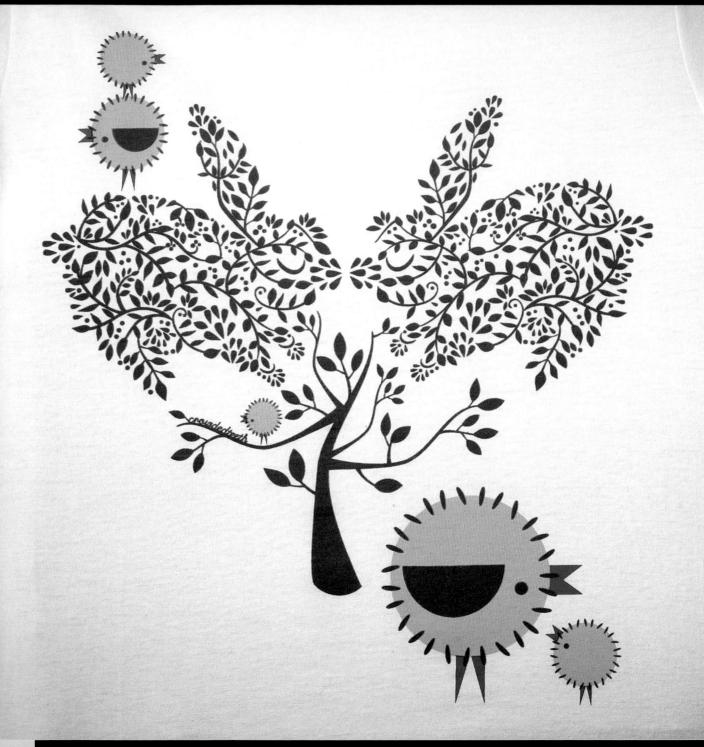

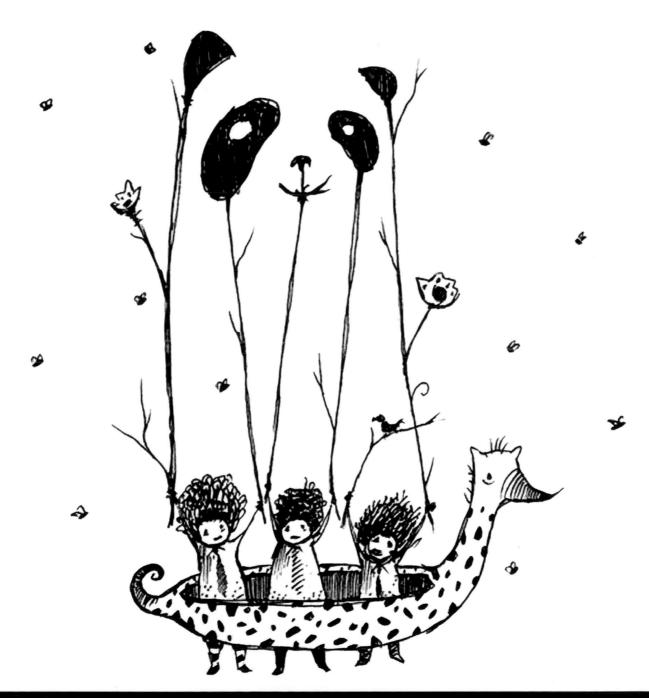

\$

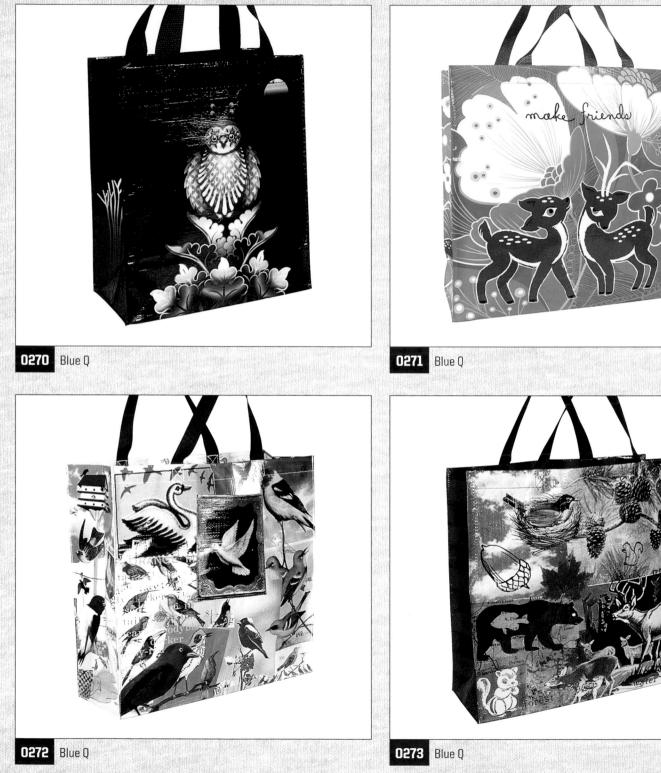

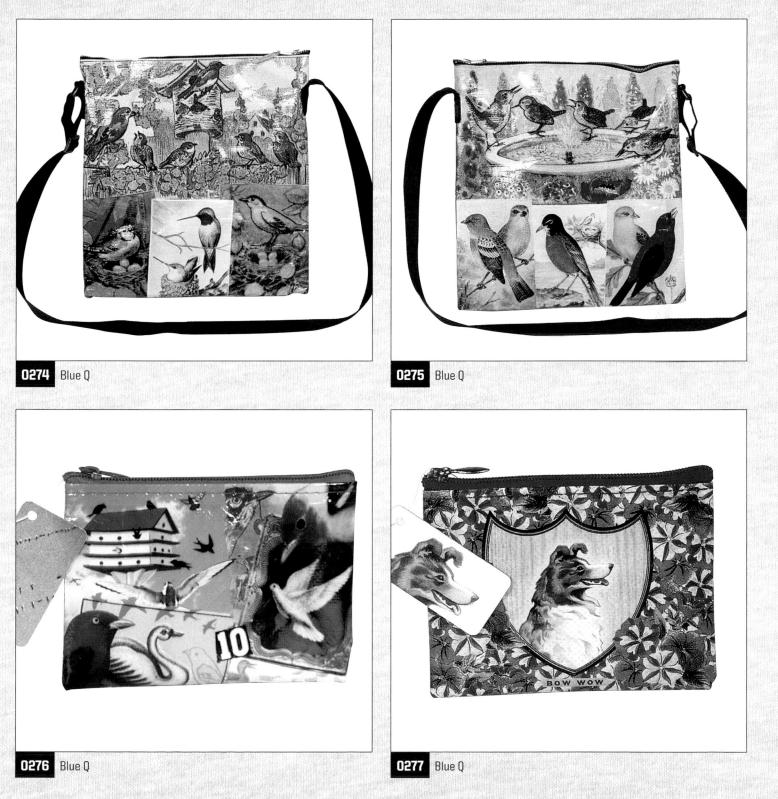

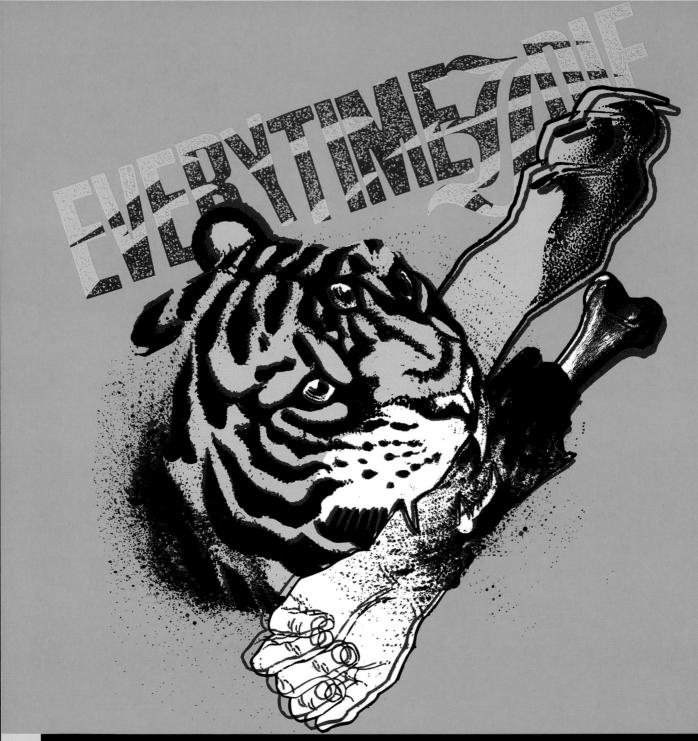

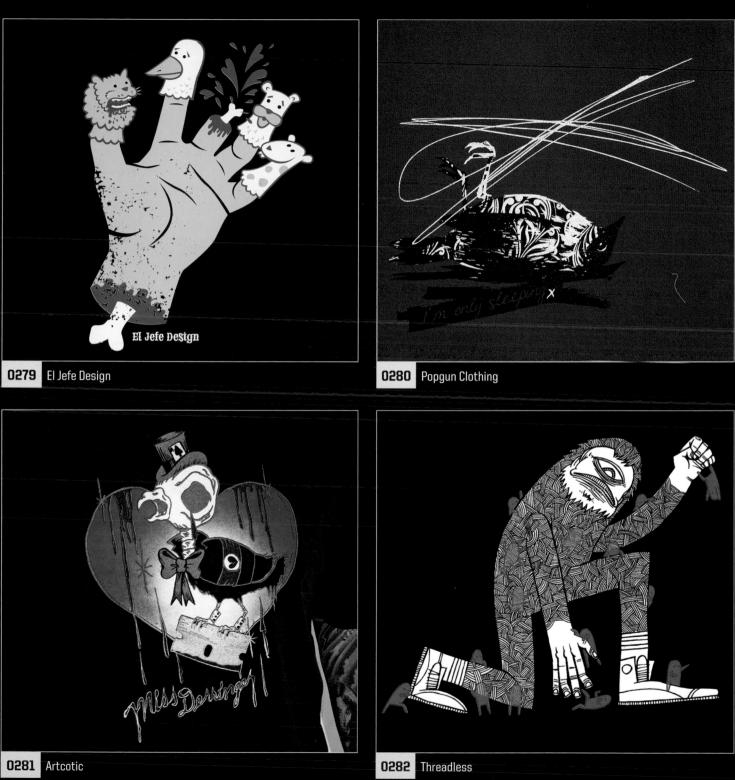

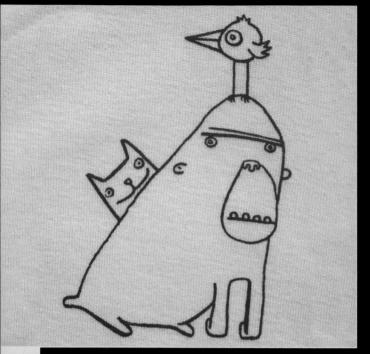

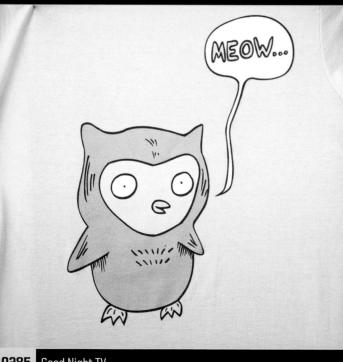

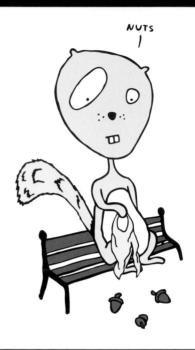

0284	Geyrhalter	Design
------	------------	--------

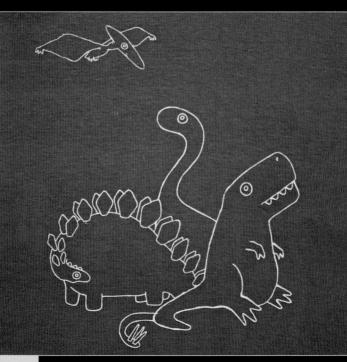

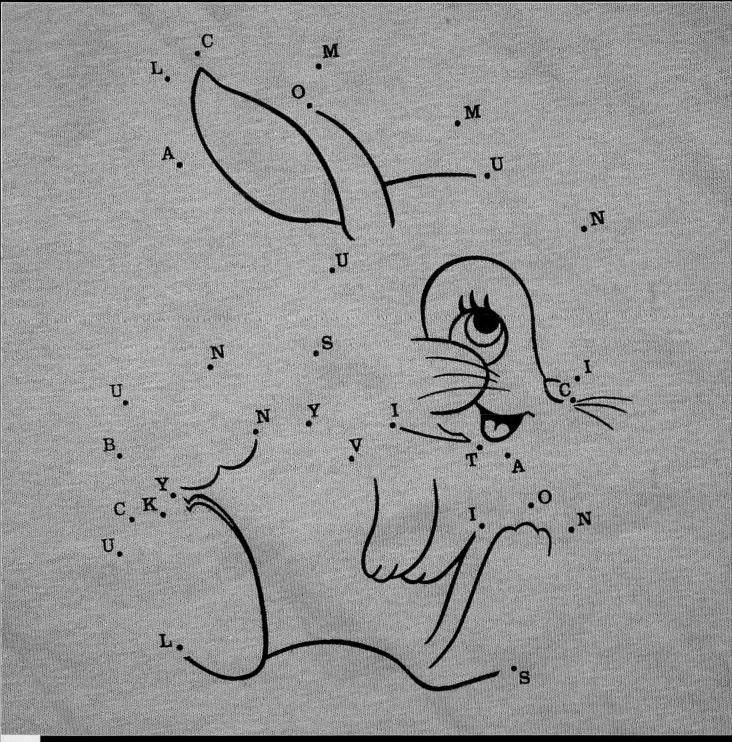

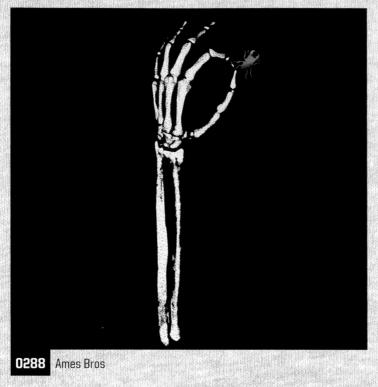

0289

Alphabet Arm Design

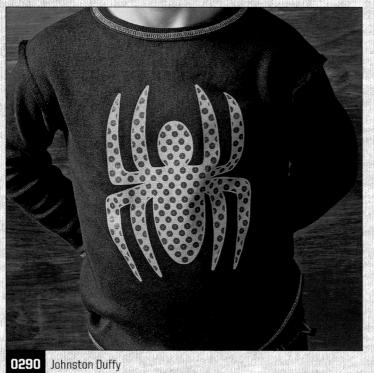

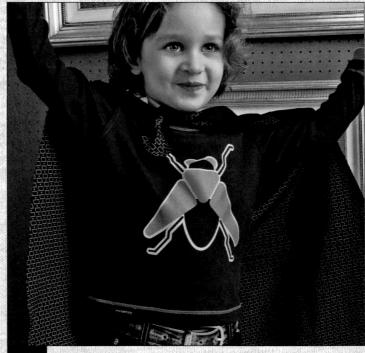

0291 Johnston Duffy

ANIMALS & NATURE | 97

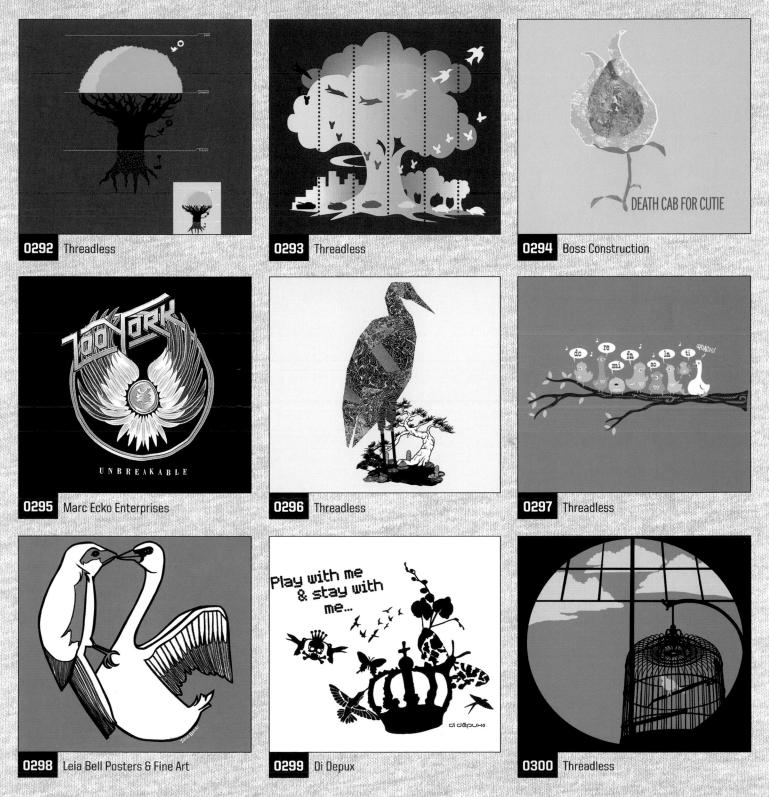

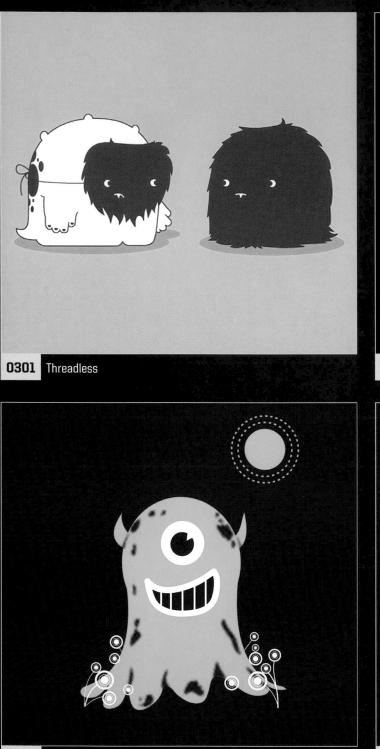

0302 Threadless

SUMMER TOUR 2007

7/5 - Newport, RI 7/6 - Hyannis, MA 7/7 - Hampton Beach, NH 7/8 - Hampton Beach, NH 7/10 - Ottawa, Ontario 7/12 - Buffalo, NY 7/13 - Utica, NY 7/14 - Masontown, WV 7/17 - Cincinnati, OH 7/18 - N. Kansas City, MO 7/19 - Council Bluffs, IA 7/20 - Detroit Lakes, MN 7/26 - Salt Lake City, UT 7/28 - Morrison, CO 8/3 - Chicago, IL

ANIMALS & NATURE | 99

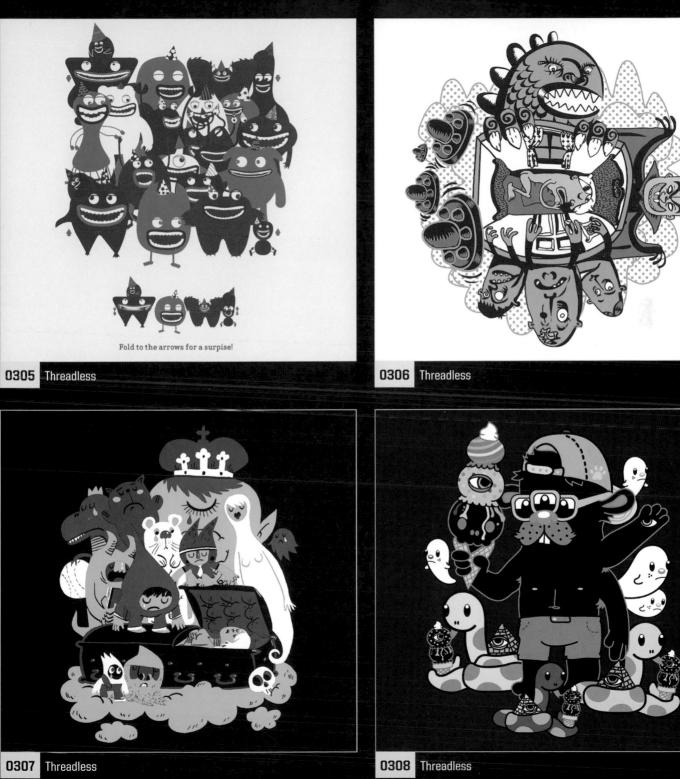

0309 Threadless

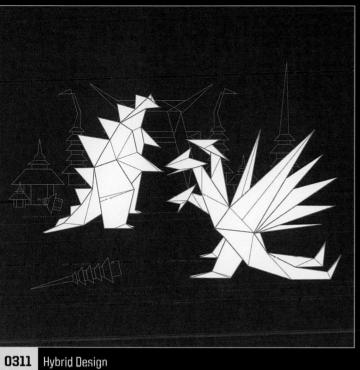

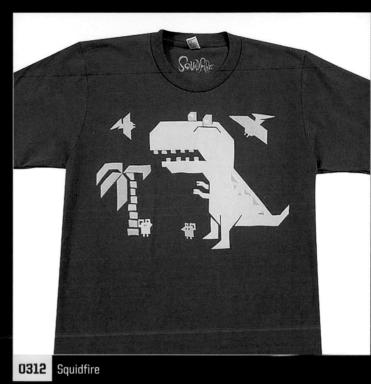

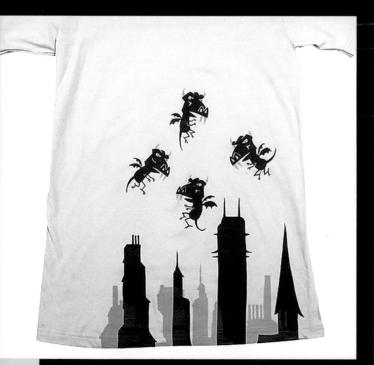

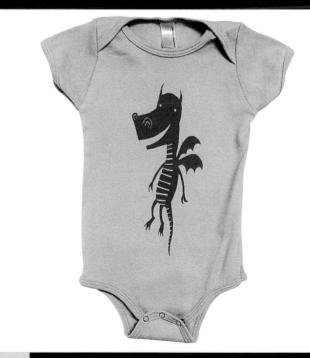

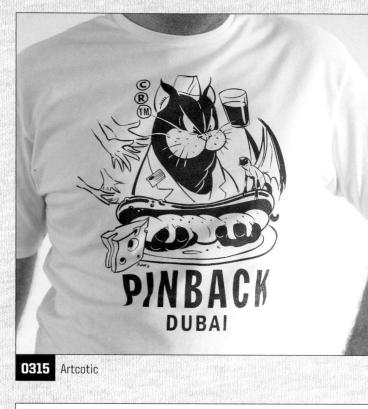

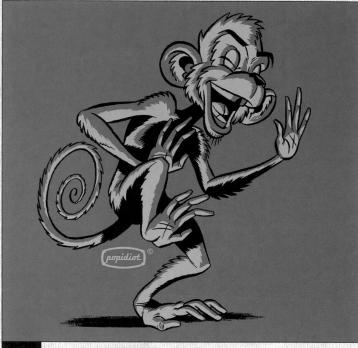

0316 popidiot

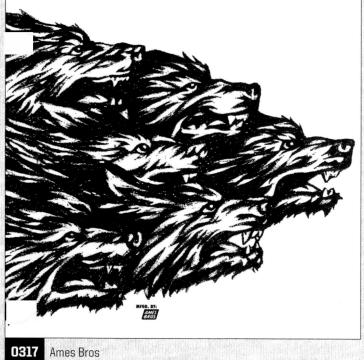

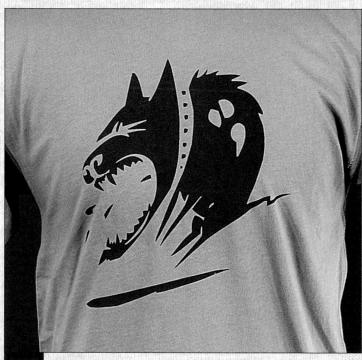

0318 Artcotic

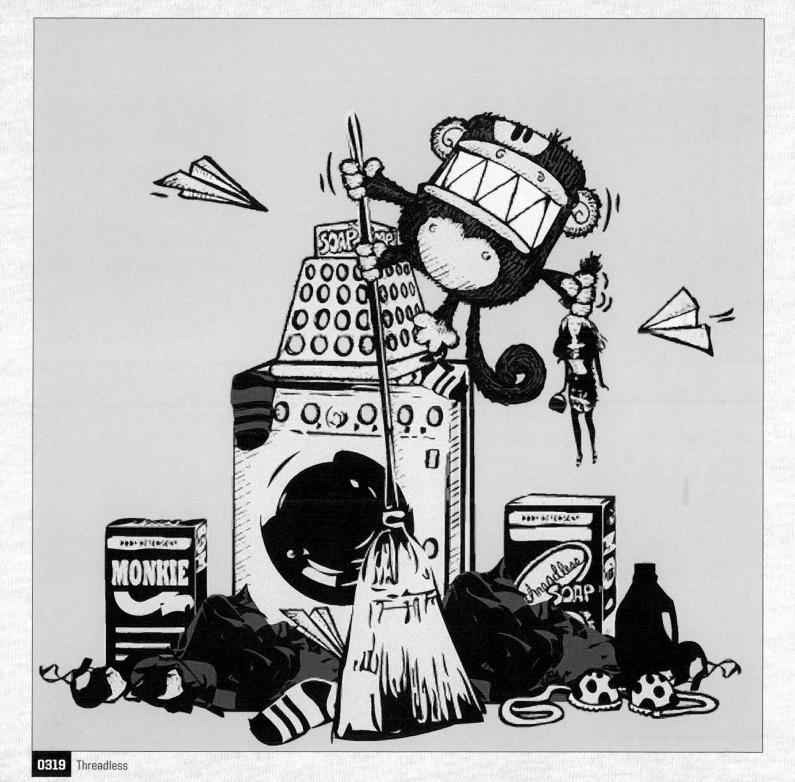

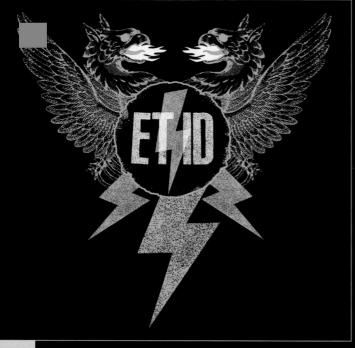

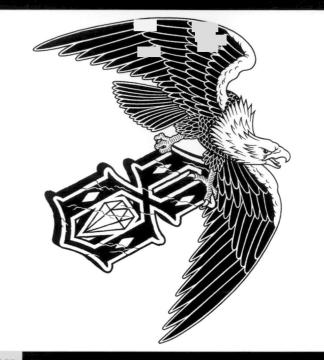

0320 Hero Design Studio

0321 REBEL8

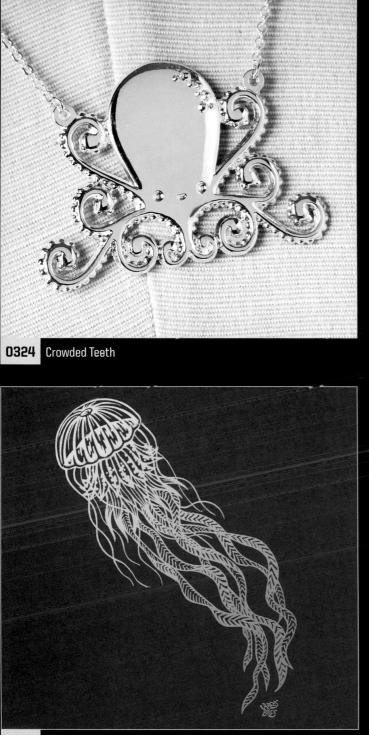

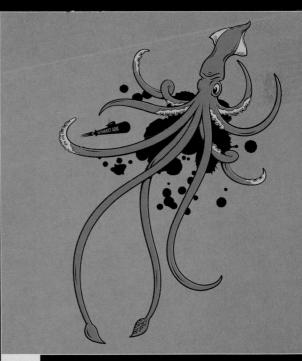

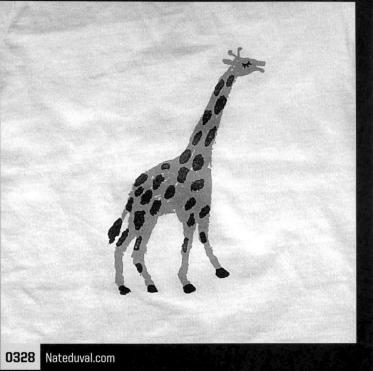

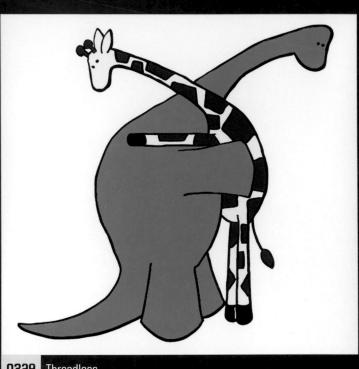

0329 Threadless

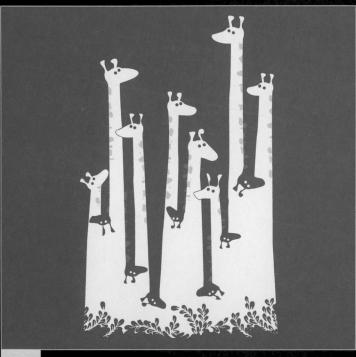

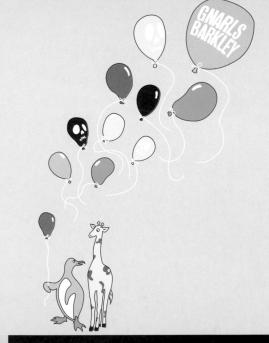

0332 Hero Design Studio

0335 Ames Bros

0336 Threadless

0338 Johnny Cupcakes

0339 Blue Q

0337 Ames Bros

0340 Leia Bell Posters & Fine Art

0341 Pappas MacDonnell, Inc

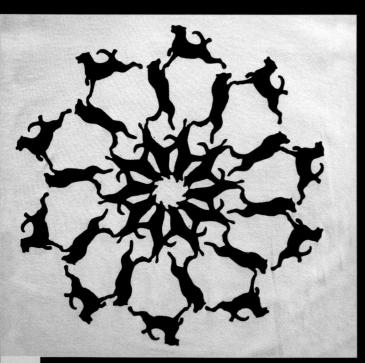

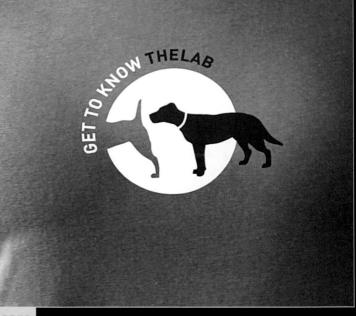

0342 EBD

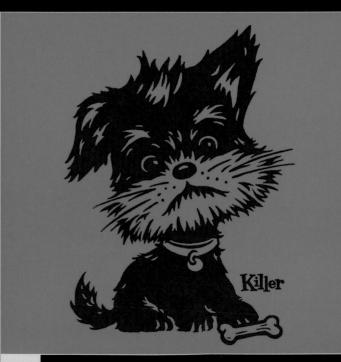

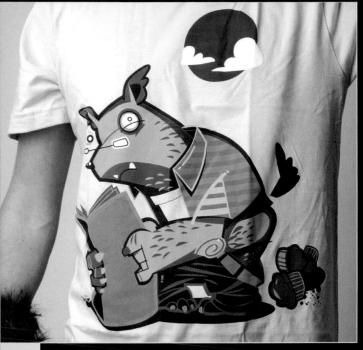

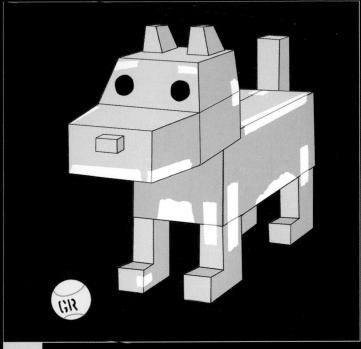

0345 Johnny Cupcakes

0346 Methane Studios, Inc.

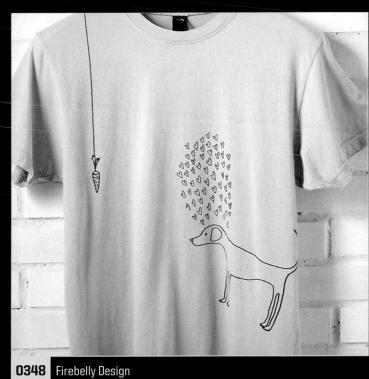

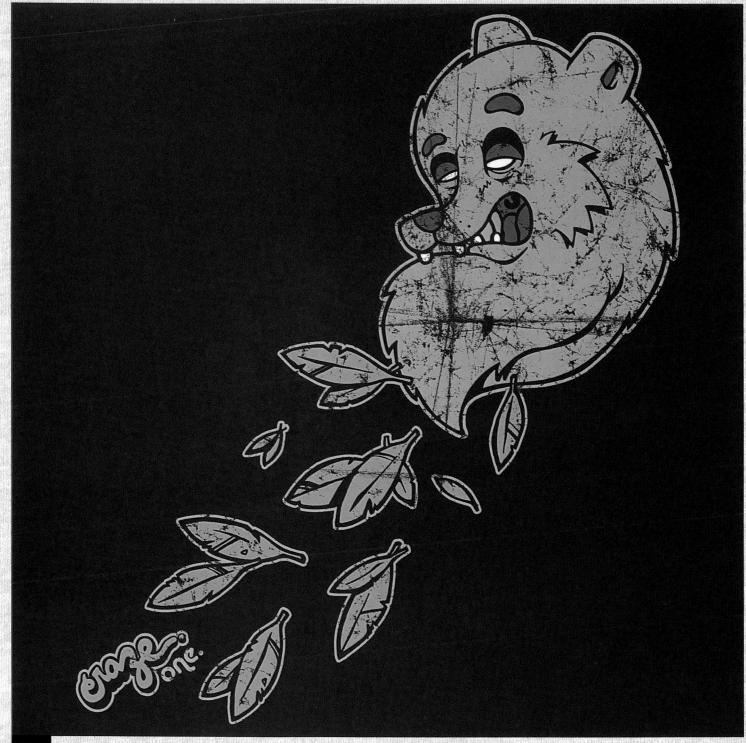

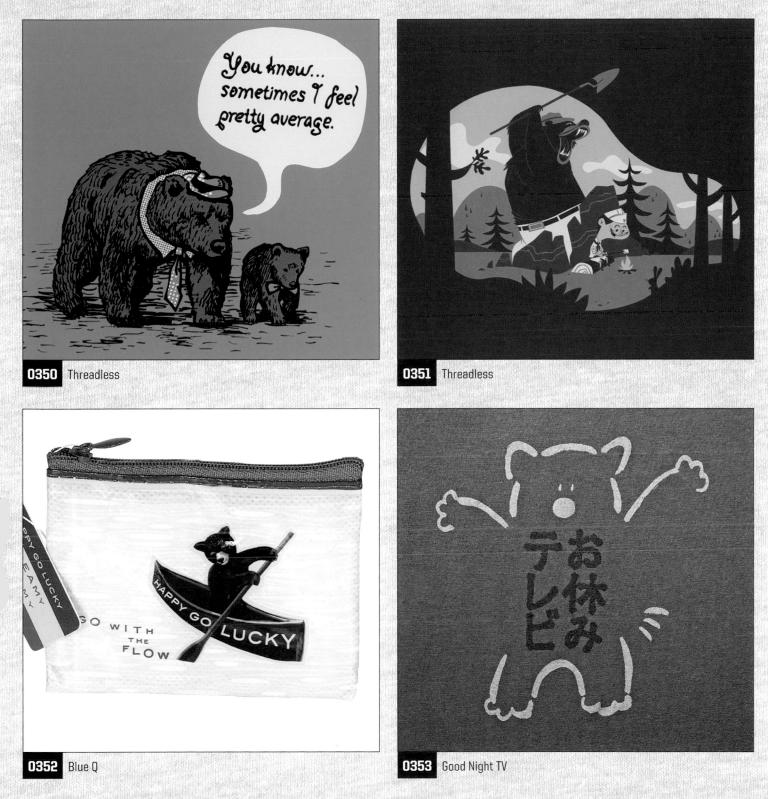

```
0355 Nateduval.com
```

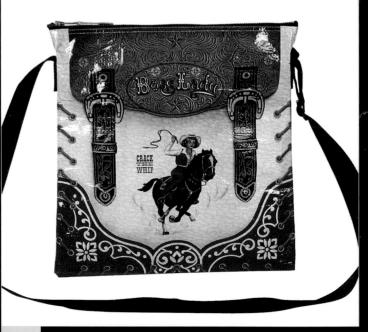

0357 Blue Q

ANIMALS & NATURE | 113

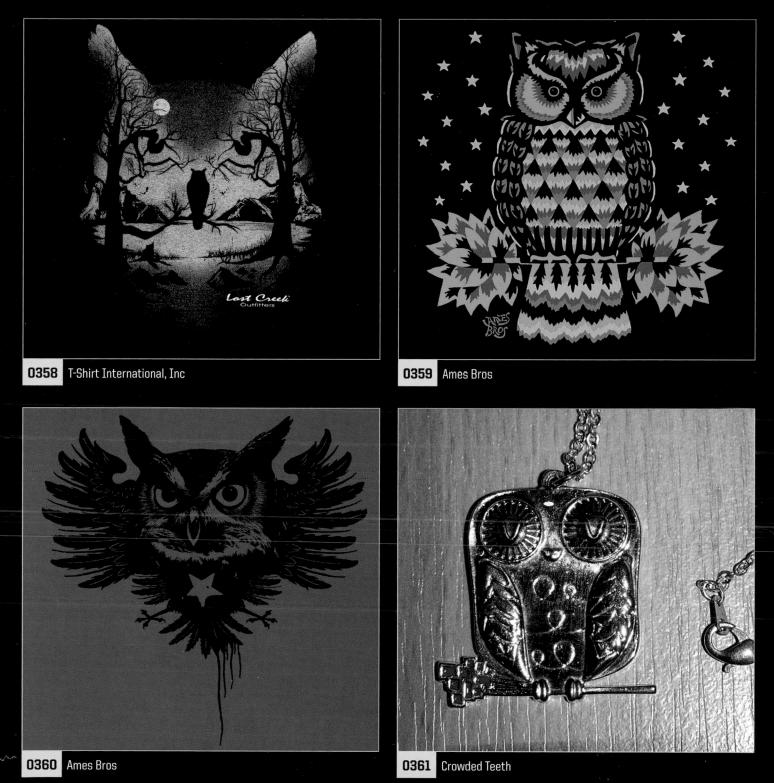

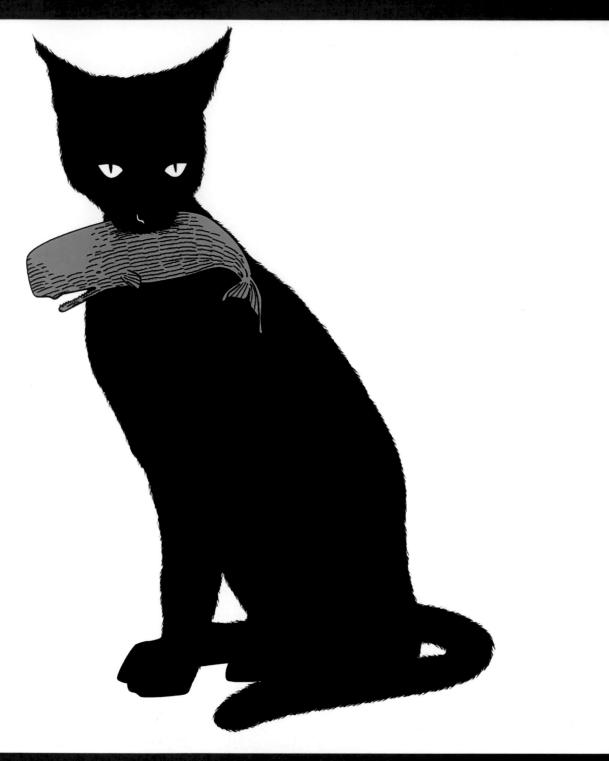

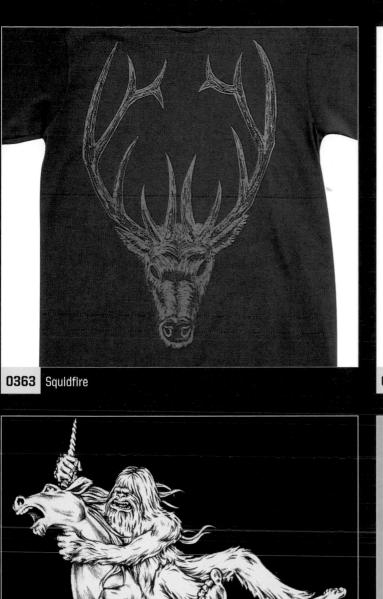

MFGD. BY: AMES BROS

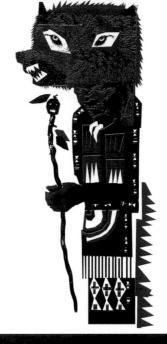

0364 Ames Bros

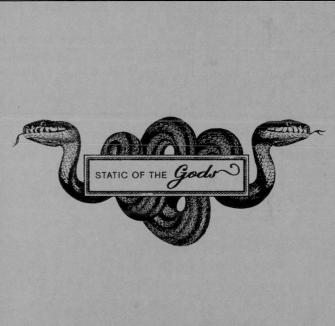

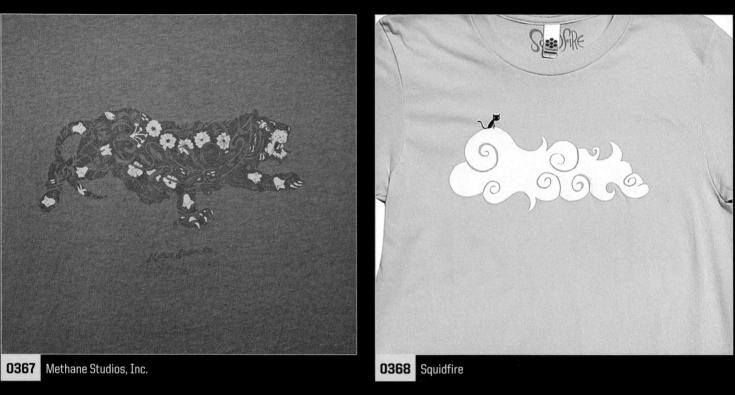

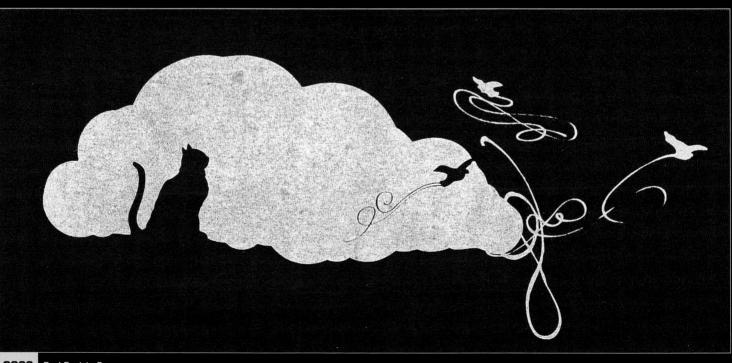

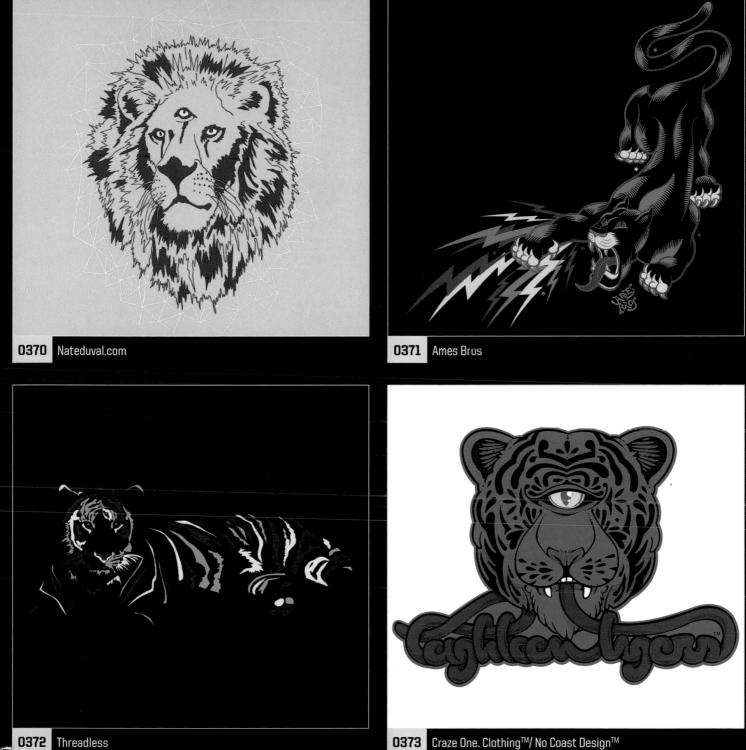

0372 Threadless

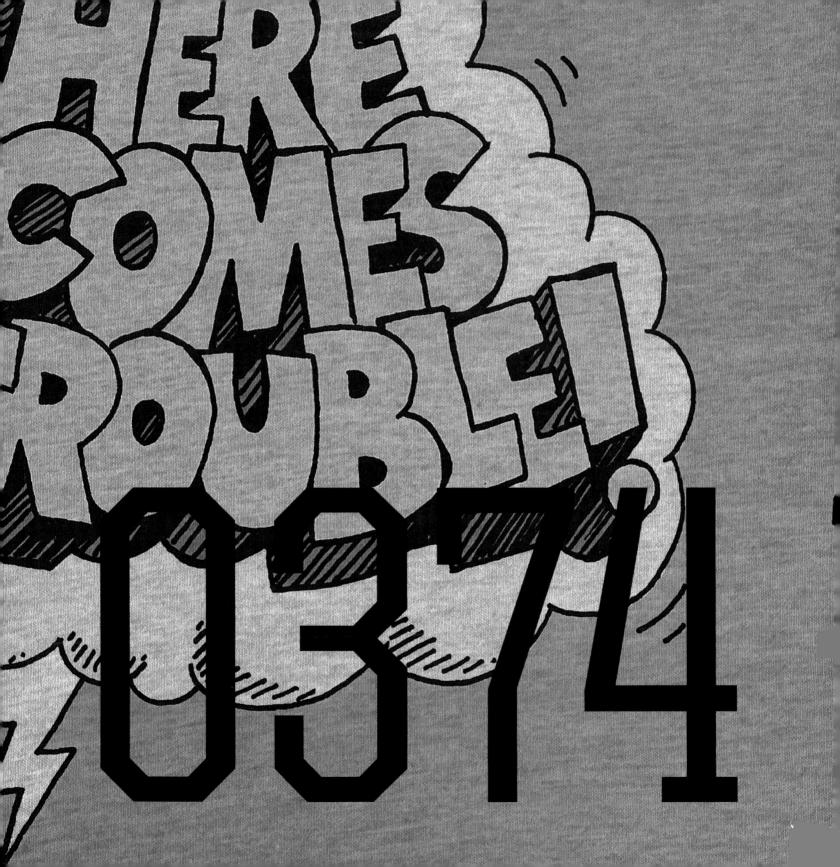

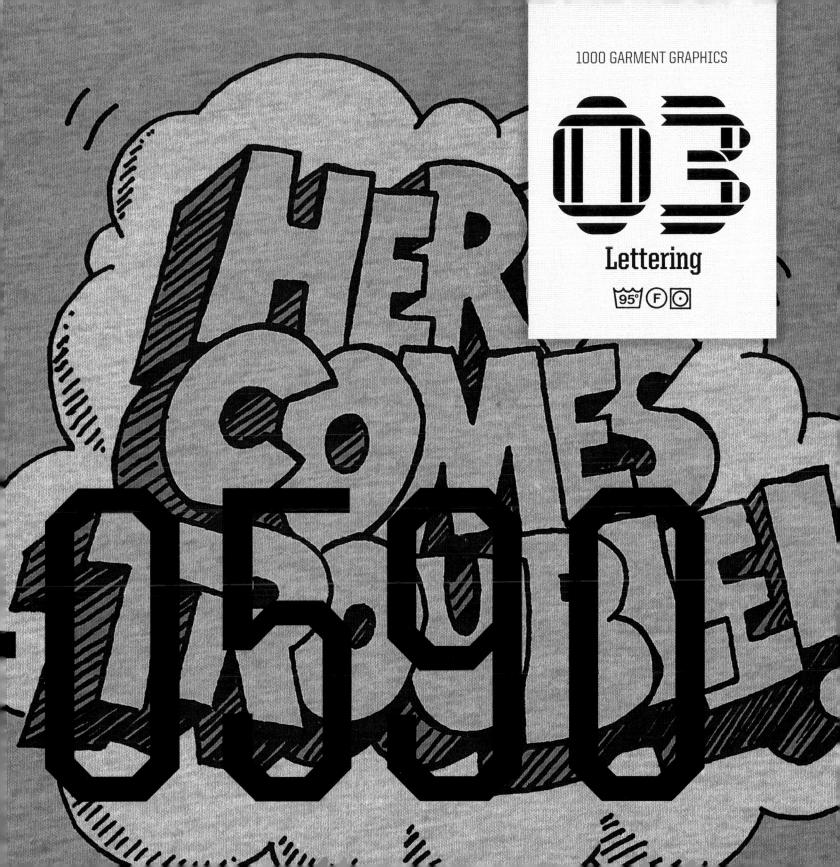

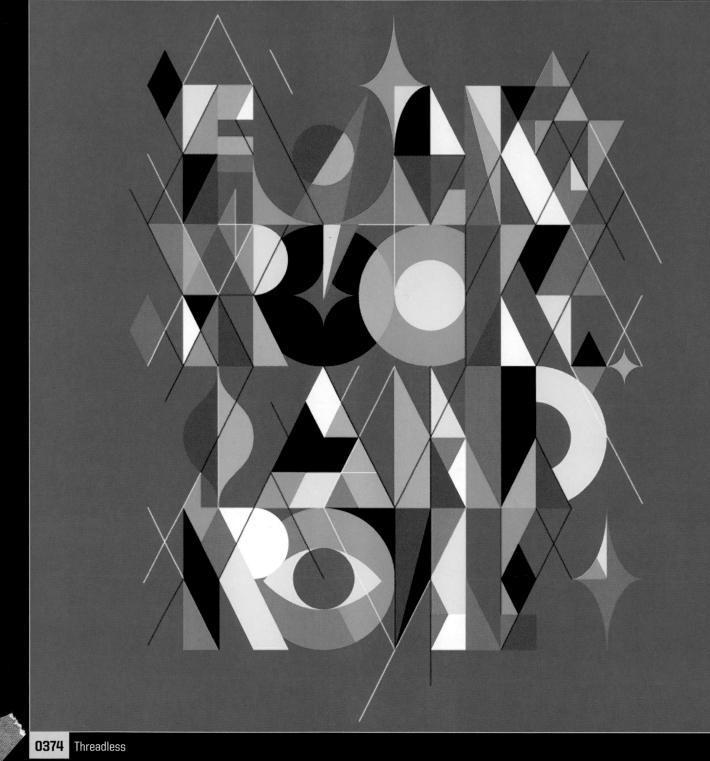

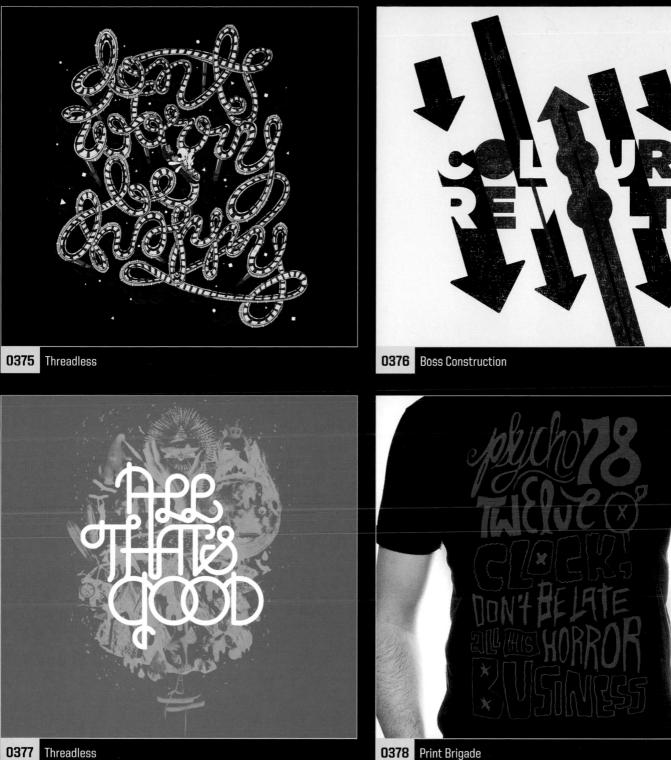

0378 Print Brigade

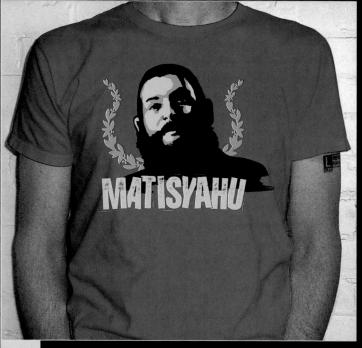

0379 Alphabet Arm Design

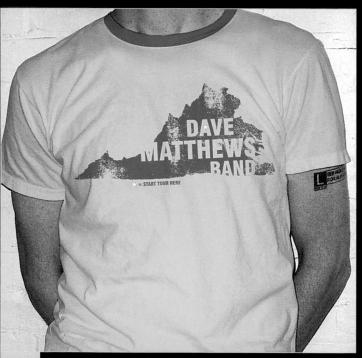

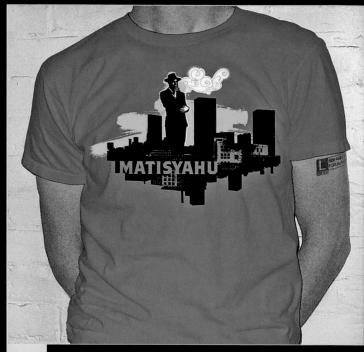

0380 Alphabet Arm Design

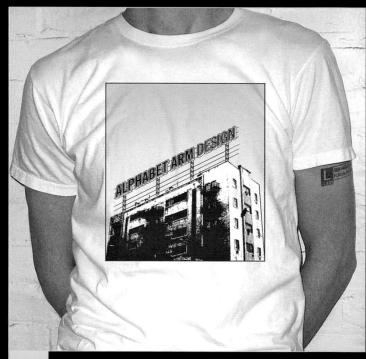

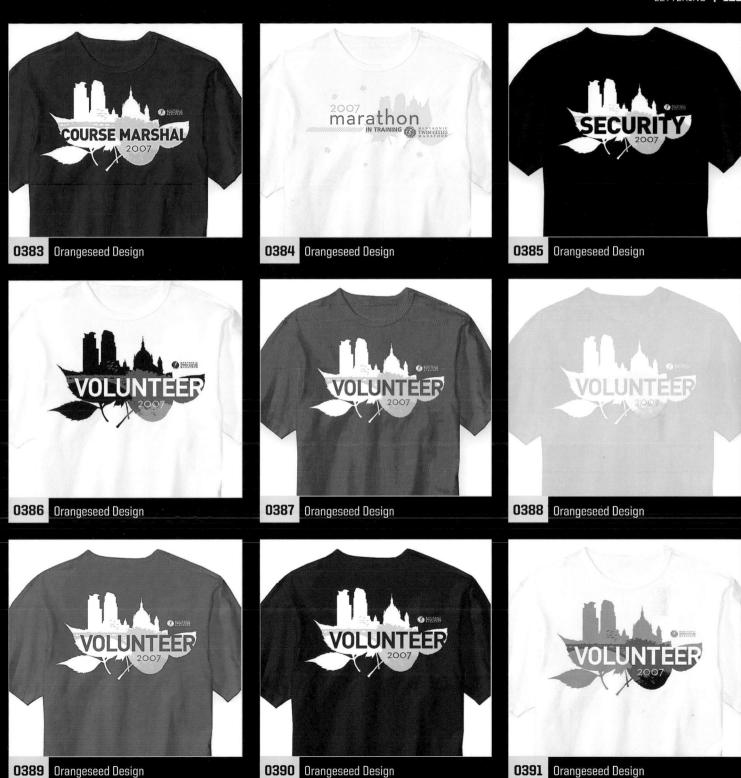

126 | 1000 GARMENT GRAPHICS

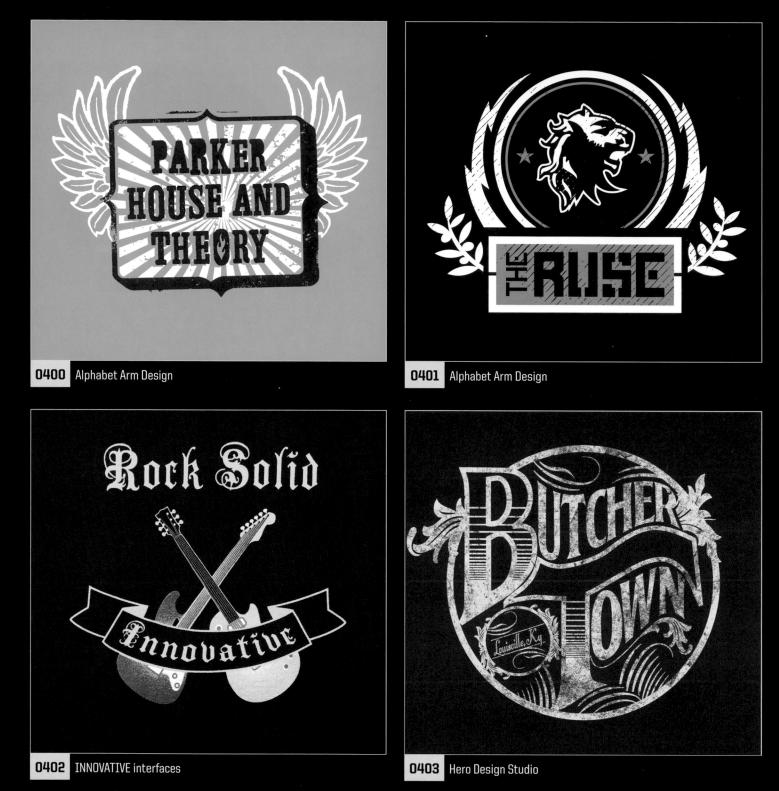

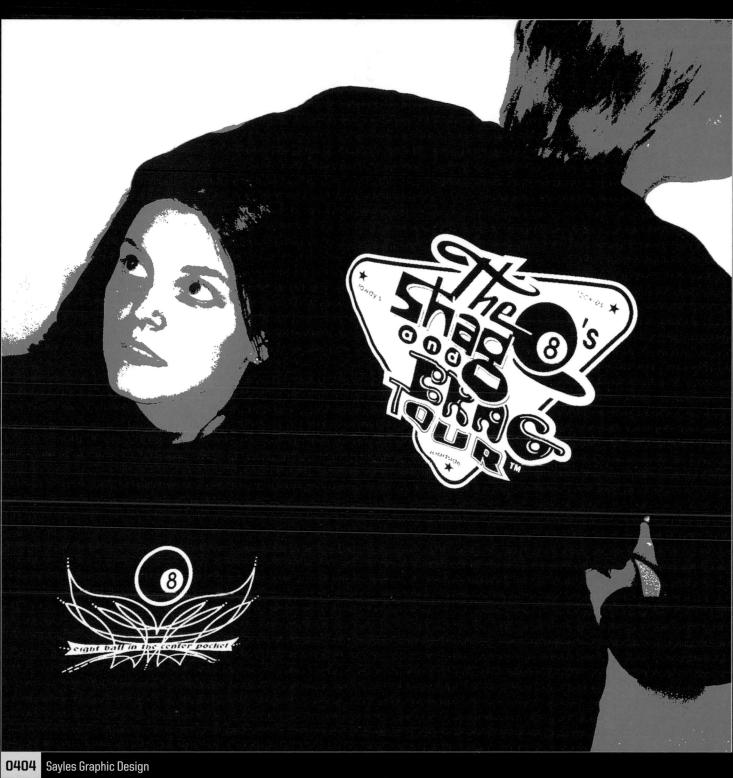

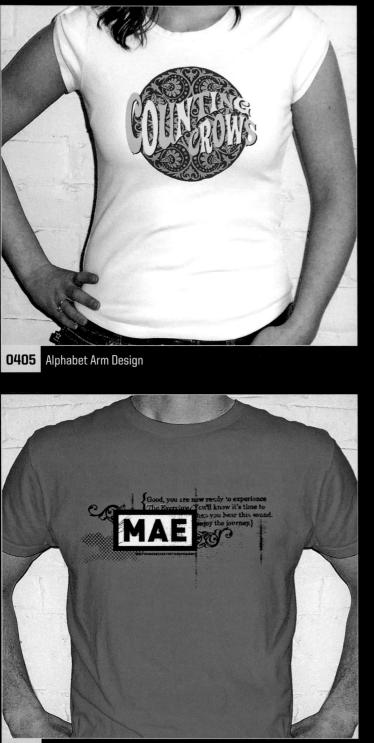

0406 Alphabet Arm Design

S OF MEN WITH BLANK IN HEADLIGHTS TERR-WONDER WHEN THEY'LL COME GET ME I WONDER WHEN THEY'LL THE YOU HAVE TO NEEGECEEEEED YOU AND WE'LL TELL YOU WHEN THEY'RE THEL YOU WHEN THEY'RE HUNGRY AGAIN IT NEVER ENDS NEVER ENDS WE RY AUAIN DE HUN WANT YOU HAVE TO NEEEEEEED YOU AND WE'LL TELL YOU WHEN THEY'RE HUNGRY AGAIN AND WE'LL TELL YOU WHEN THEY'RE HUNGRY AGAIN IT NEVER ENDS NEVER ENDS NEVER ENDS ETC. BIG SHOT SCREAMING PUT YOUR HANDS IN THE SKY HE SAM TI DI LL AF IF IT UP OR YOURE GOING TO DIG YOU'LL GET A BULLET IN THE BACK , THE NECK IN THE BACK . THE NECK RIGHT BETWEEN THE EYES AND BIG SHOT SCREAMING STOUR HANDS IN SKY HE SM. GIVE IT UP BOY GIVE IT UP OR YOU'RE GOING TO DIE YO' S GET OF THE ECK IN THE BACK OF THE NECK RIGHT BETWEEN THE GREEN W INGRY + IN INCI al Yo WE'LL TELL YOU WHEN THEY'RE HUNGRY AGA . I'WE W OUWEN YOU WEV YOU WE ANT YOU WE WANT YOU WE WANT YOU WE WANT YO WE WANT NE WEWAM NEWAN WE WANT YOU WE WANT YOU WE WANT YOU , SWANT YOU NANT YOU EWANTYOUL WEWANT YOU WE WANT YOU WE WANT YOU MWANT YOU UWEWANI WANT YOU WEWANT YOU WE WANT YOU W WANT YOU'VE WE WANT YOU WE WANT YOU WE WAN YOU WE WANT YO ETC. ETC

G. WIE

Har more B

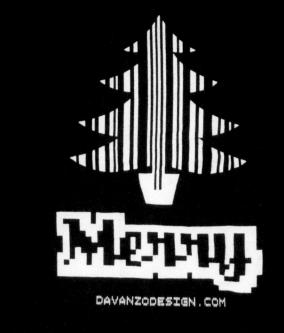

411 Giorgio Davanzo Design

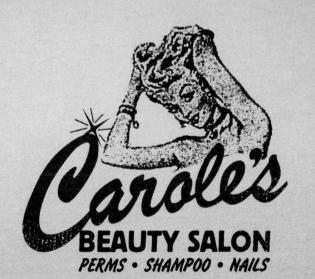

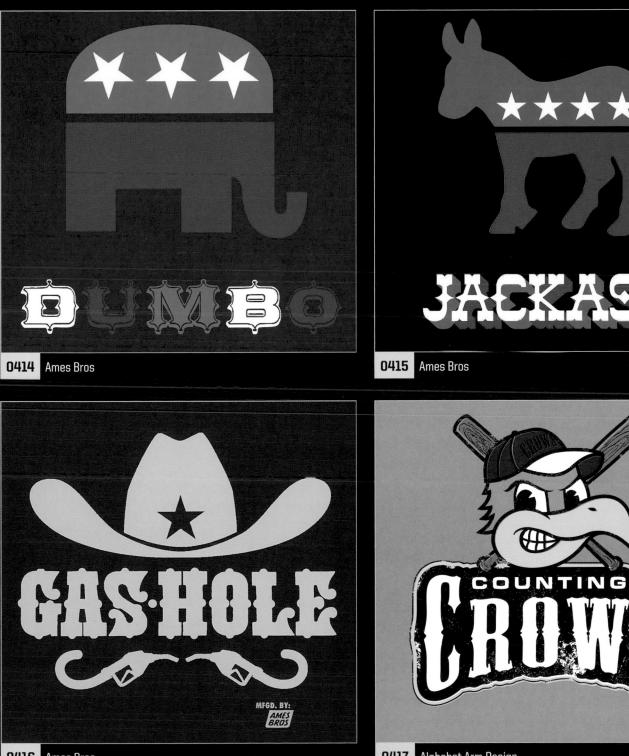

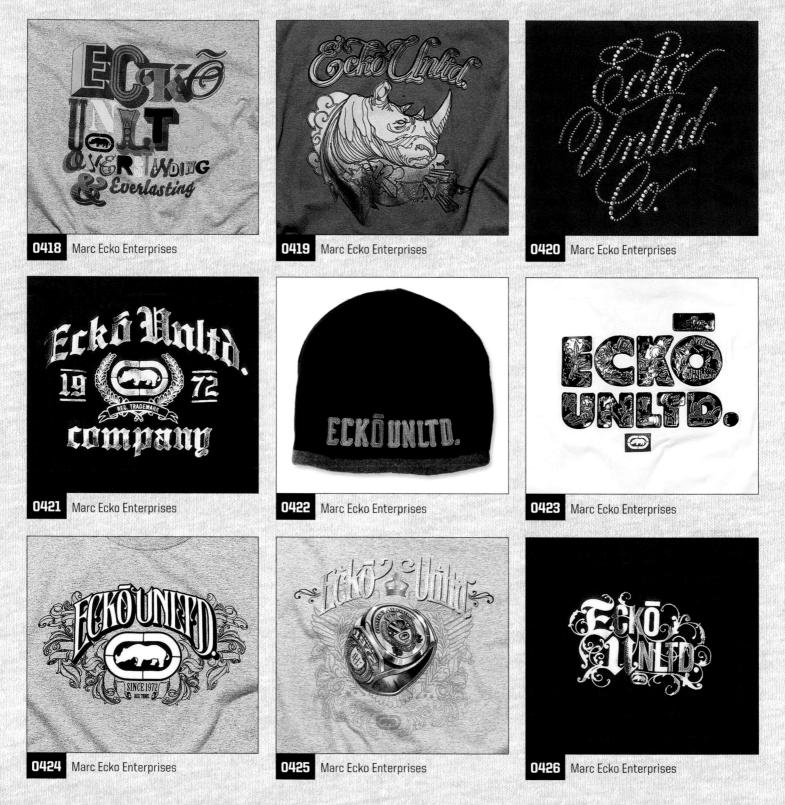

LETTERING | 133

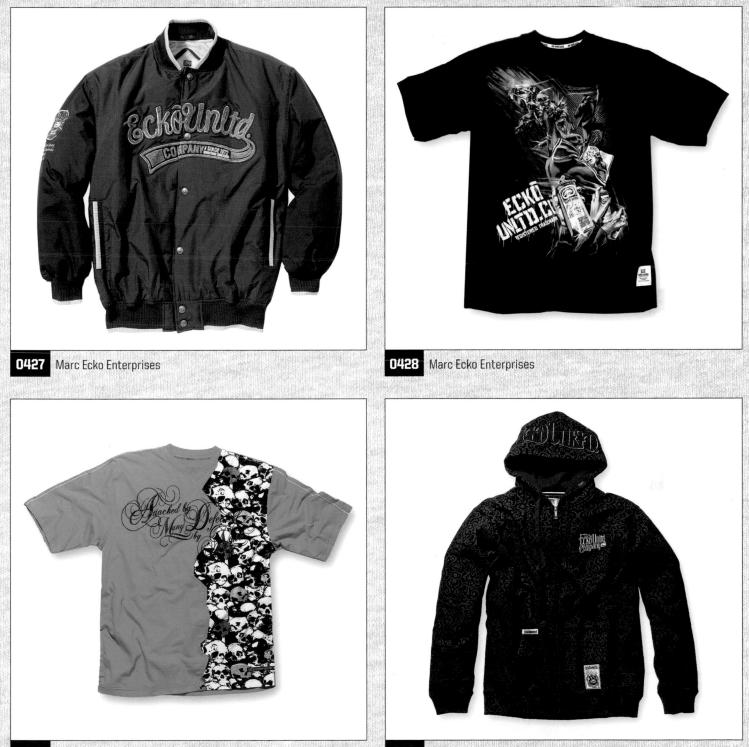

0430 Marc Ecko Enterprises

JE SUIS LE SHIT

0431 ATX/Aesthetix

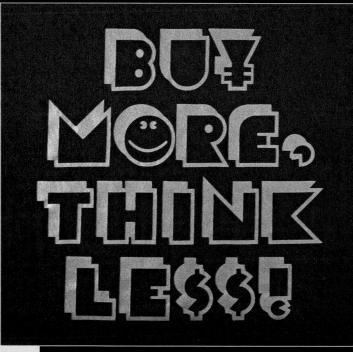

ABANDN THE STERE©TYPE

0432 ATX/Aesthetix

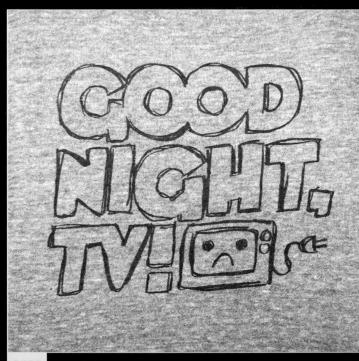

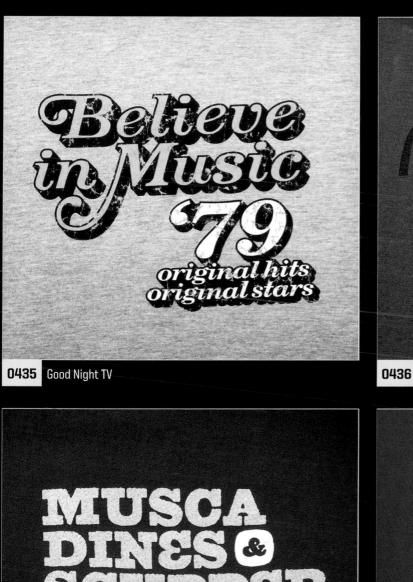

better's grape

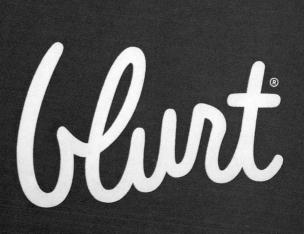

YOU ARE THE

M

Good Night TV

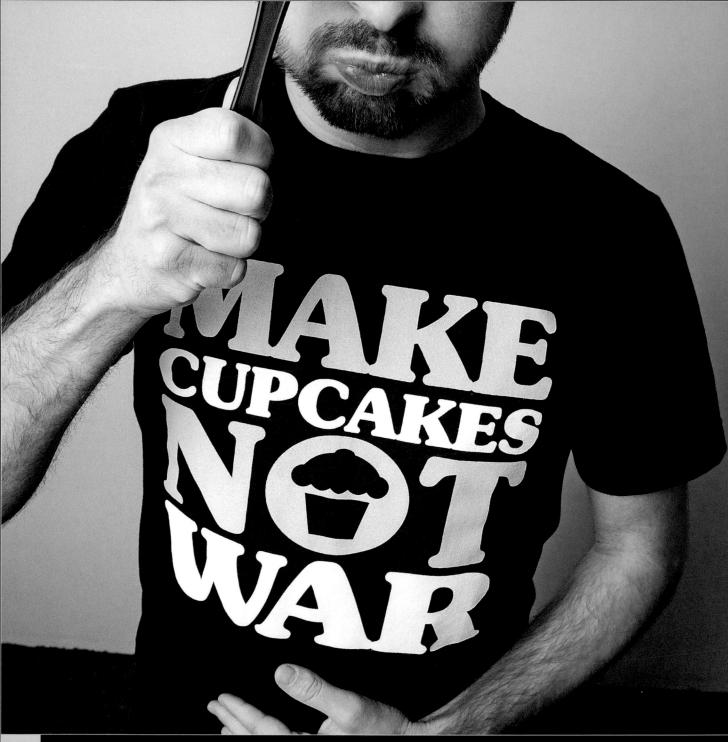

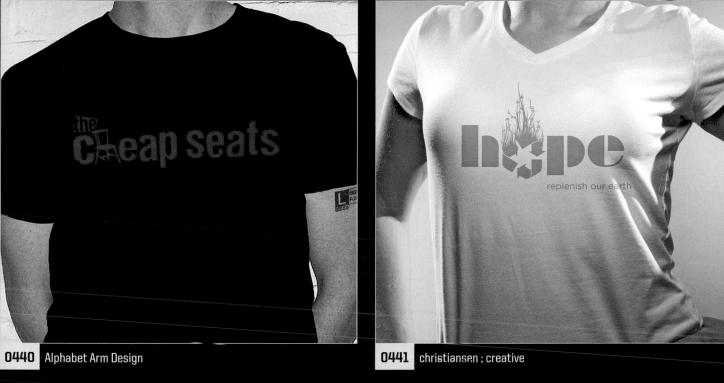

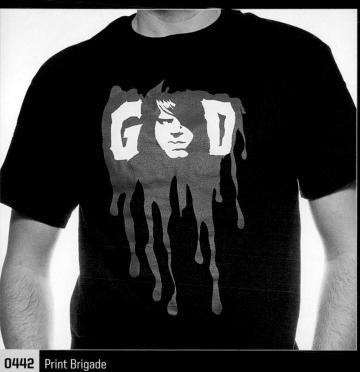

0448 Hybrid Design

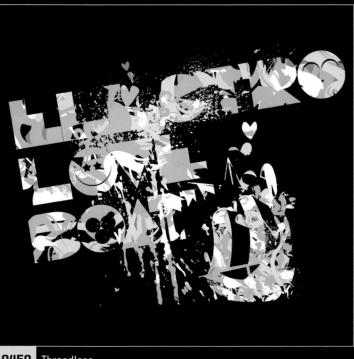

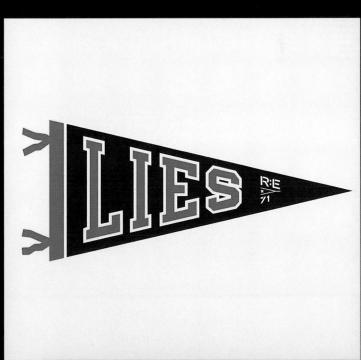

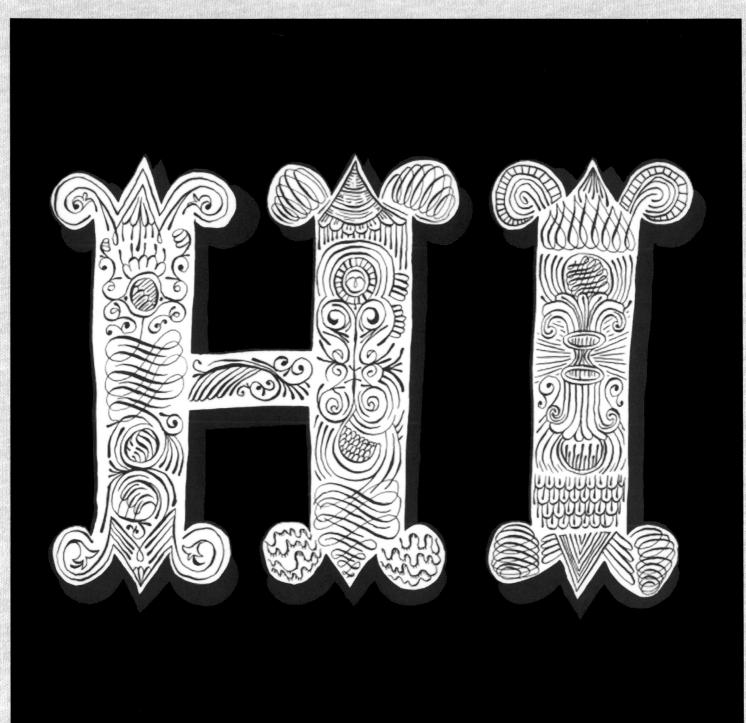

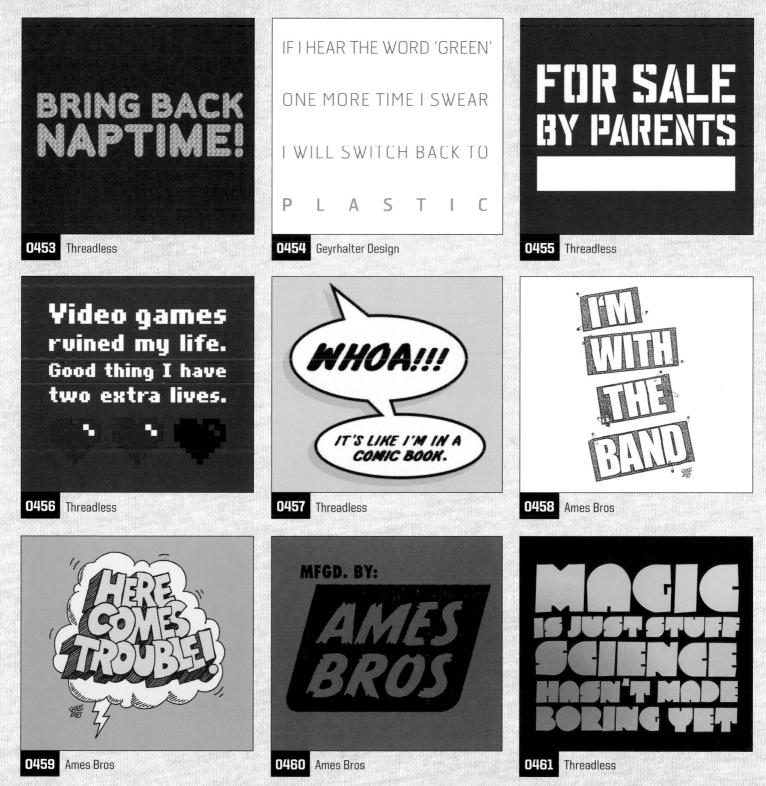

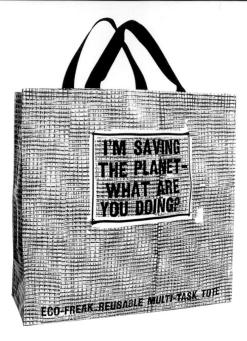

0462 Blue Q

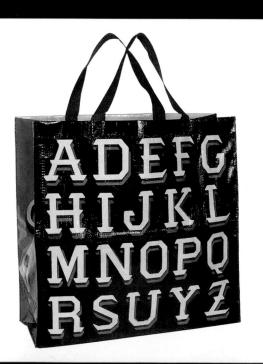

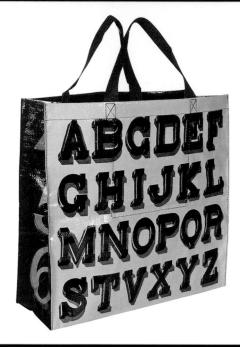

0463 Blue Q

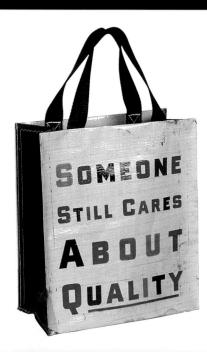

0467 Blue Q

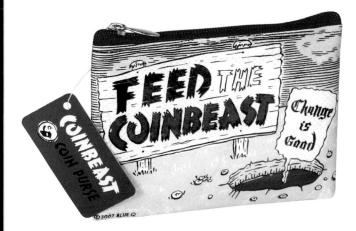

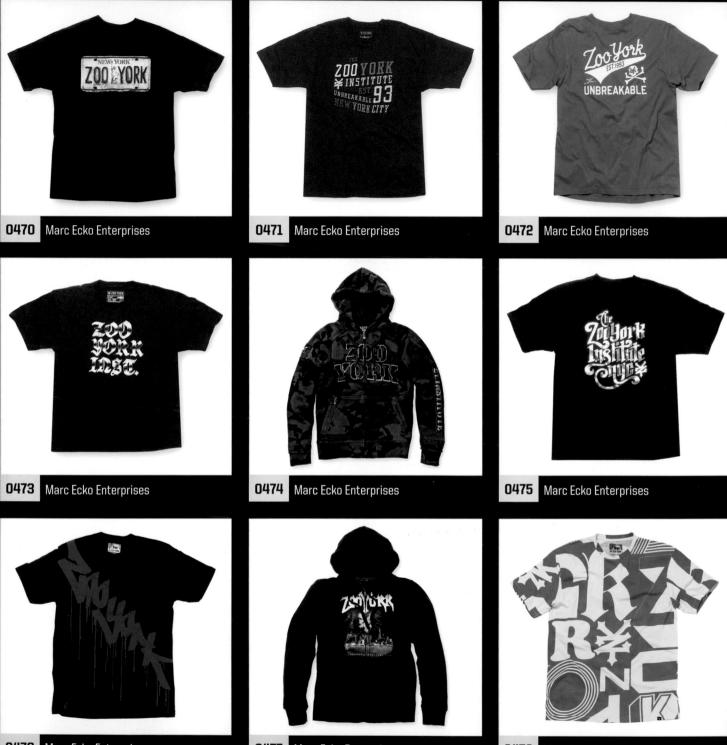

0476 Marc Ecko Enterprises

0477 Marc Ecko Enterprises

0478 Marc Ecko Enterprises

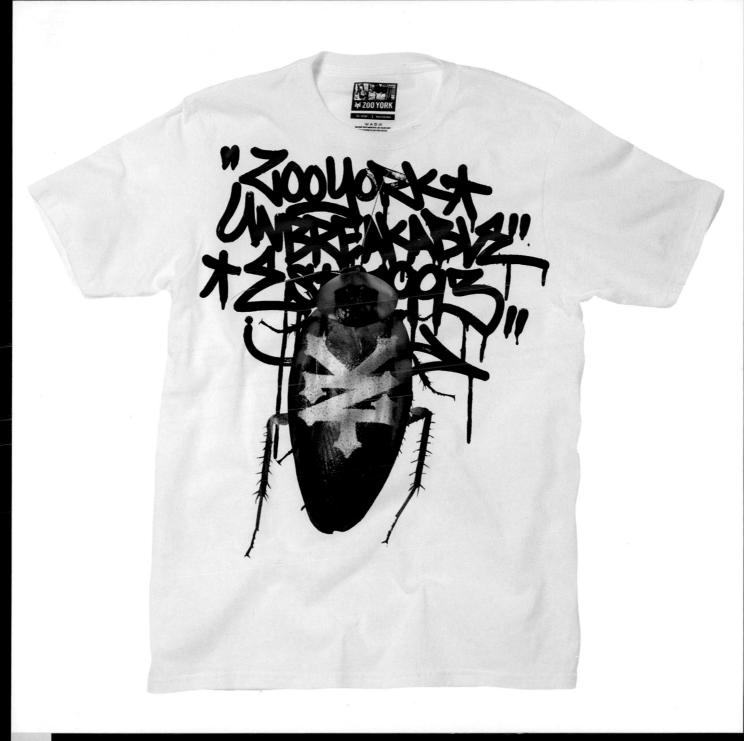

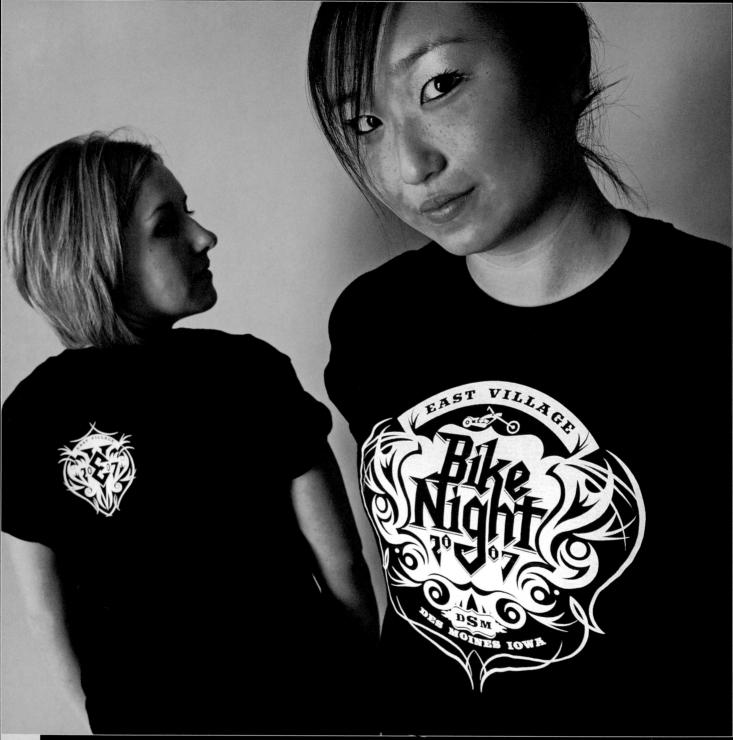

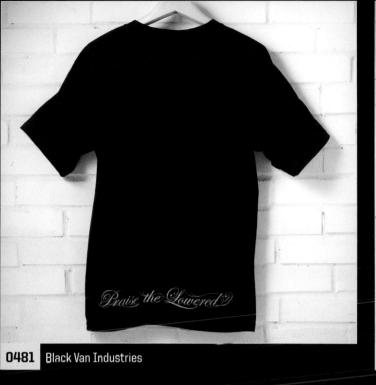

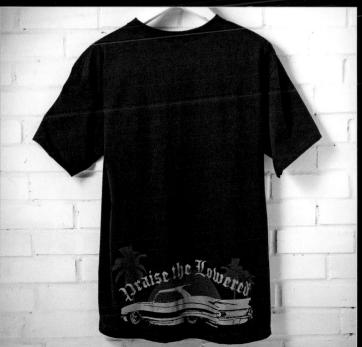

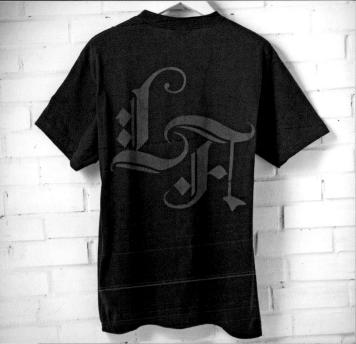

0482 Black Van Industries

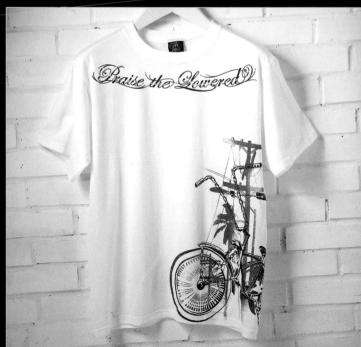

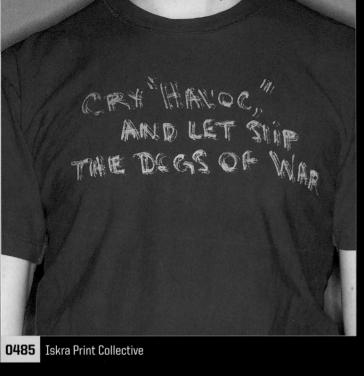

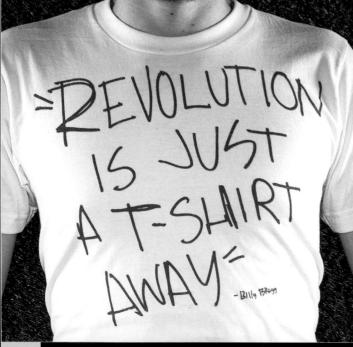

0487 Iskra Print Collective

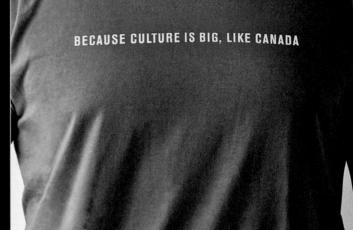

0486 EBD

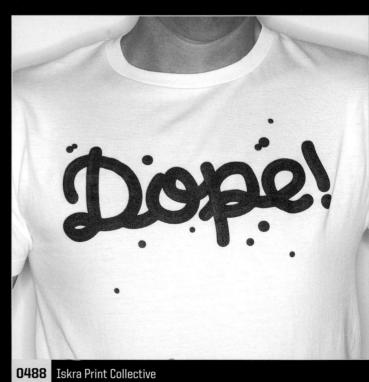

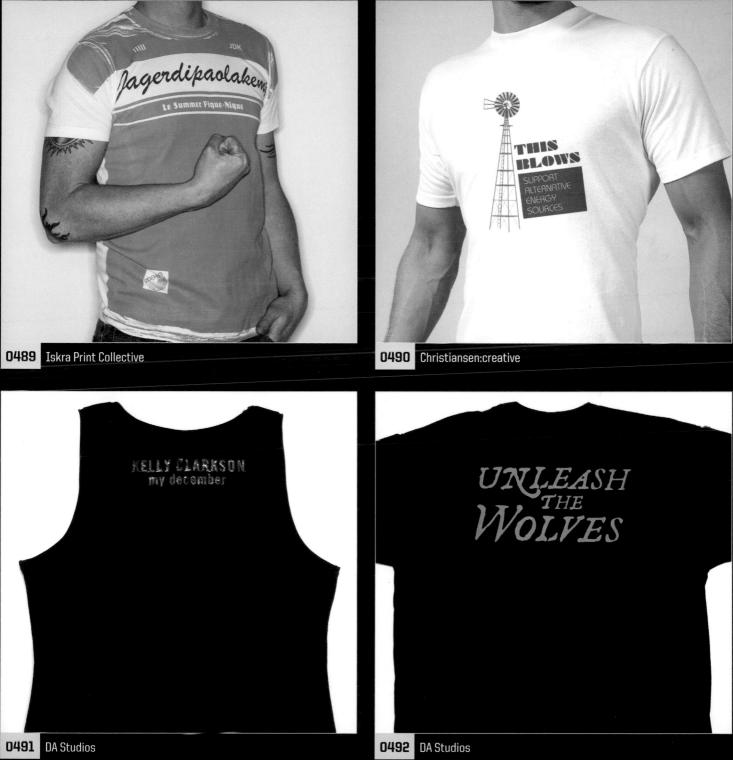

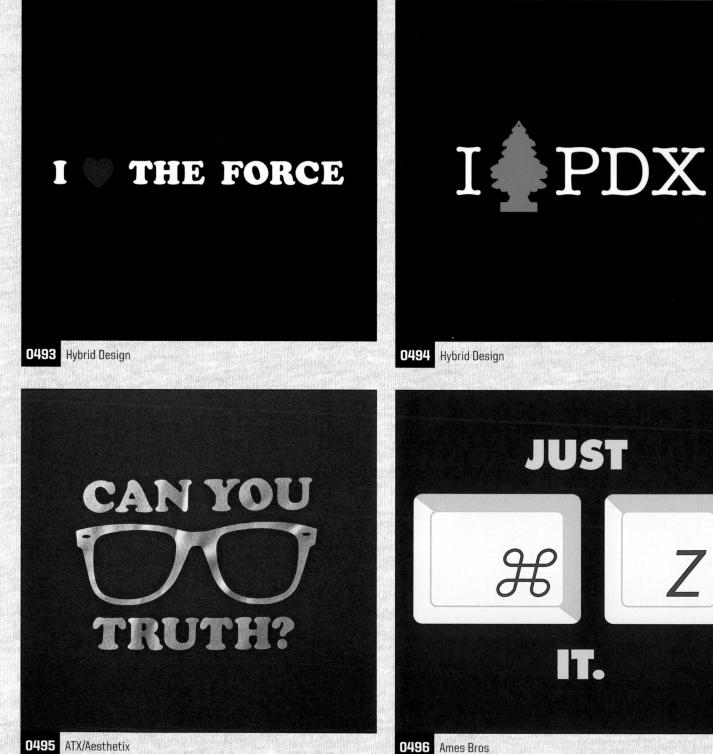

JUST 2 IT.

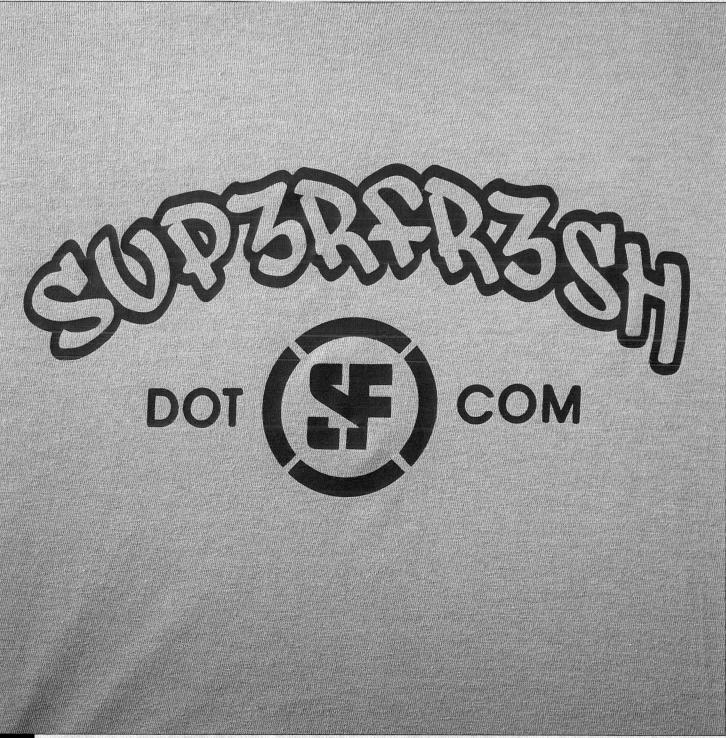

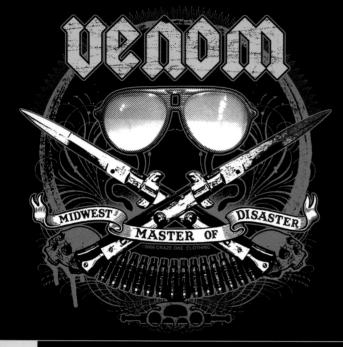

0498 Craze One. Clothing[™]/No Coast Design[™]

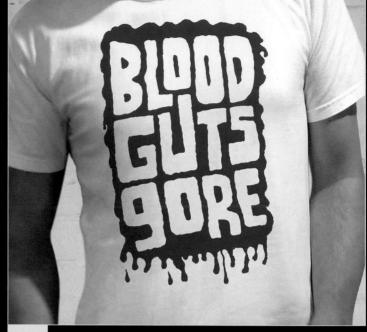

0499 Print Brigade

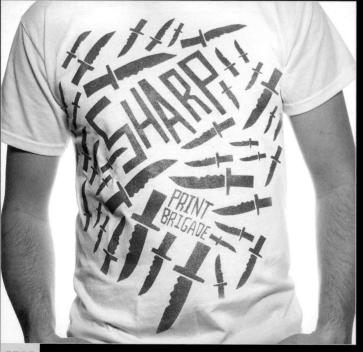

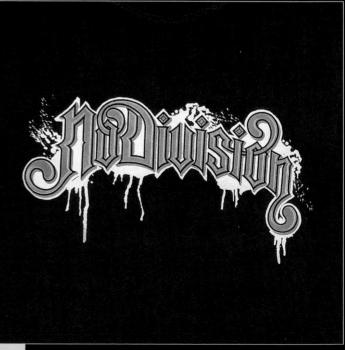

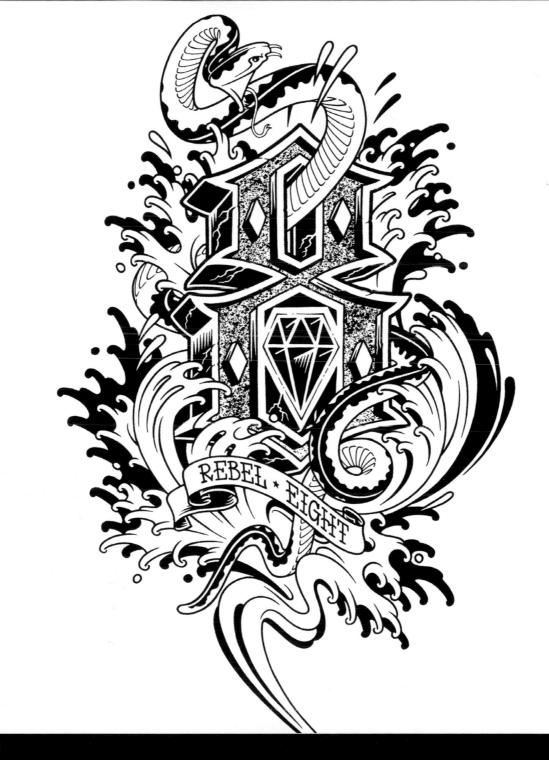

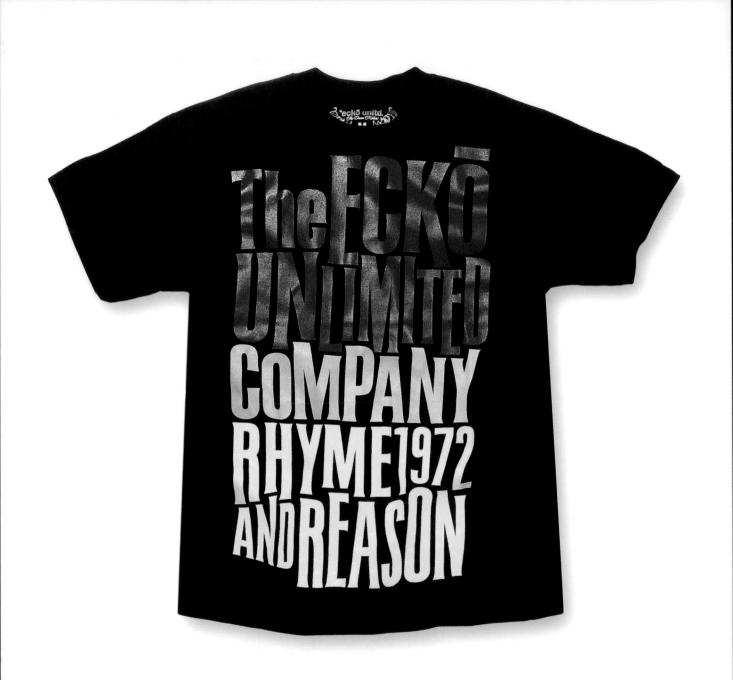

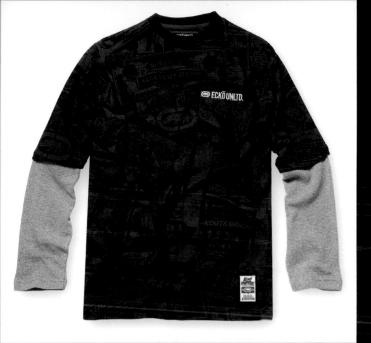

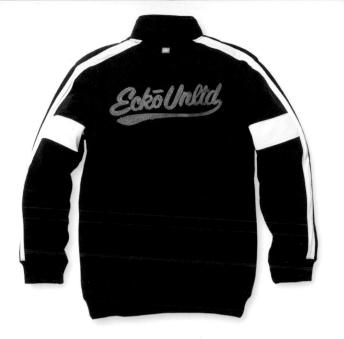

0504 Marc Ecko Enterprises

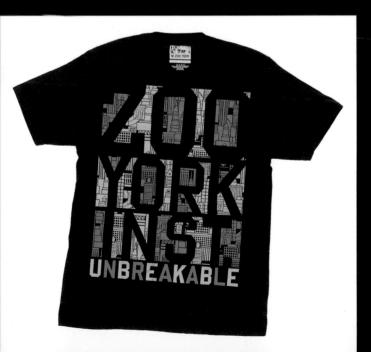

0505 Marc Ecko Enterprises

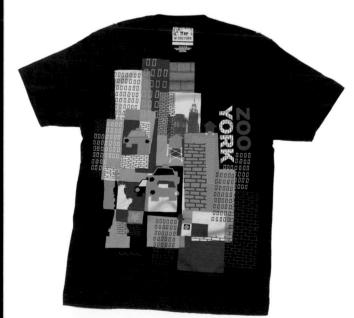

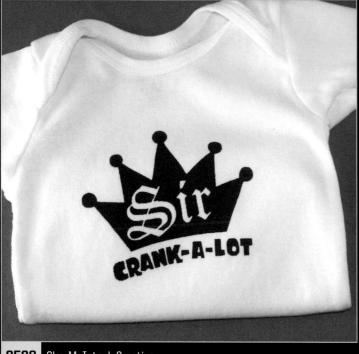

0508 Clay McIntosh Creative

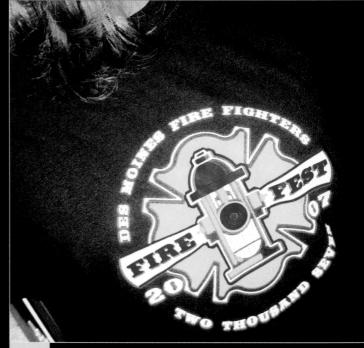

0509 Sayles Graphic Design

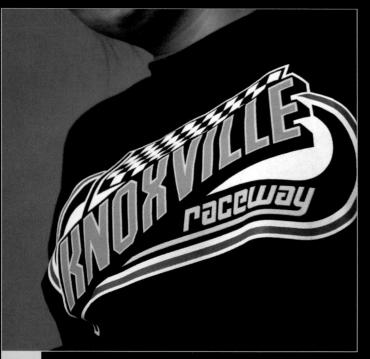

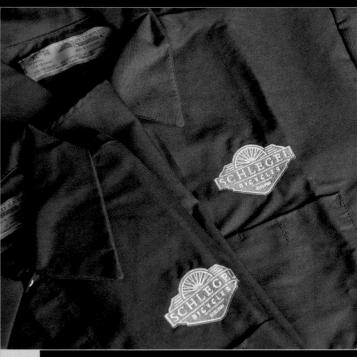

0511 S Design Inc.

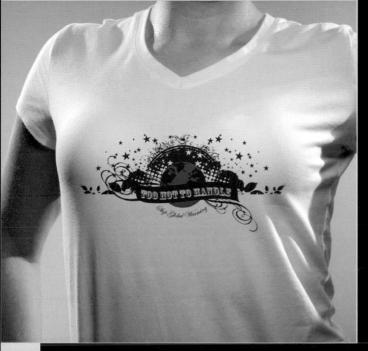

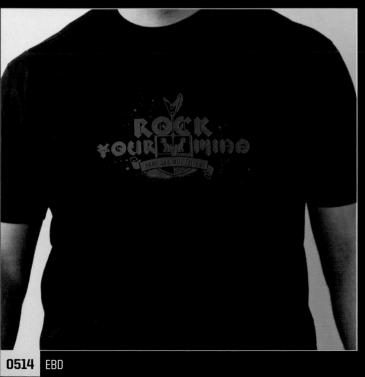

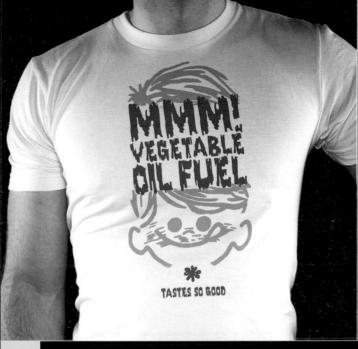

0513 Iskra Print Collective

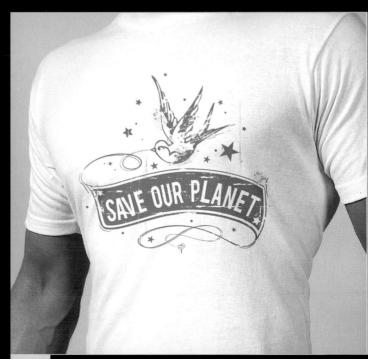

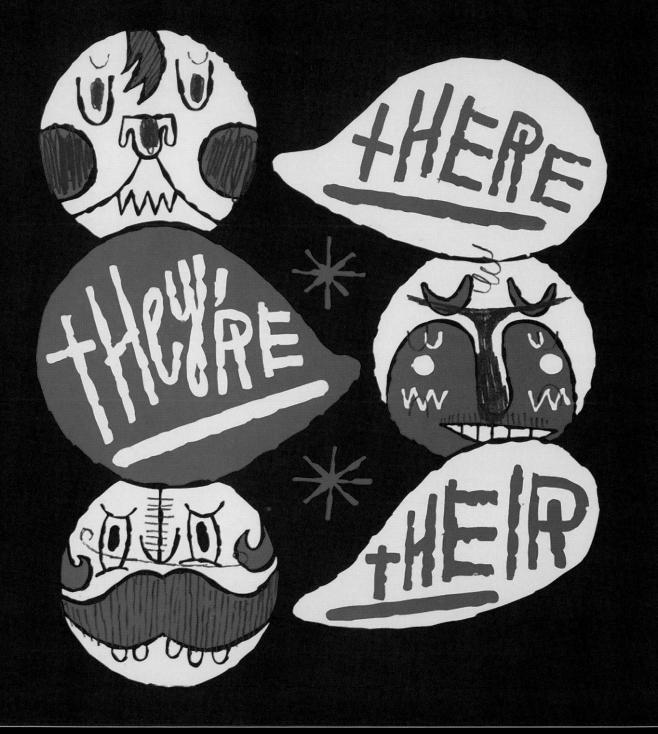

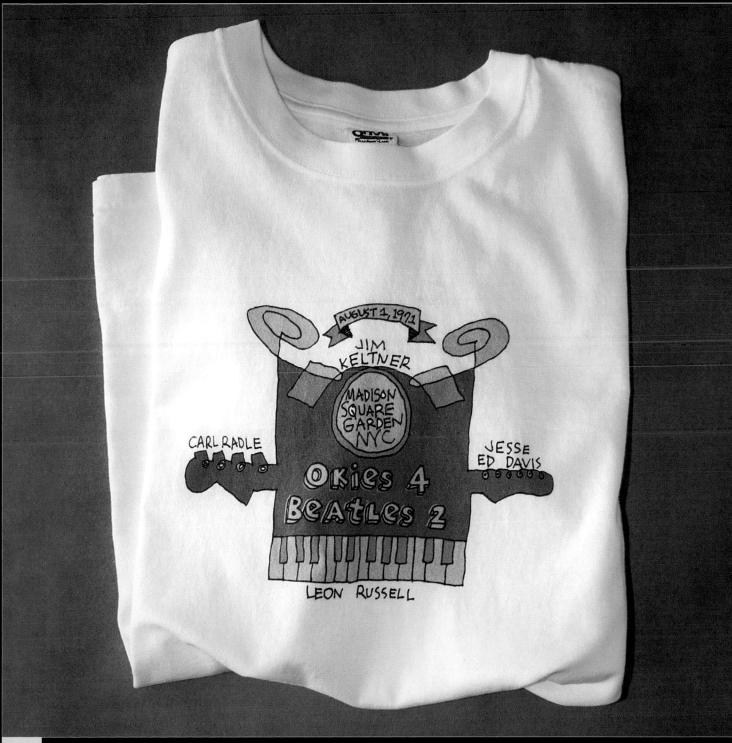

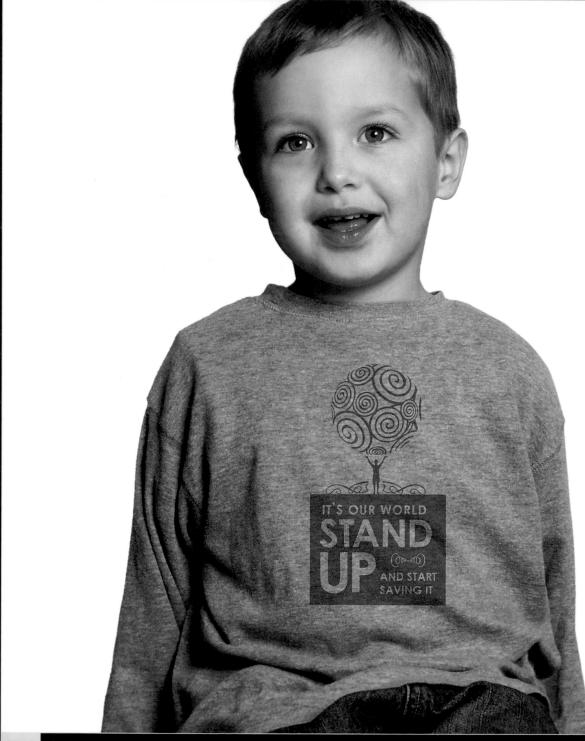

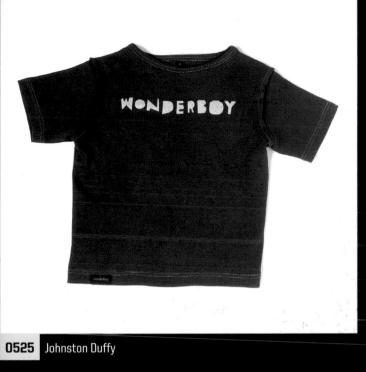

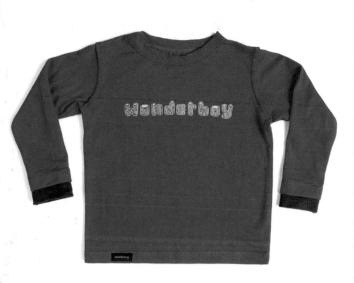

0526 Johnston Duffy

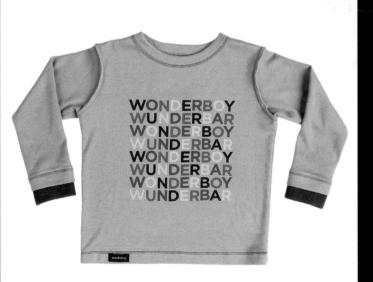

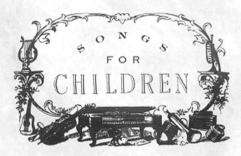

A Program of Song for the Benefit of Children with AIDS

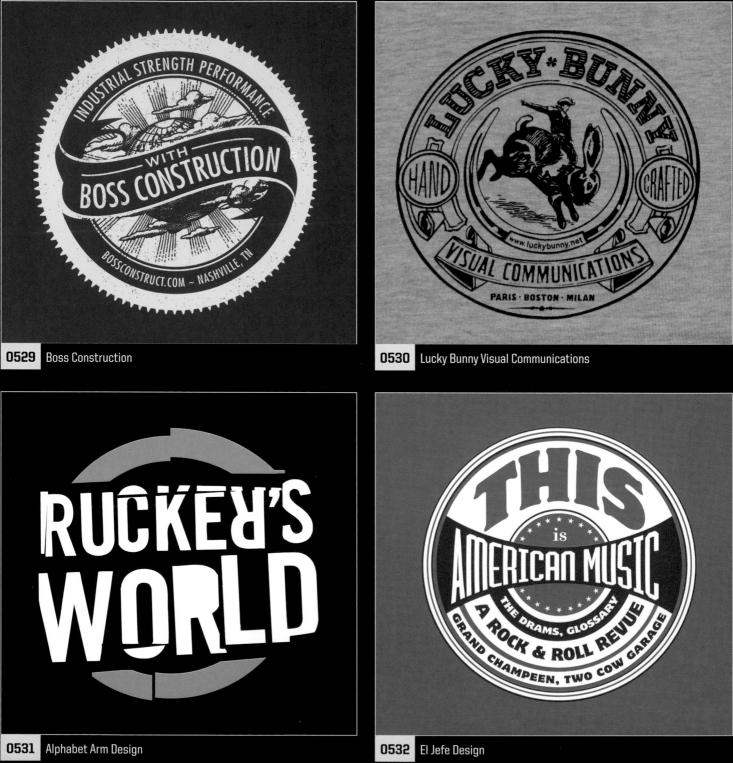

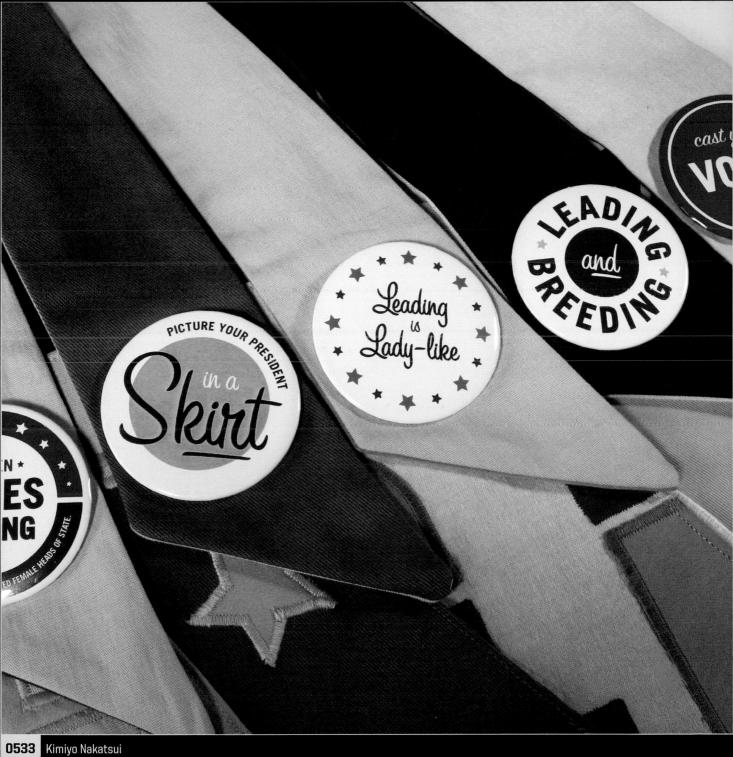

ANIMATION BLOCK PARTY BROOKLYN, NEW YORK

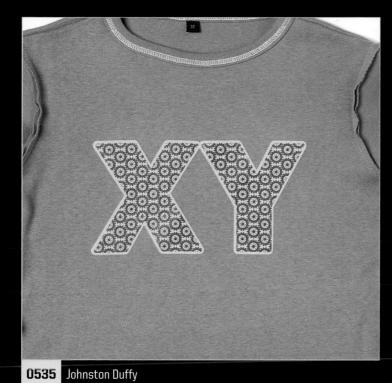

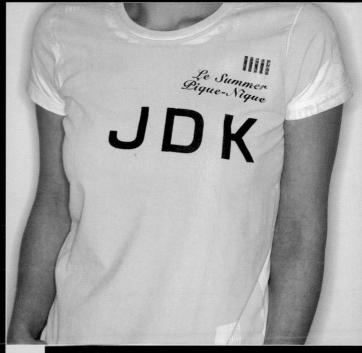

0536 Iskra Print Collective

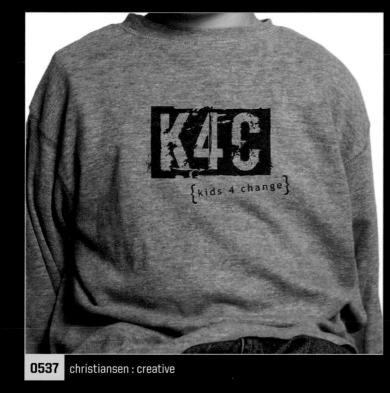

425.

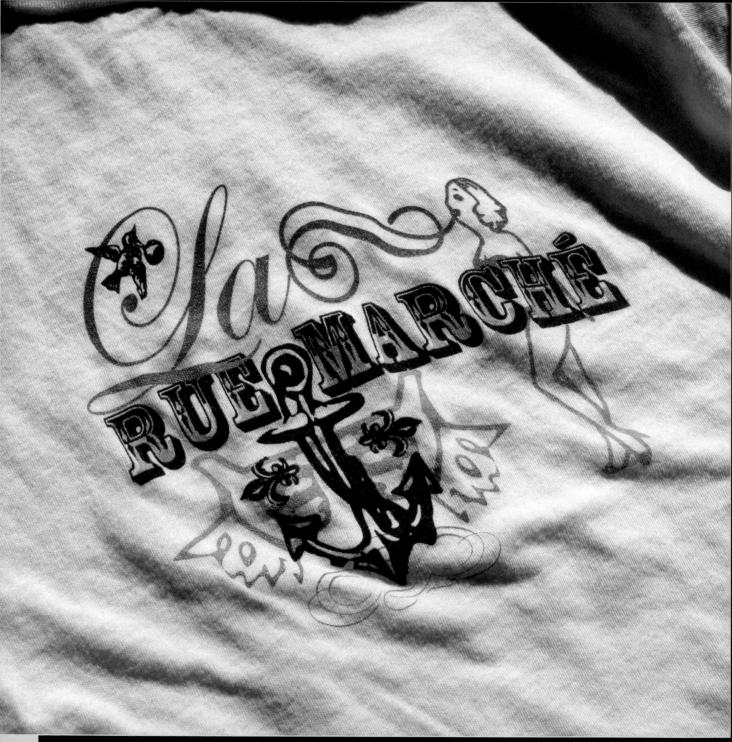

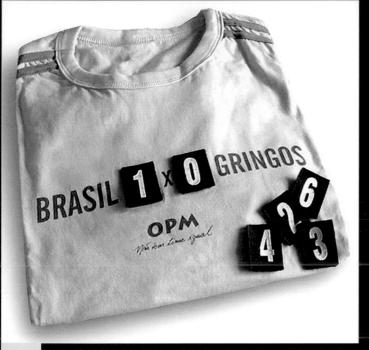

0545 OPM-Oficina de Propaganda e Marketing

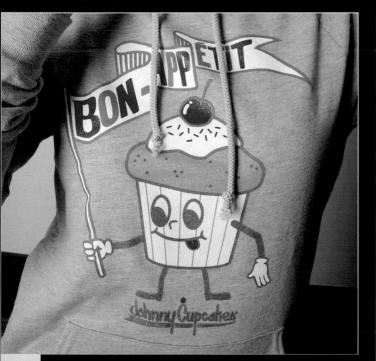

0546 OPM-Oficina de Propaganda e Marketing

ENJOY BALTIMORE

0549 **Red Prairie Press**

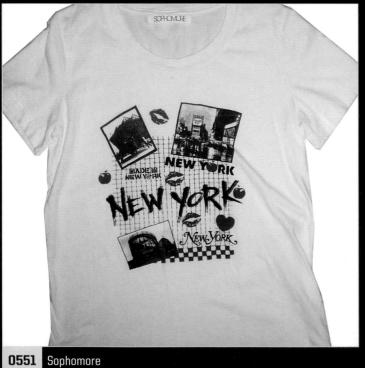

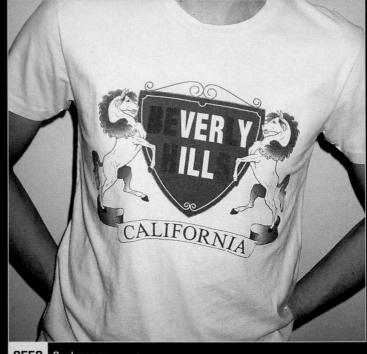

0550 Sophomore

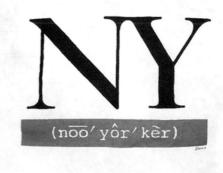

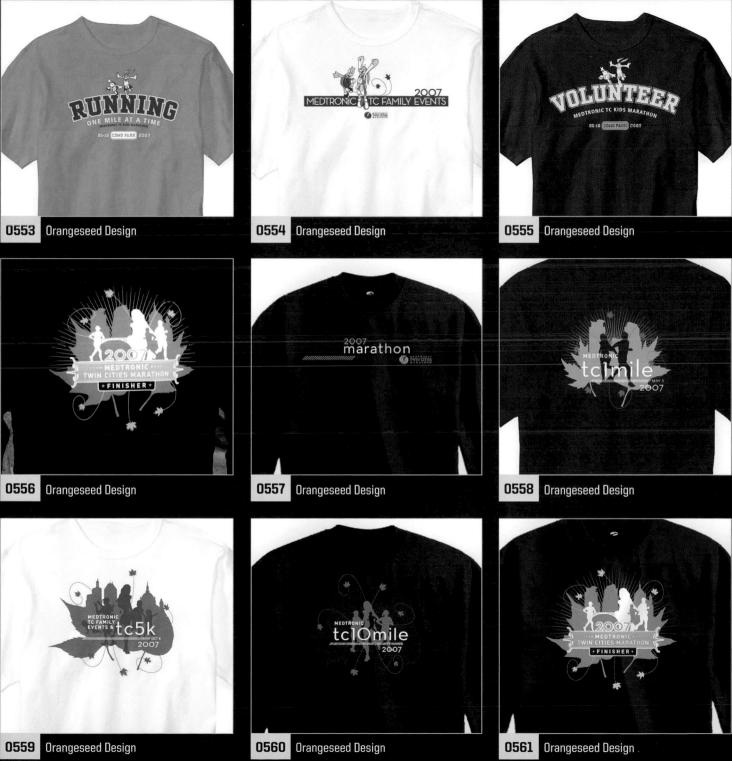

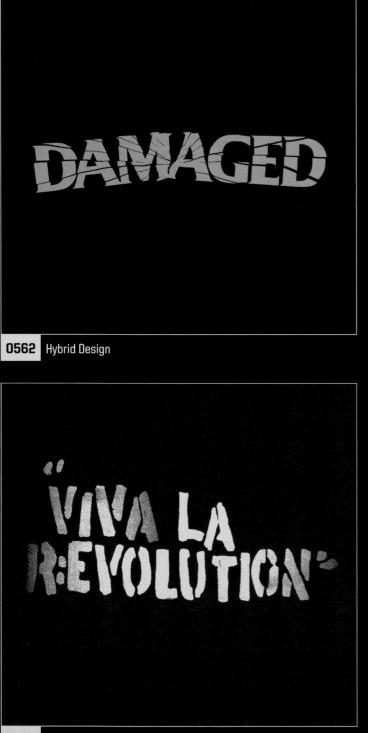

Weath Wetal Hybrid Design

0563

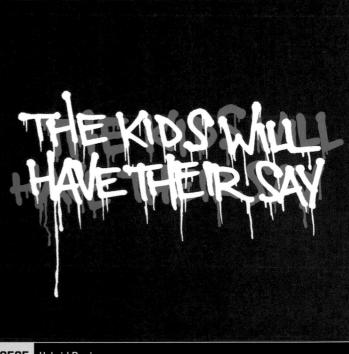

0565 Hybrid Design

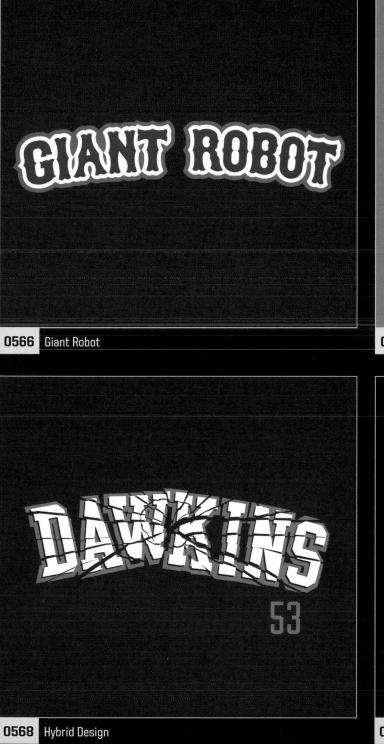

FIANT ROBOT

0567 Giant Robot

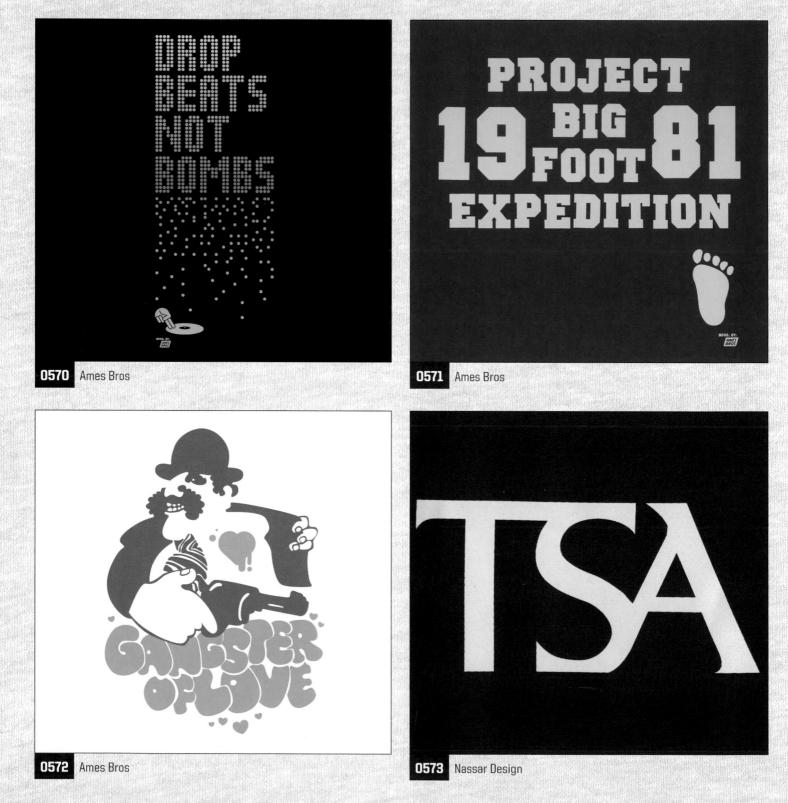

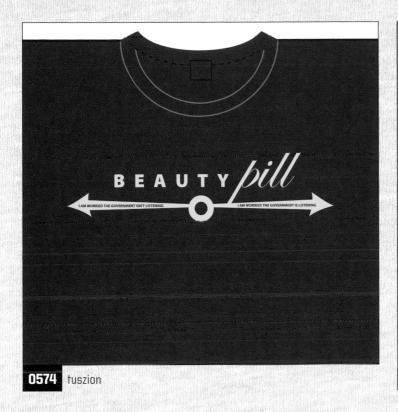

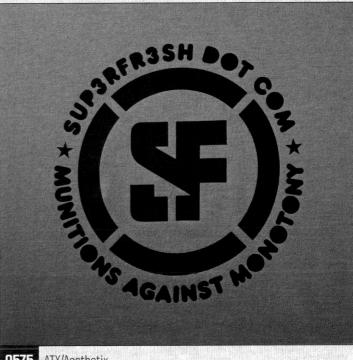

```
0575 ATX/Aesthetix
```

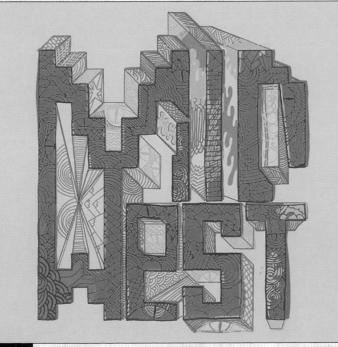

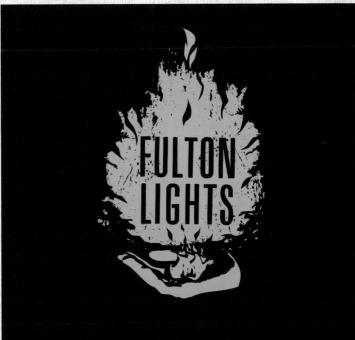

0579 Wing Chan Design, Inc.

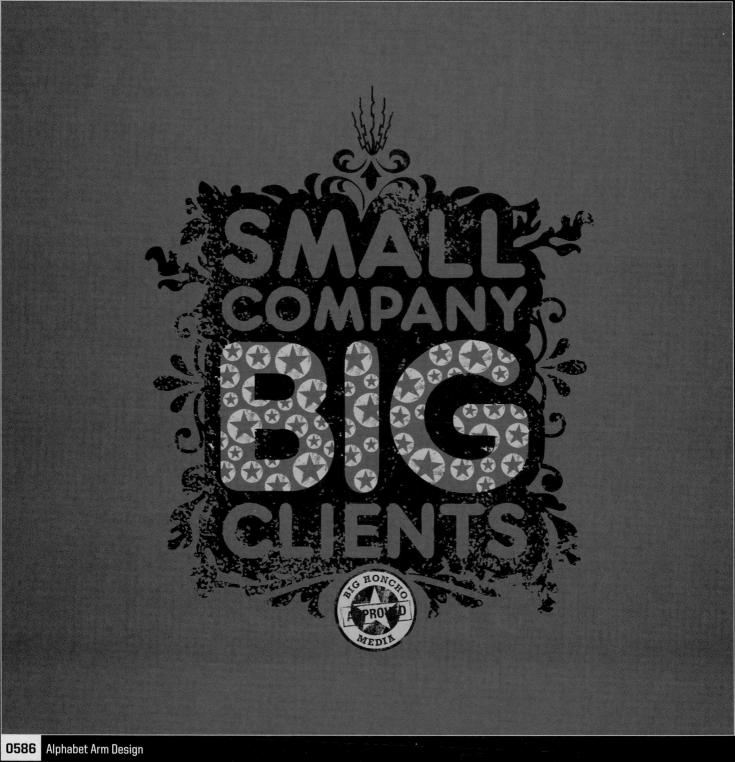

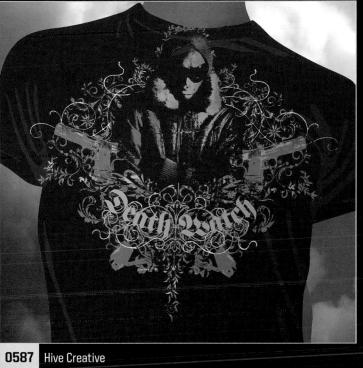

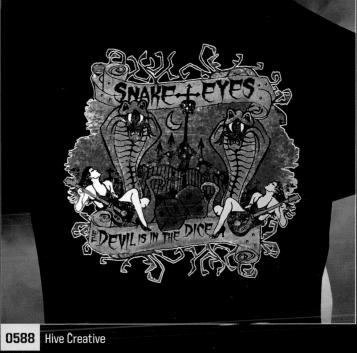

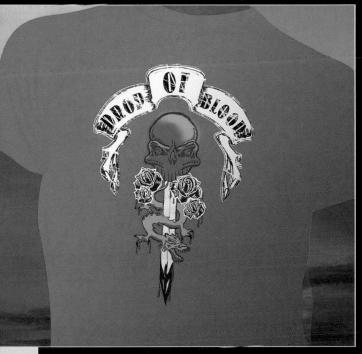

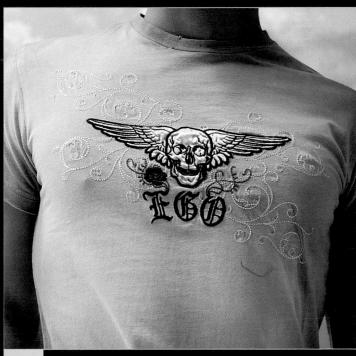

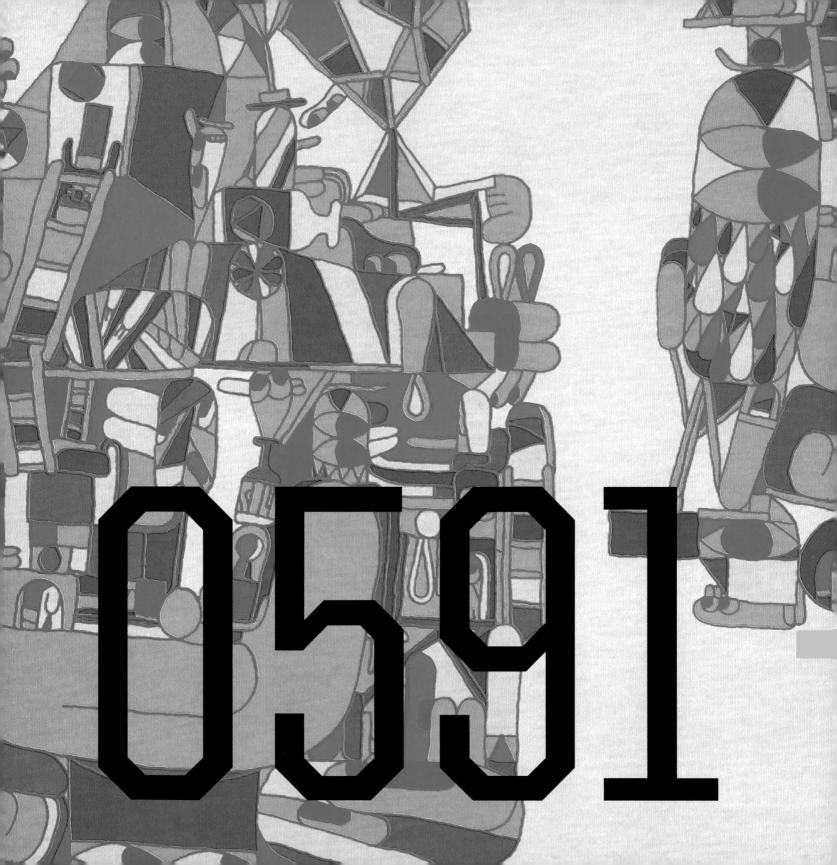

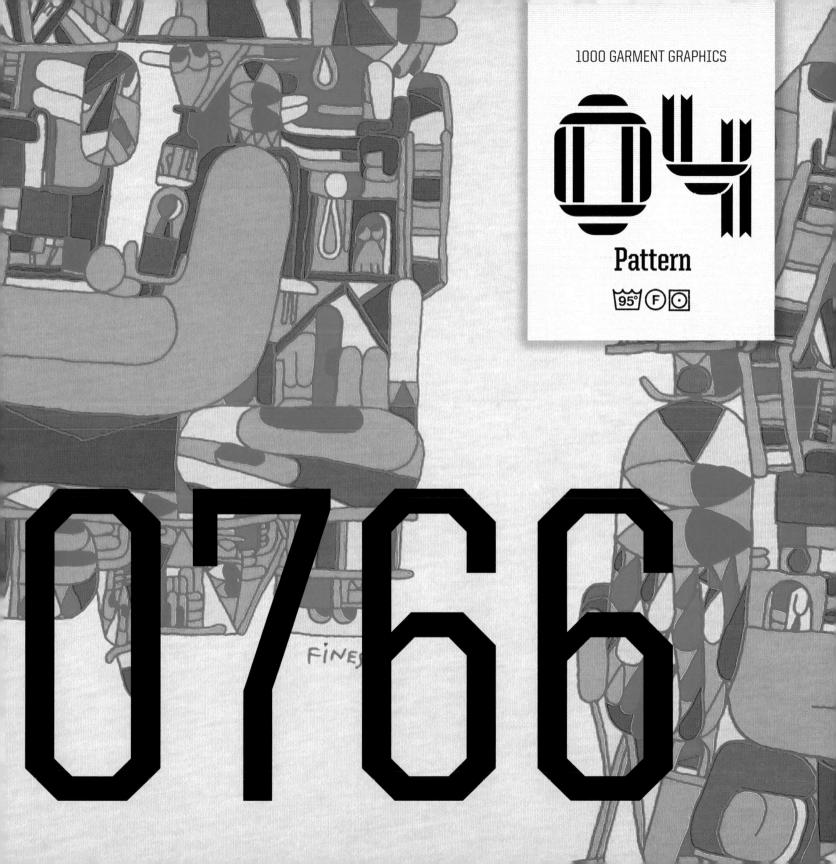

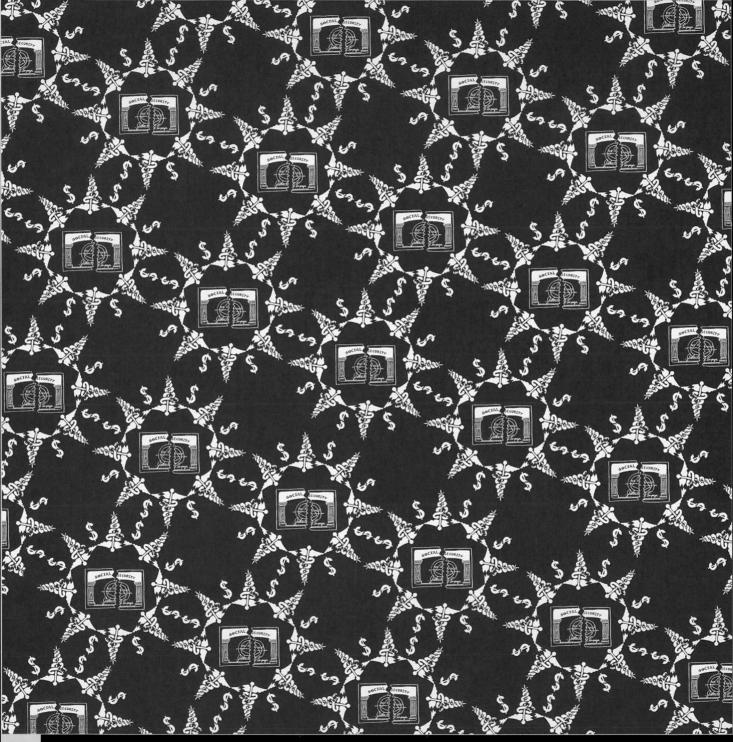

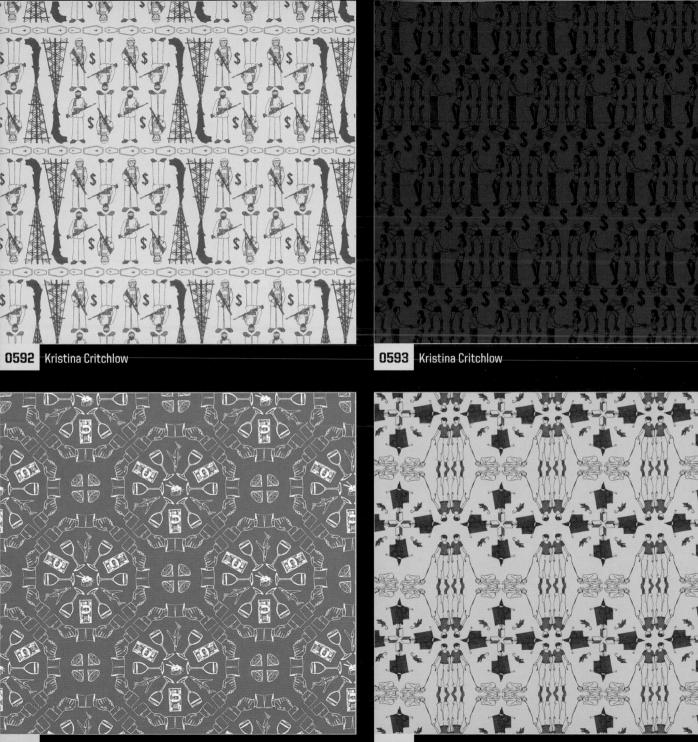

0595 Kristina Critchlow

0594 Kristina Critchlow

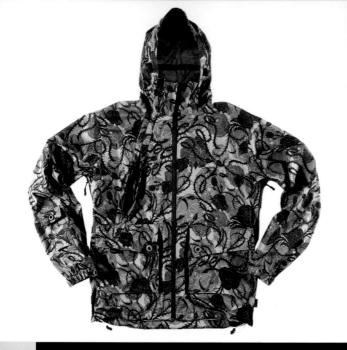

0596 Addict LTD

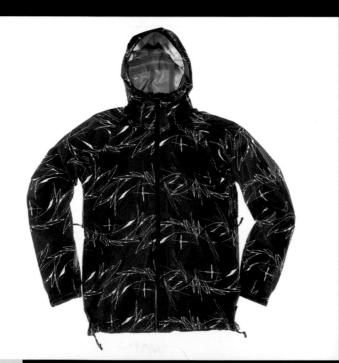

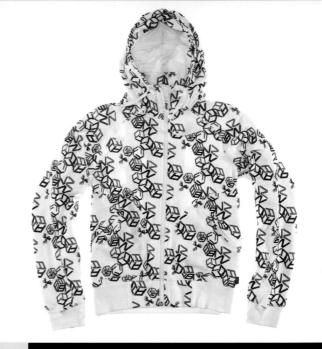

0597 Addict LTD

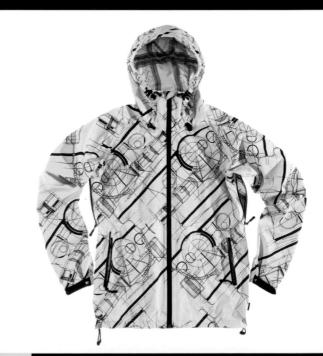

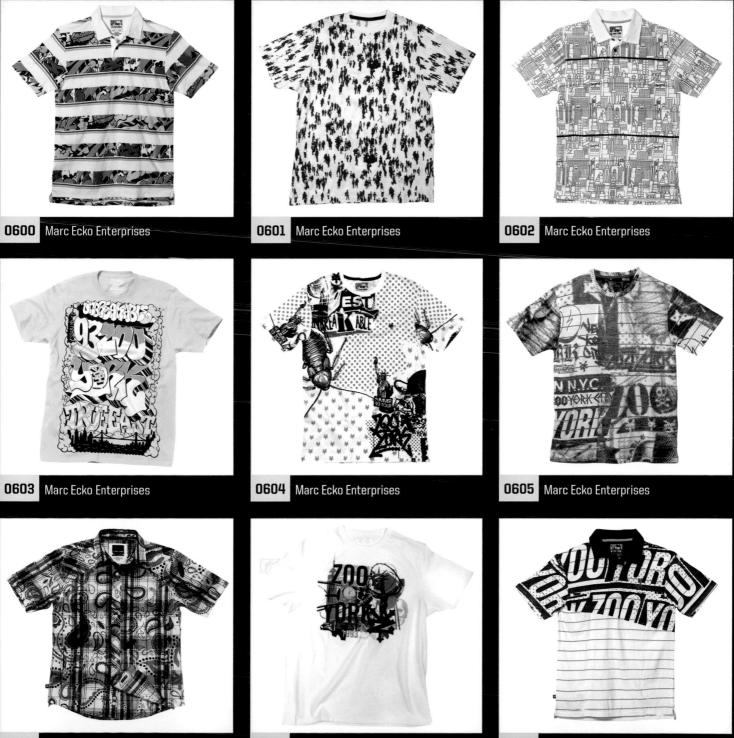

0606 Marc Ecko Enterprises

0607 Marc Ecko Enterprises

0608 Marc Ecko Enterprises

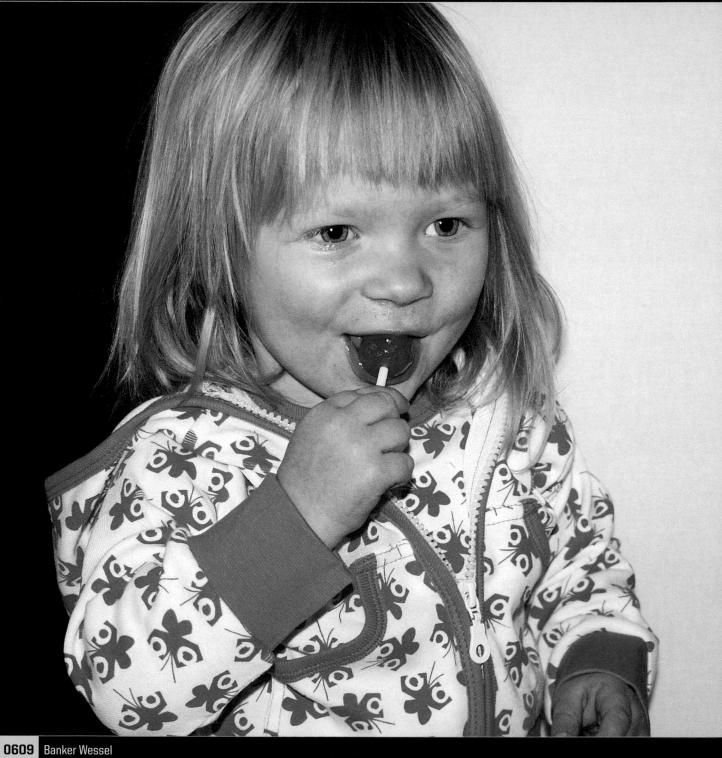

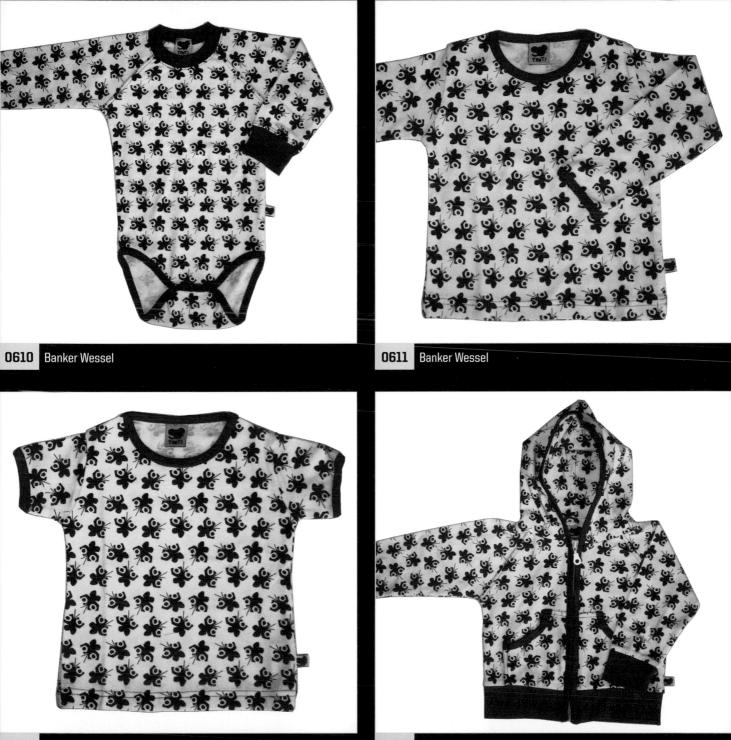

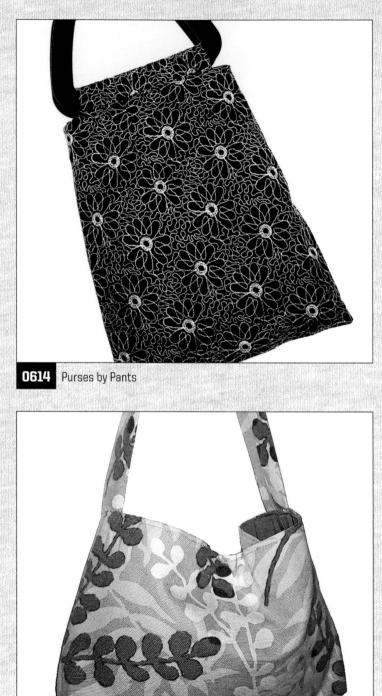

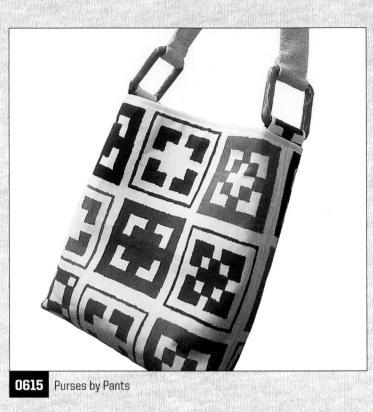

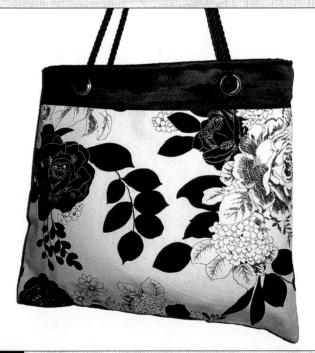

0616 Purses by Pants

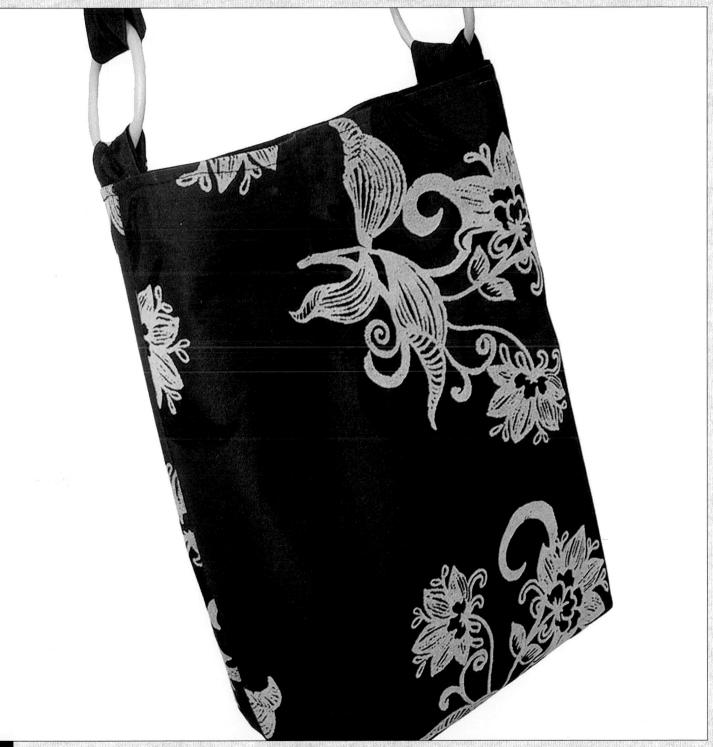

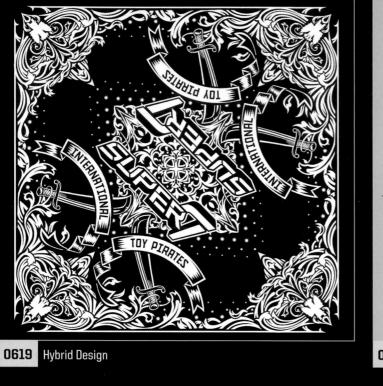

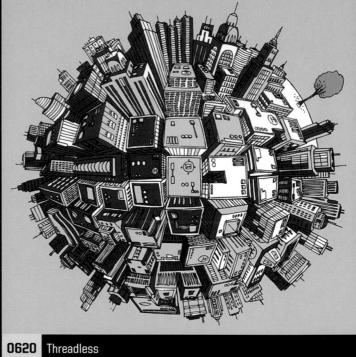

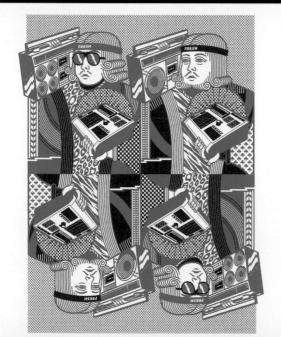

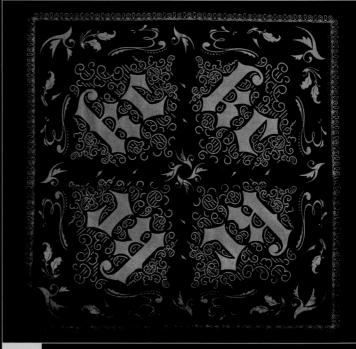

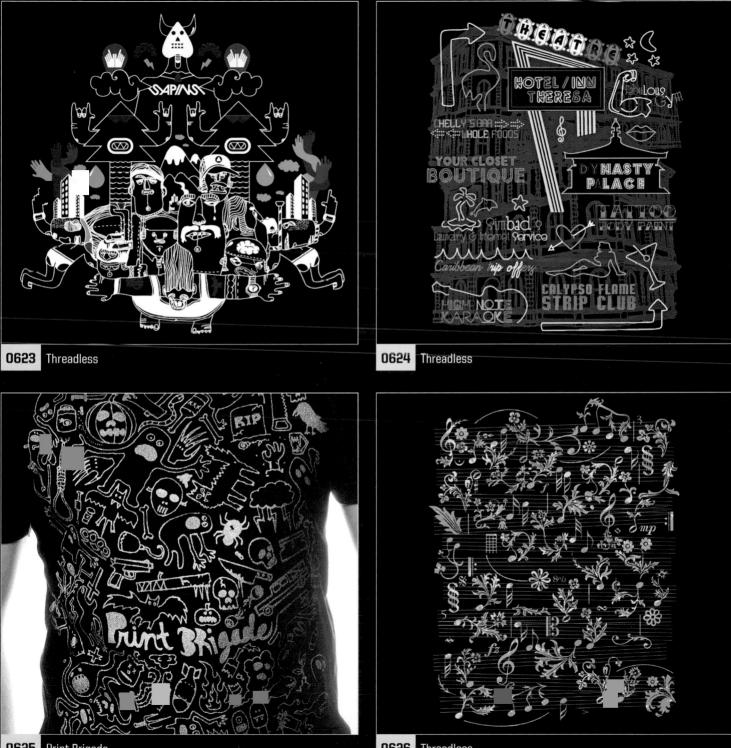

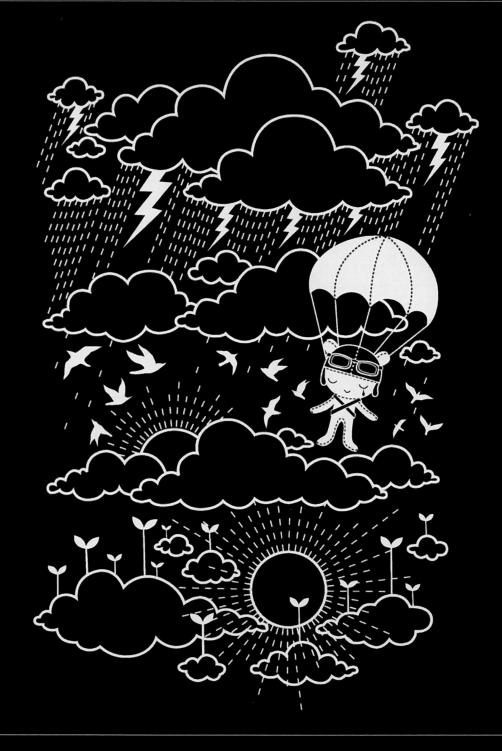

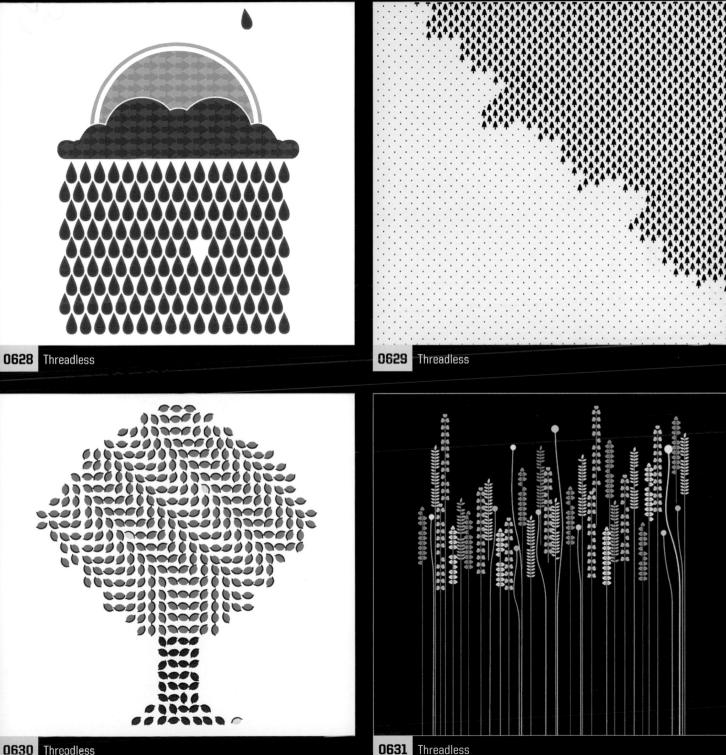

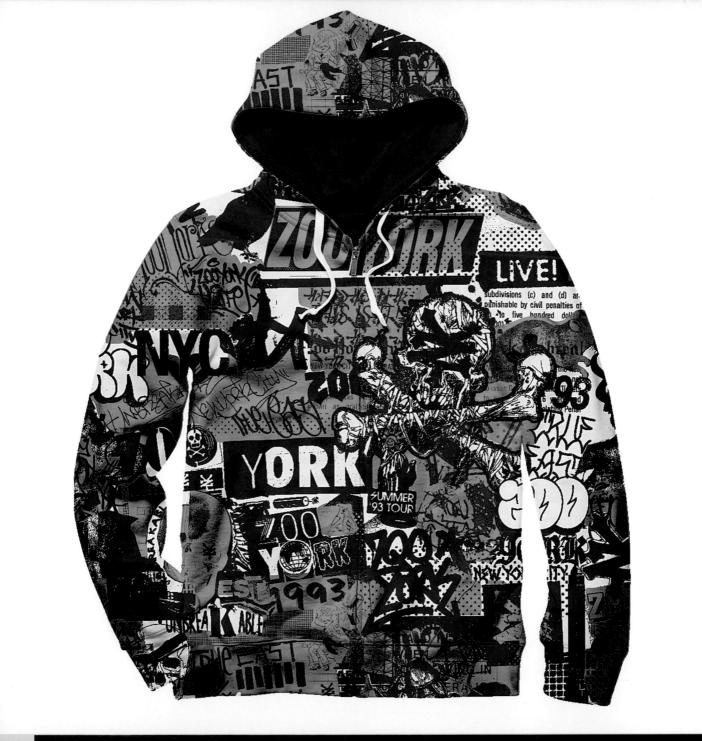

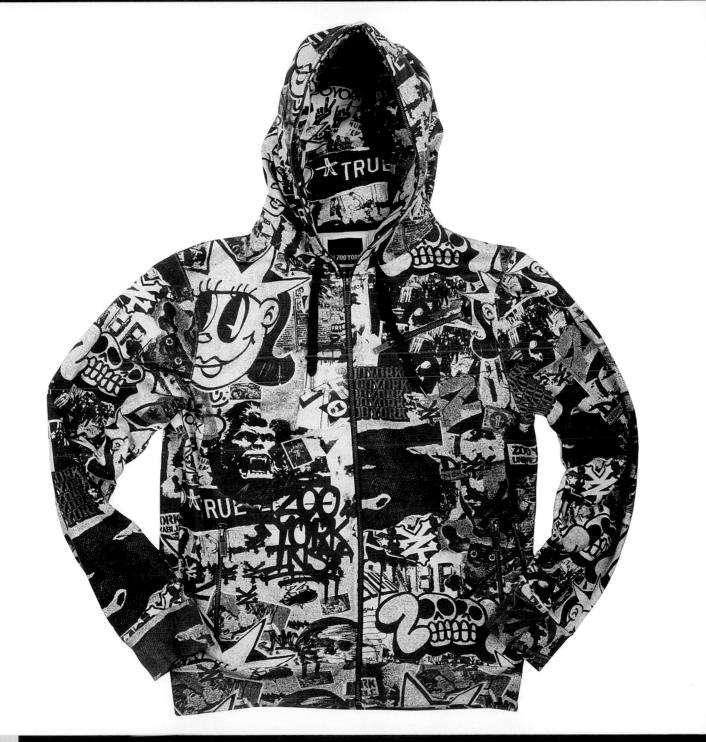

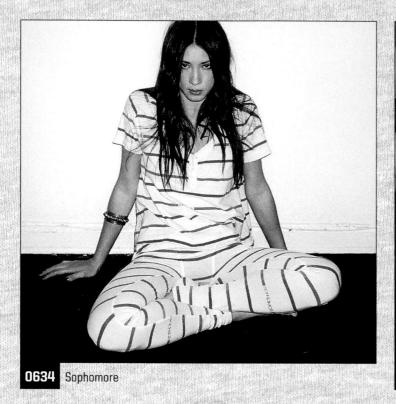

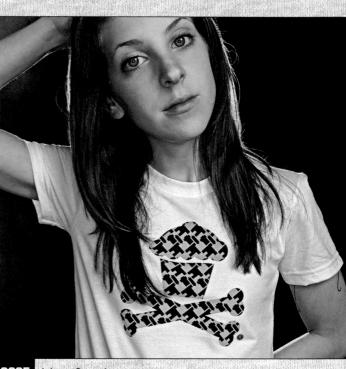

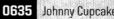

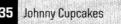

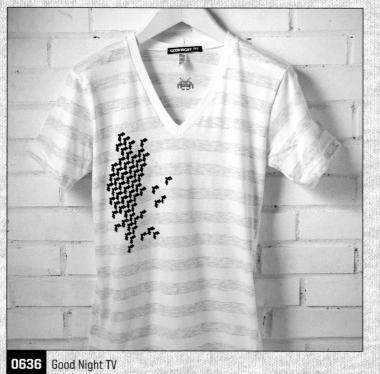

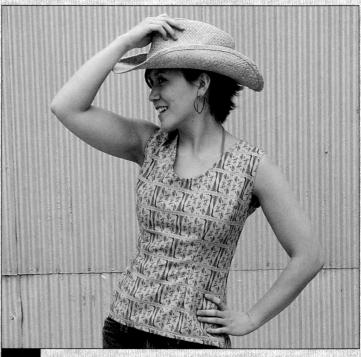

Kristina Critchlow 0637

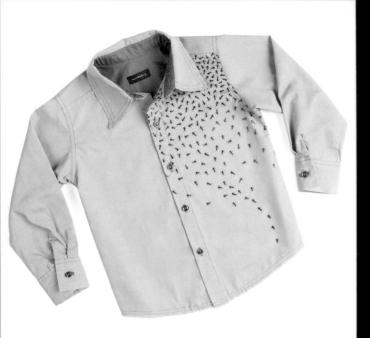

0640 Johnston Duffy

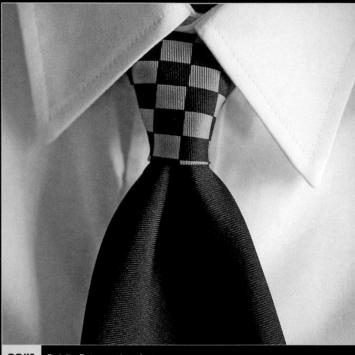

0641 Studio International

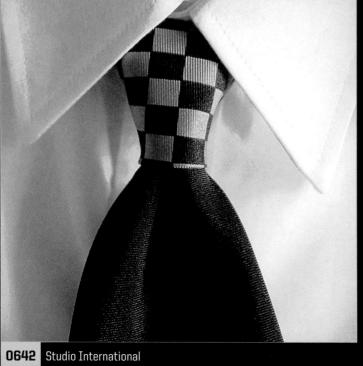

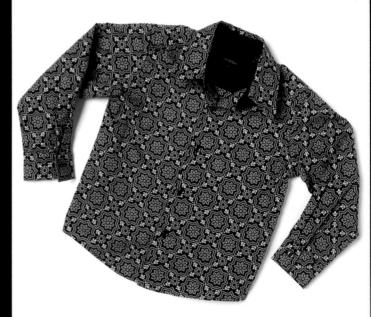

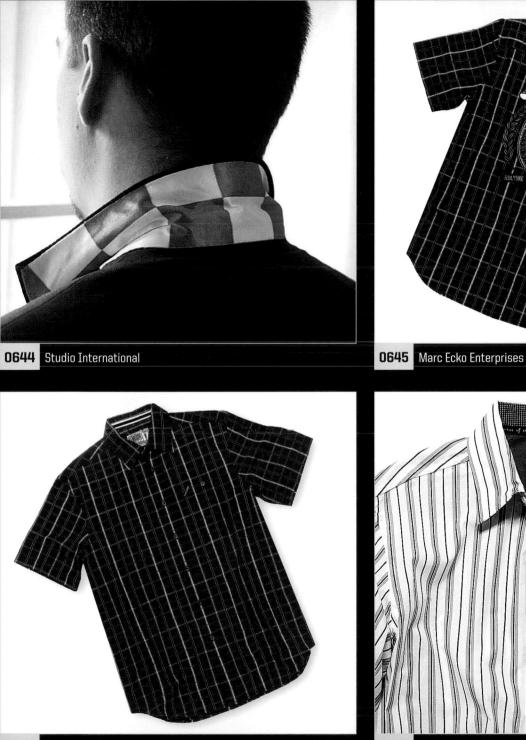

FCK

eckö unita lassic material

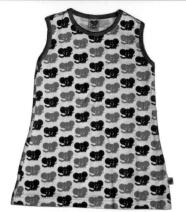

0648 Banker Wessel

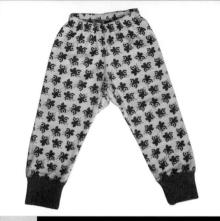

0649 Banker Wessel

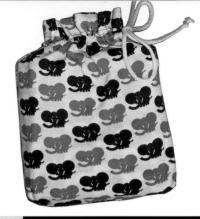

0650 Banker Wessel

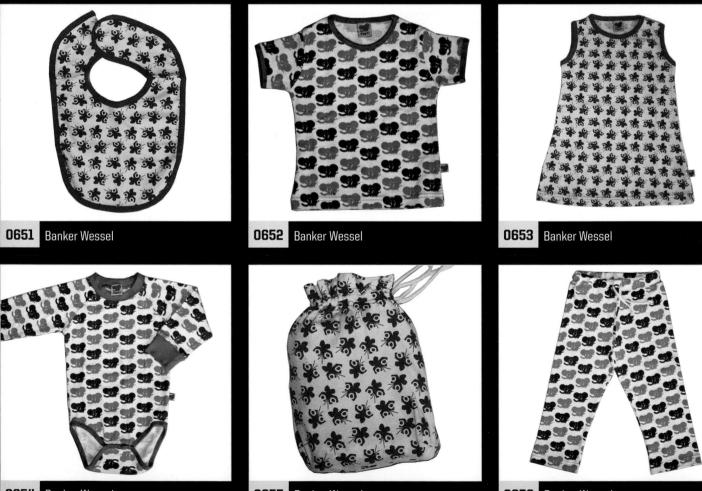

0654 Banker Wessel

0655 Banker Wessel

0656 Banker Wessel

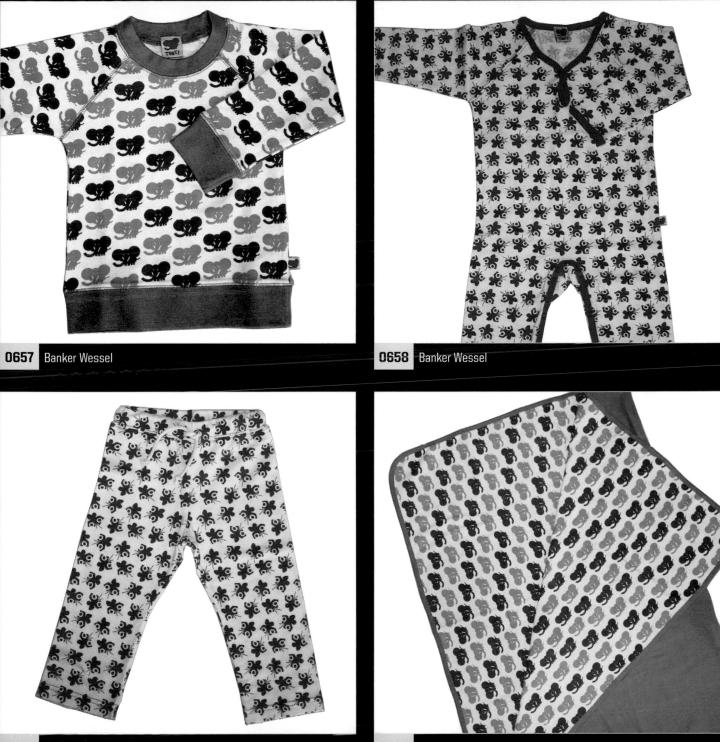

0661 Blue Q

0662 Blue Q

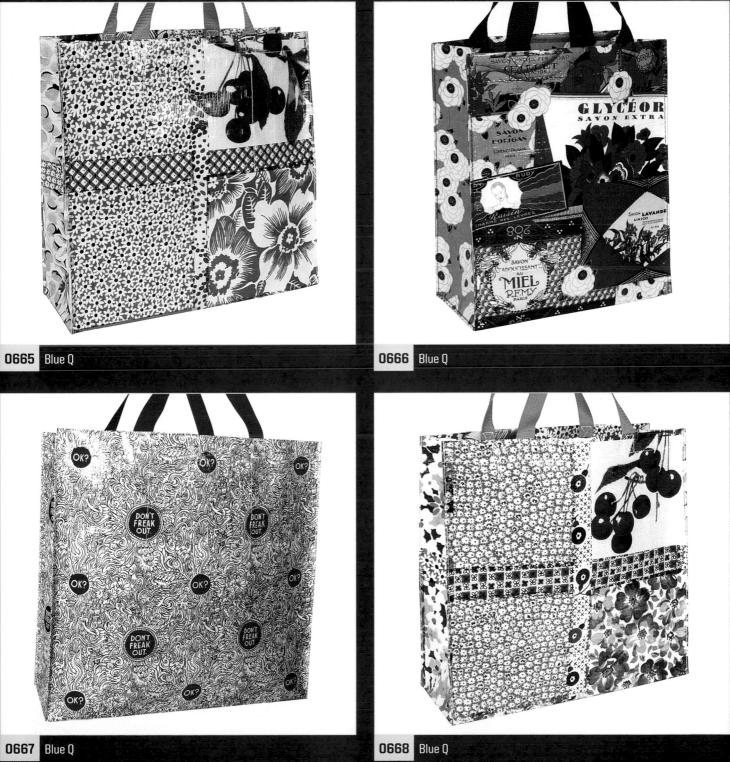

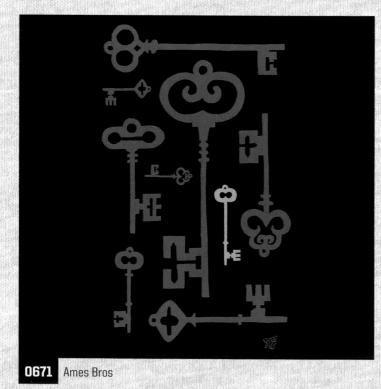

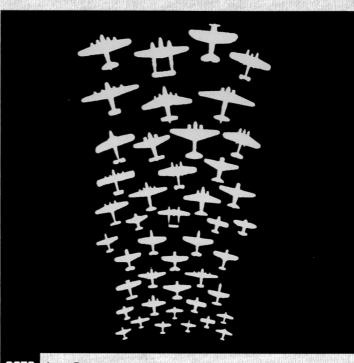

0670 Ames Bros

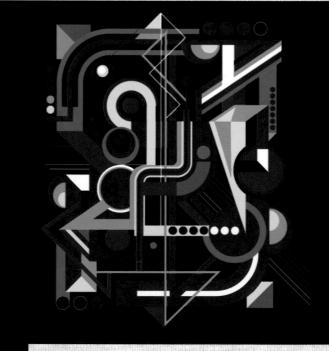

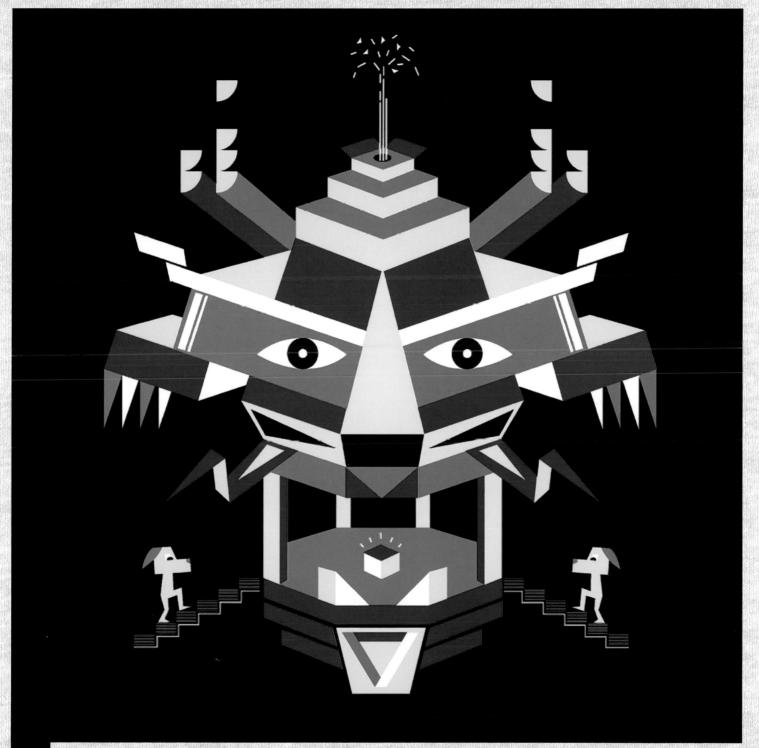

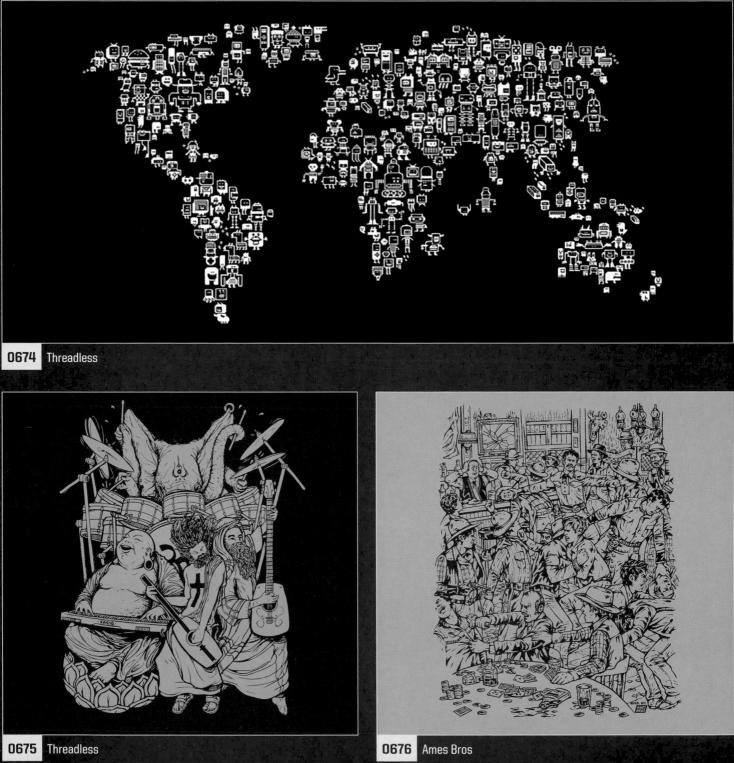

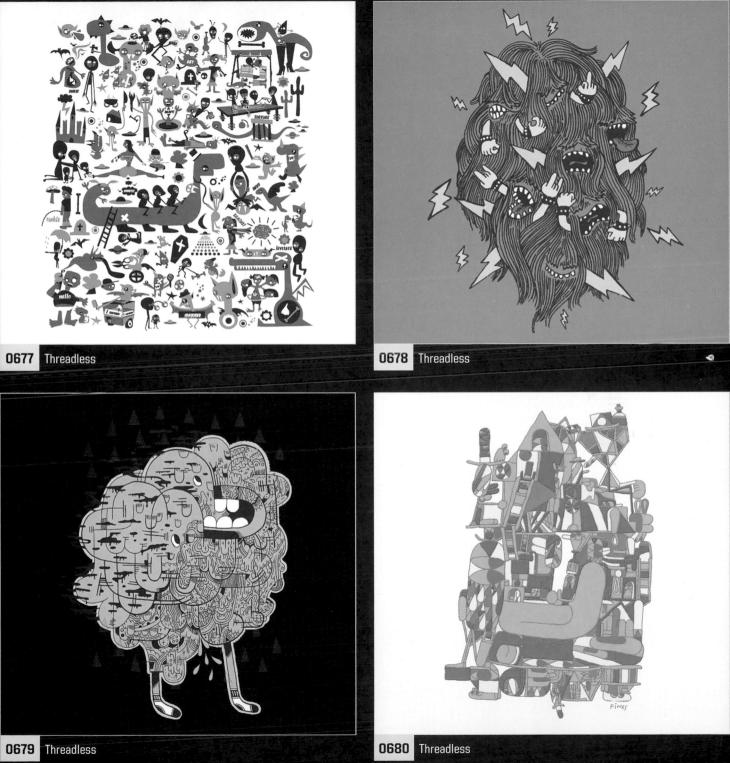

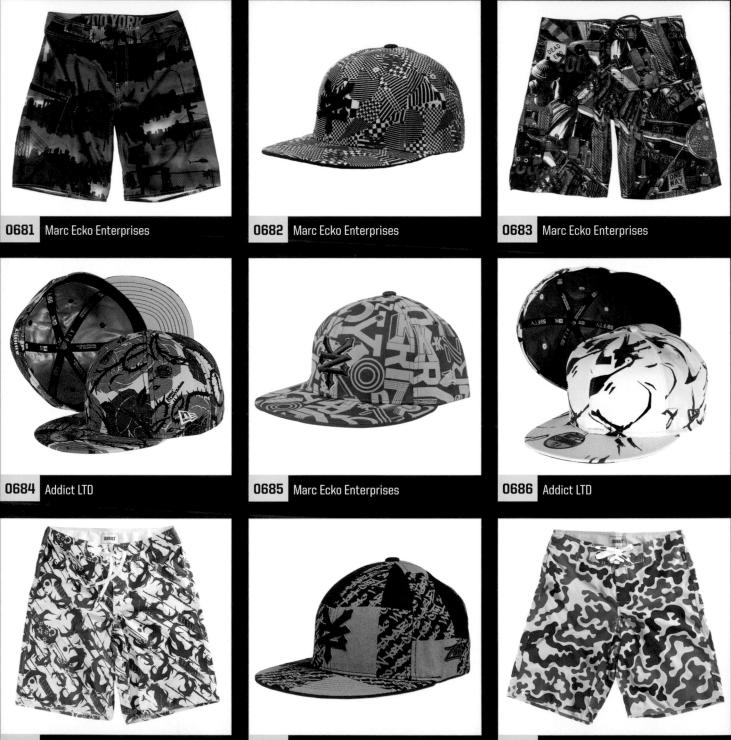

0687 Addict LTD

0688 Marc Ecko Enterprises

0689 Addict LTD

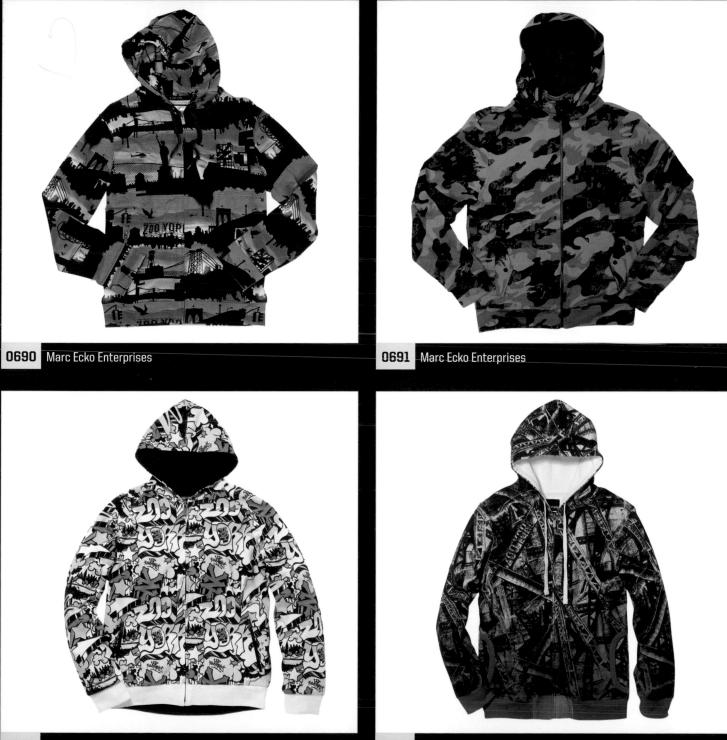

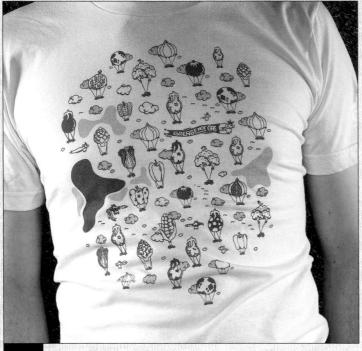

0694 Iskra Print Collective

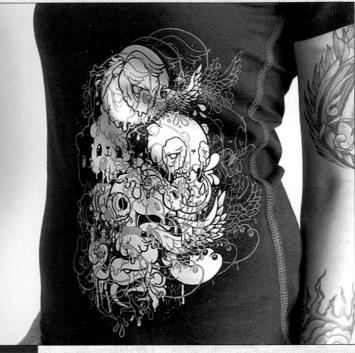

0695 Artcotic

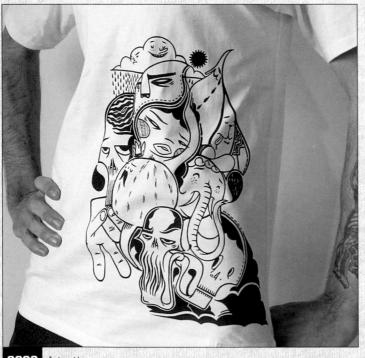

0696 Artcotic

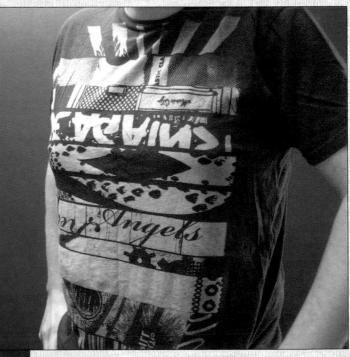

0697 Boss Construction

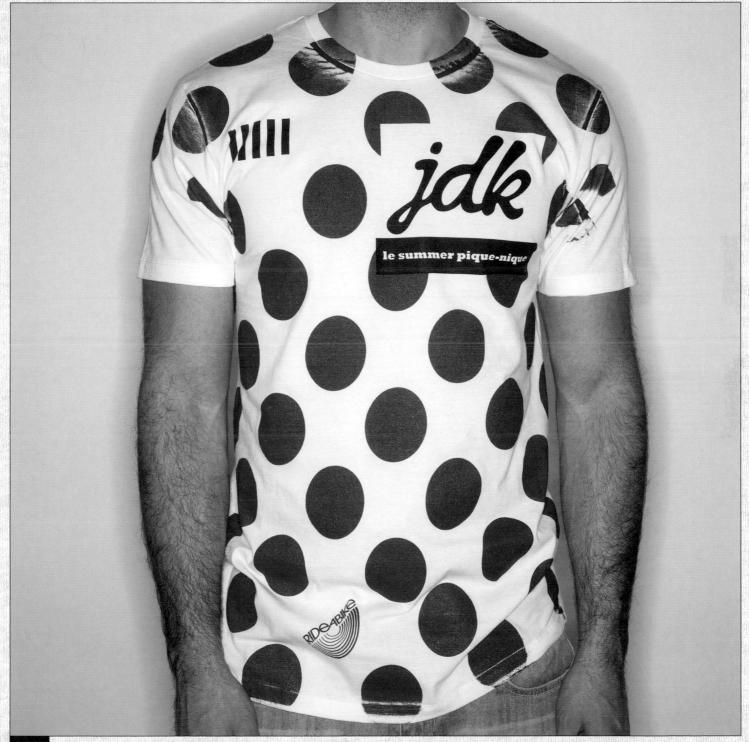

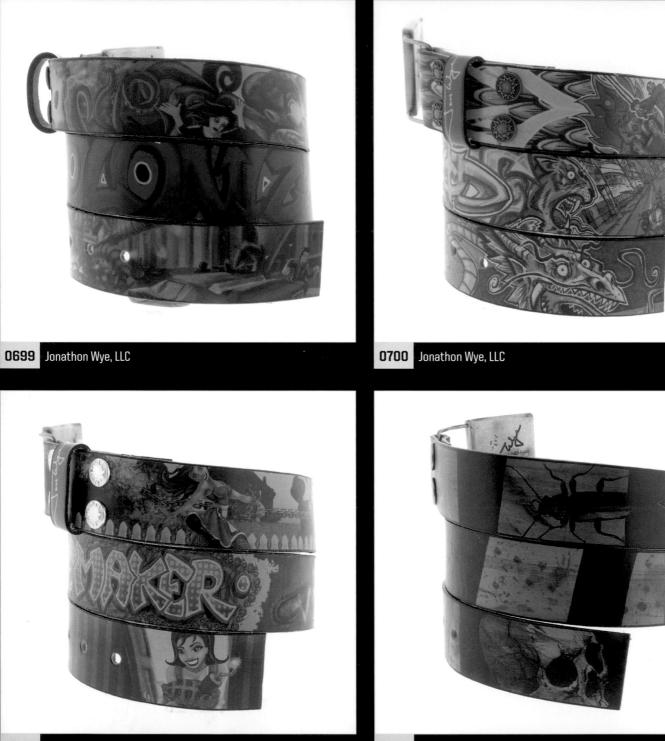

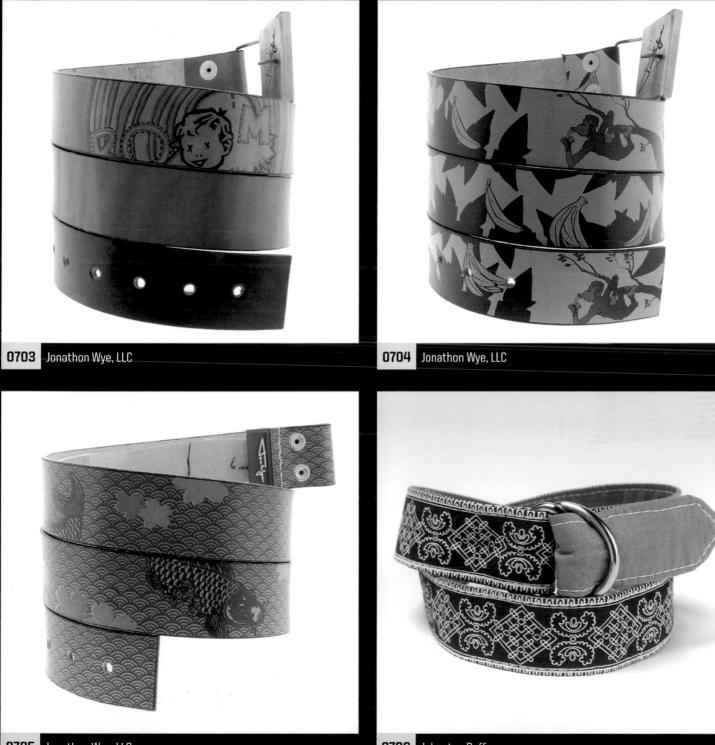

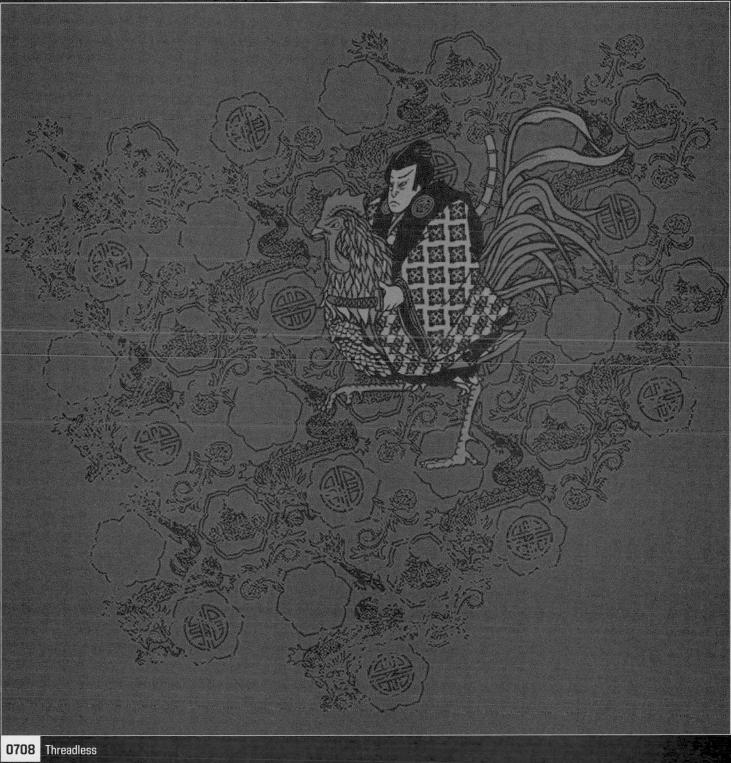

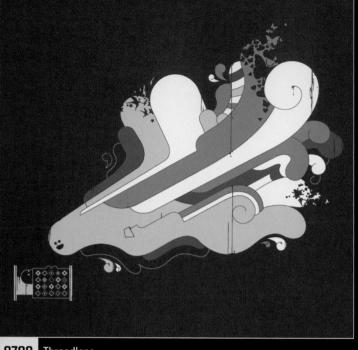

0709 Threadless

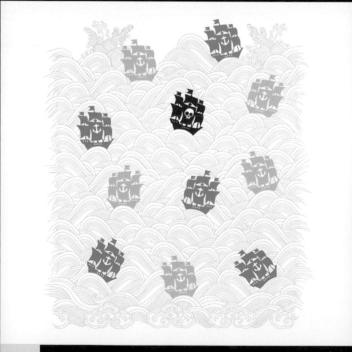

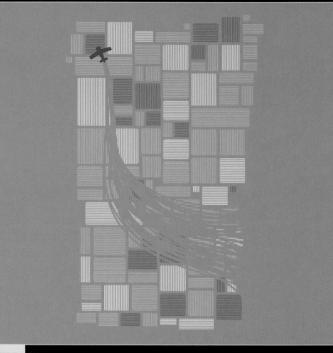

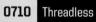

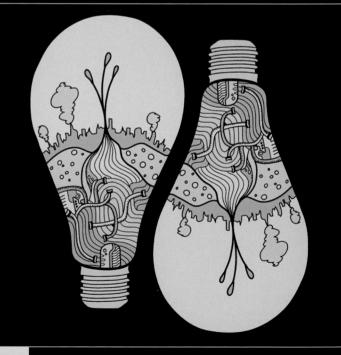

220 | 1000 GARMENT GRAPHICS

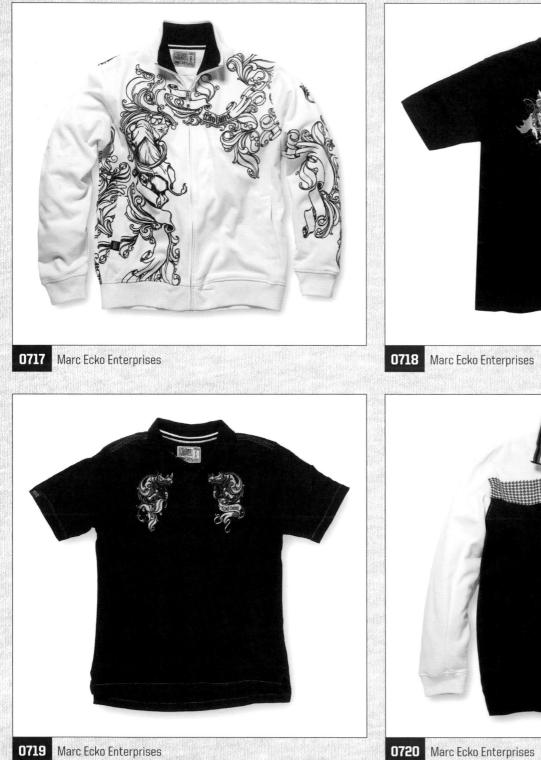

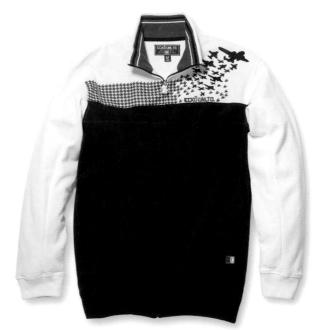

國情報

PATTERNS | 221

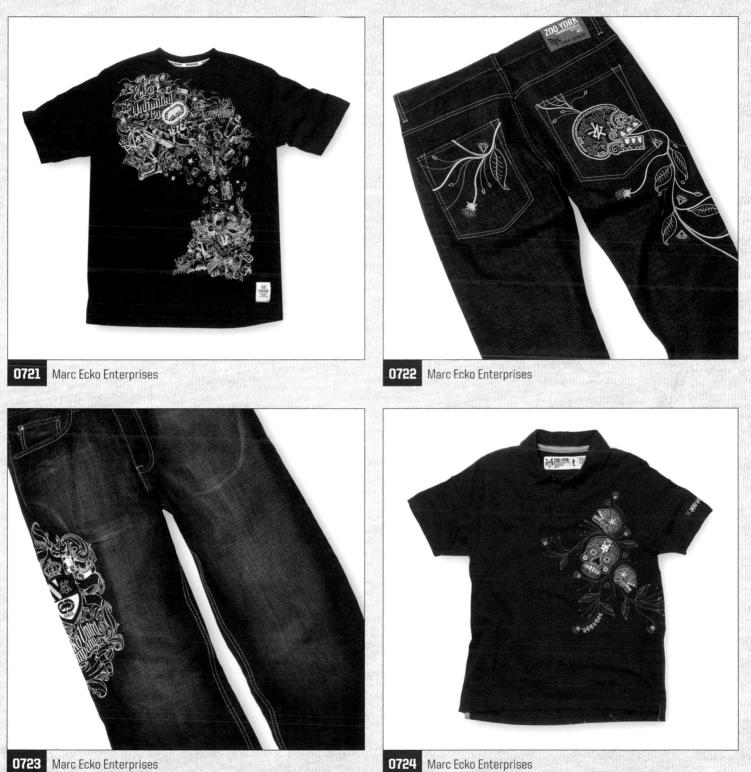

0723 Marc Ecko Enterprises

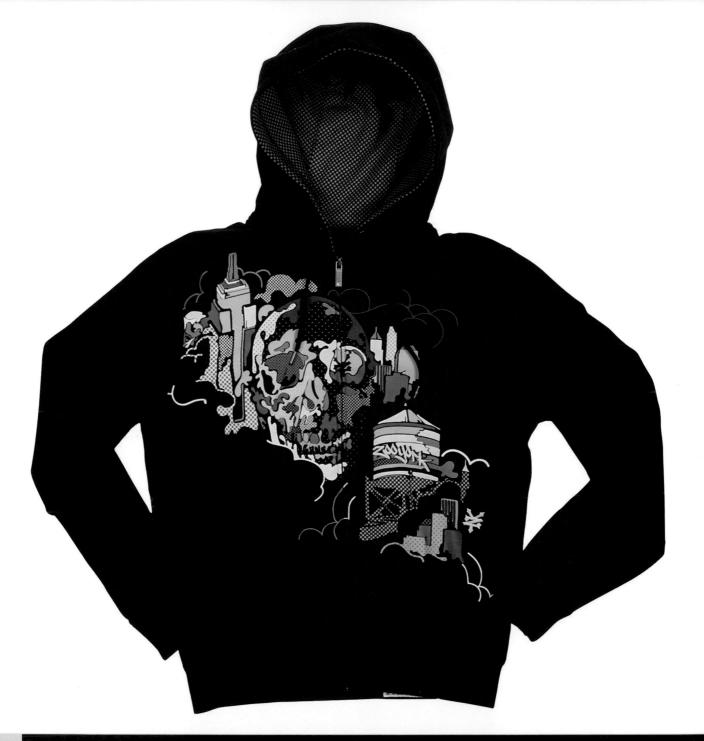

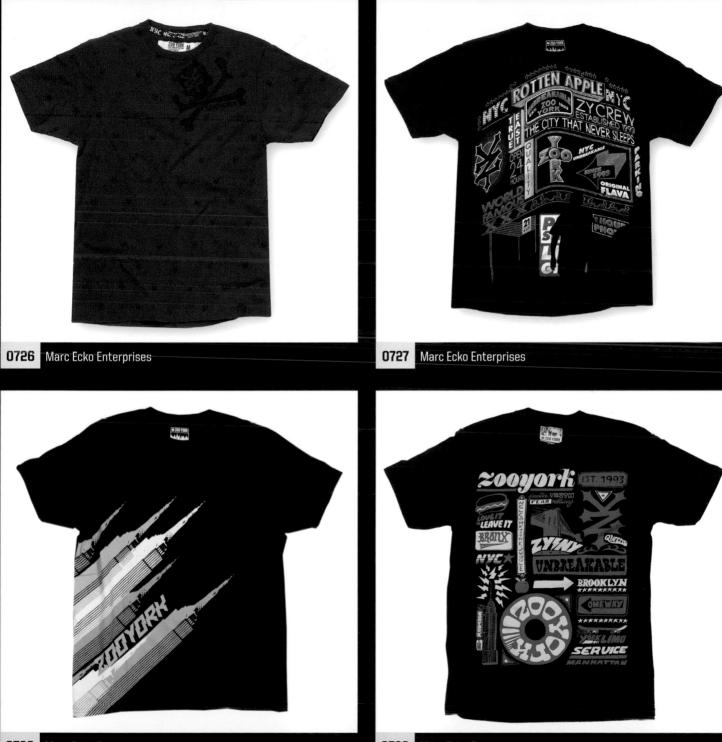

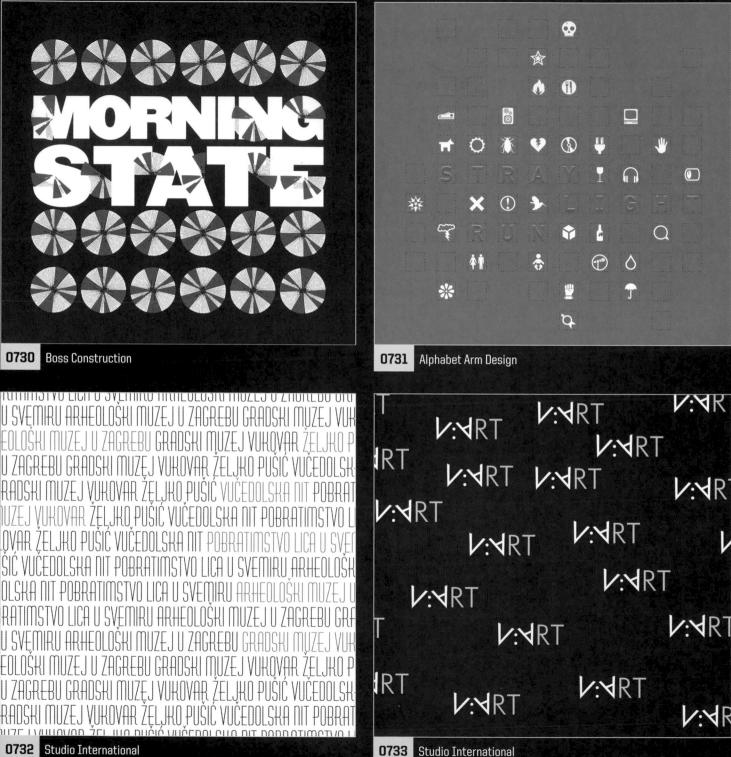

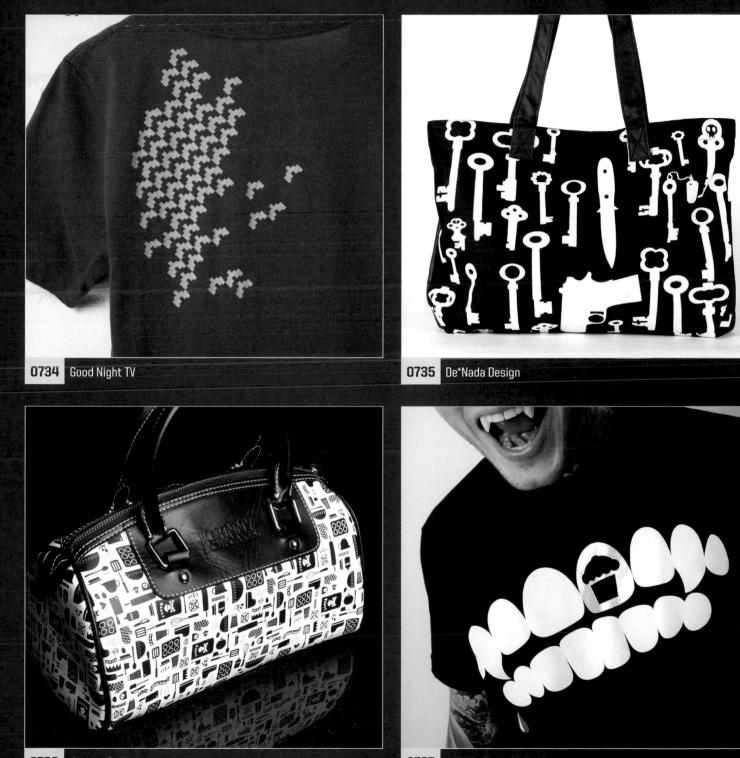

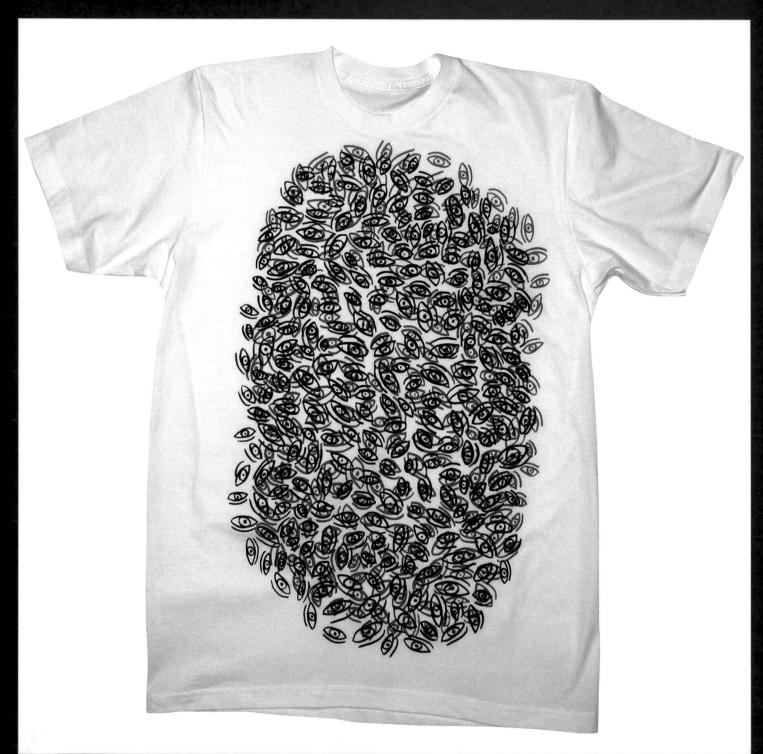

0746 Loyalty + Blood

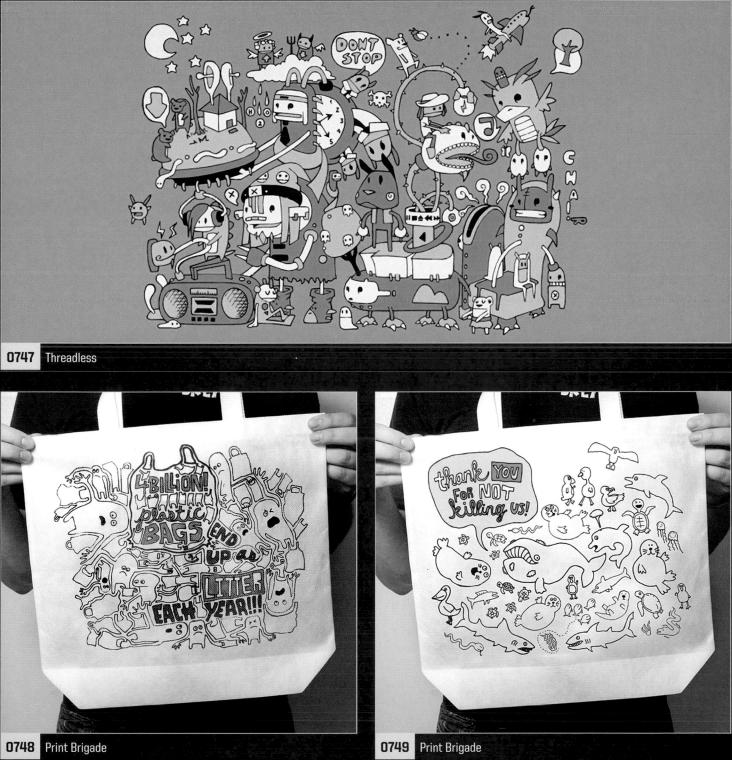

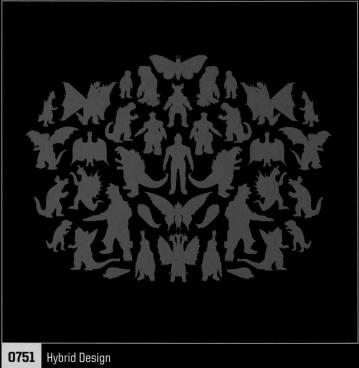

0750 Ames Bros

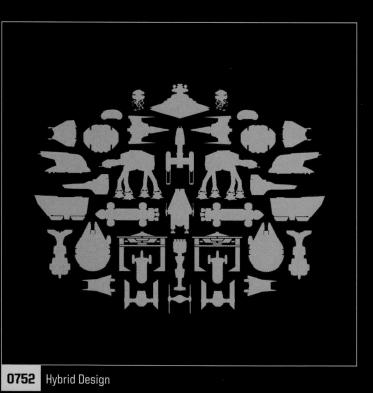

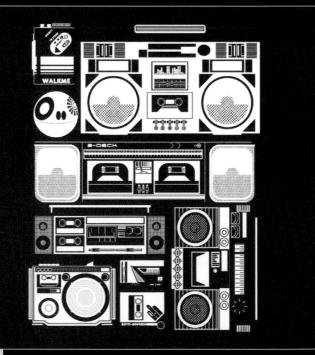

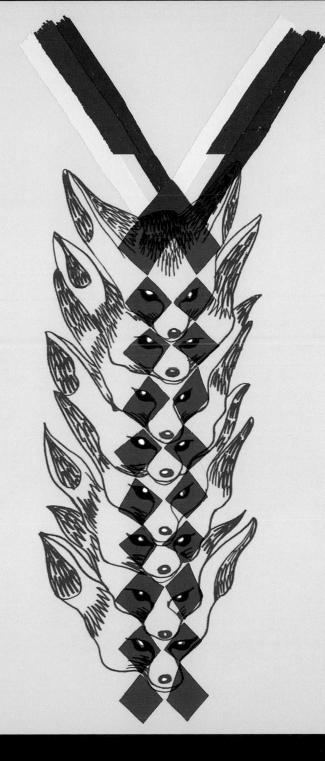

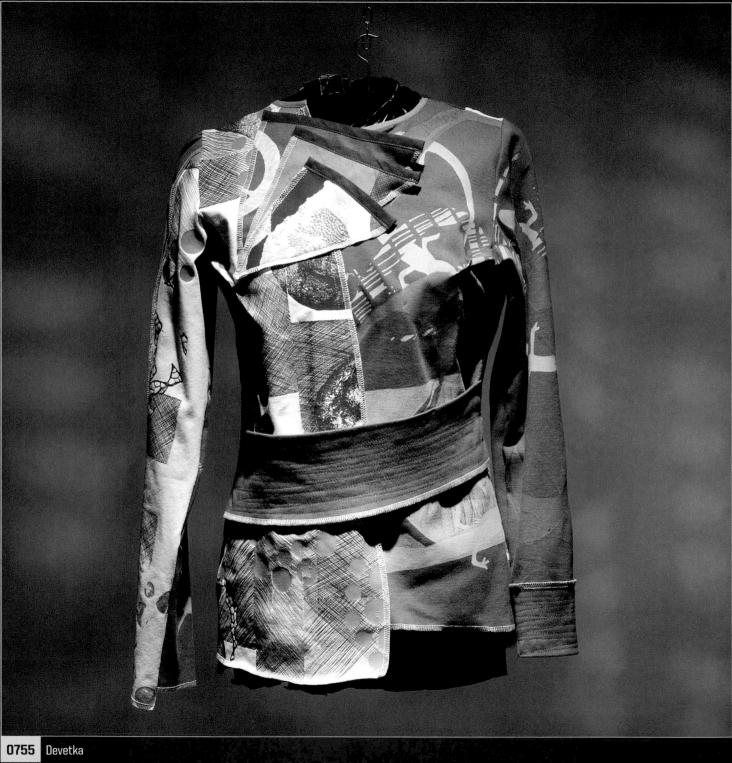

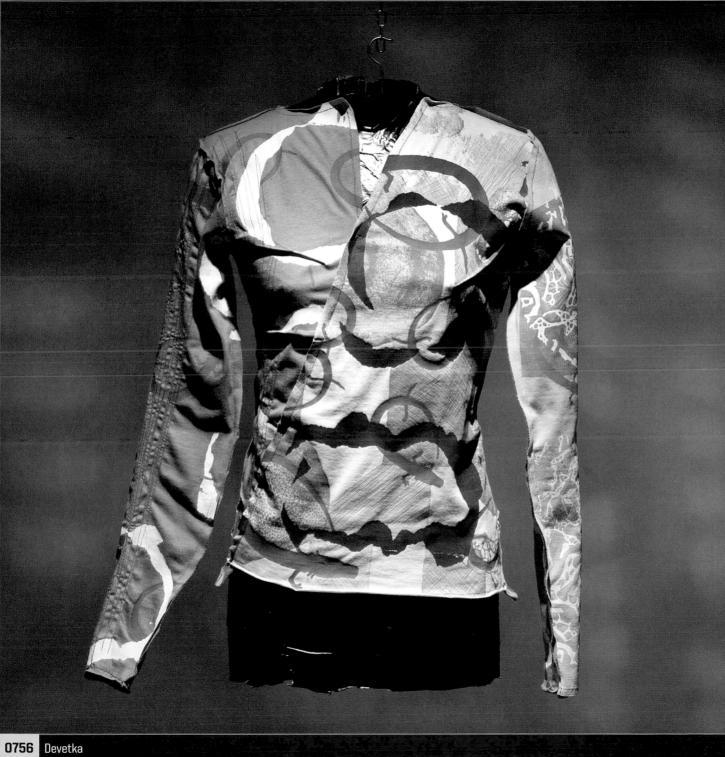

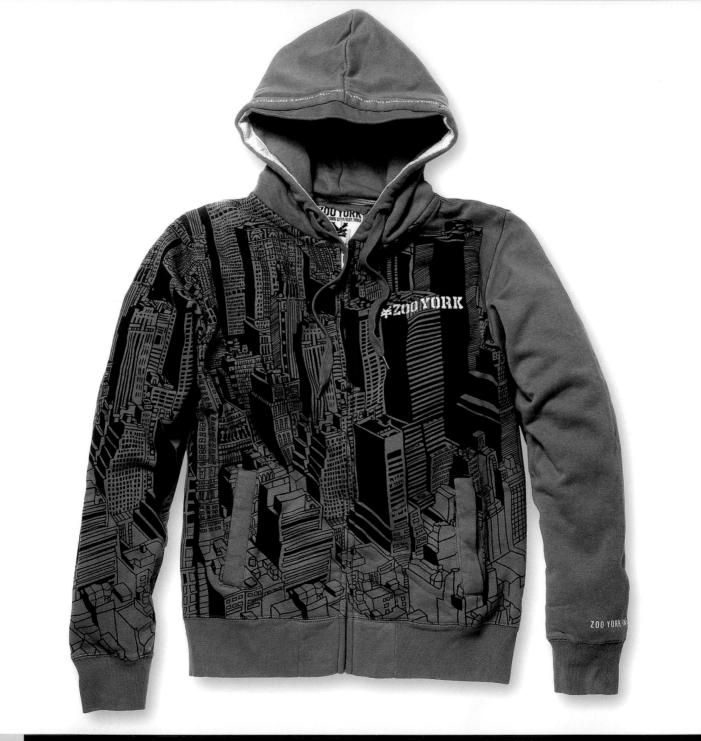

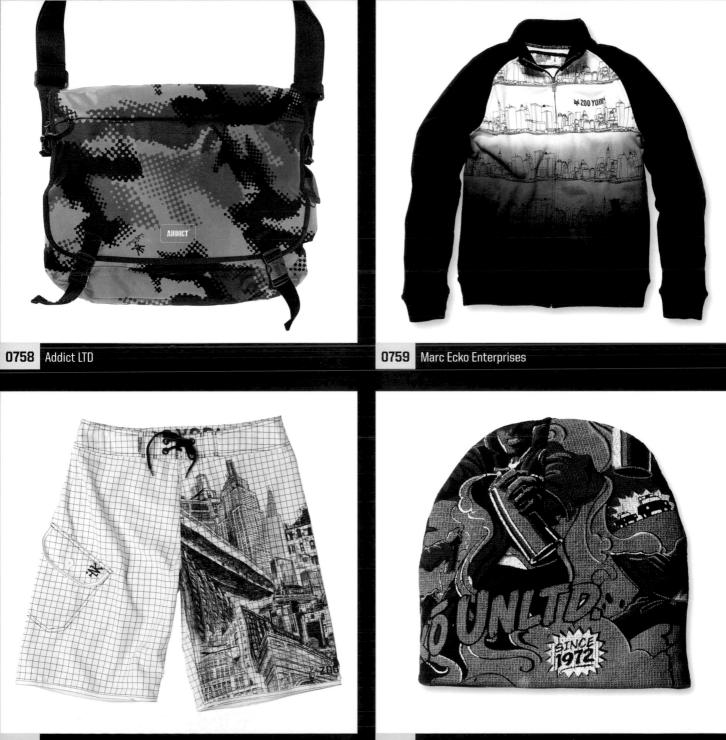

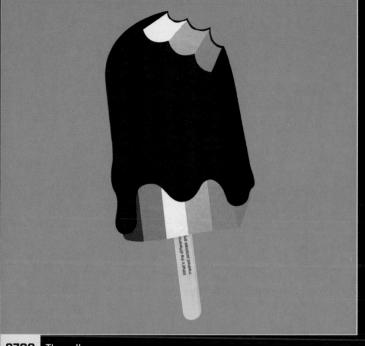

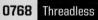

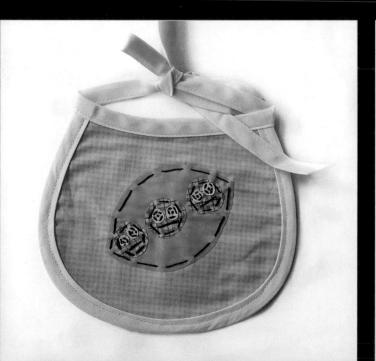

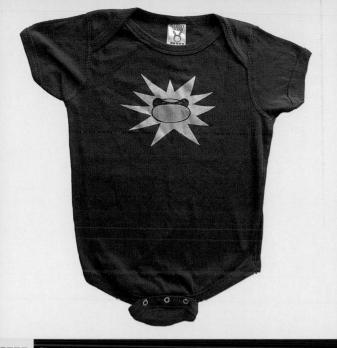

0769 Sheriff Peanut

0772 Alphabet Arm Design

0773 fuszion

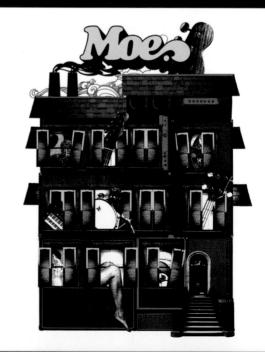

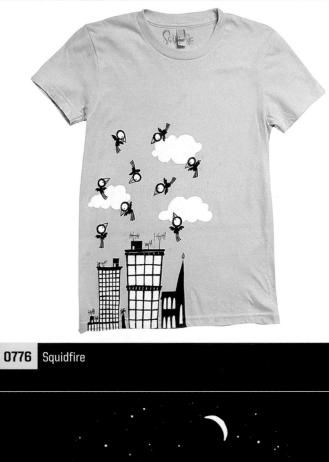

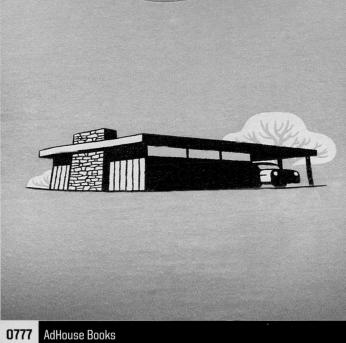

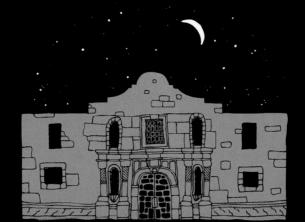

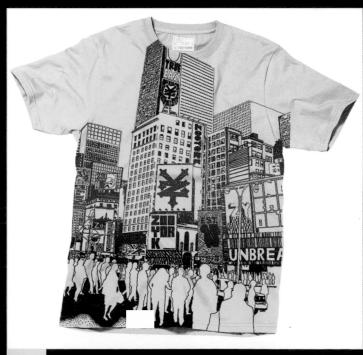

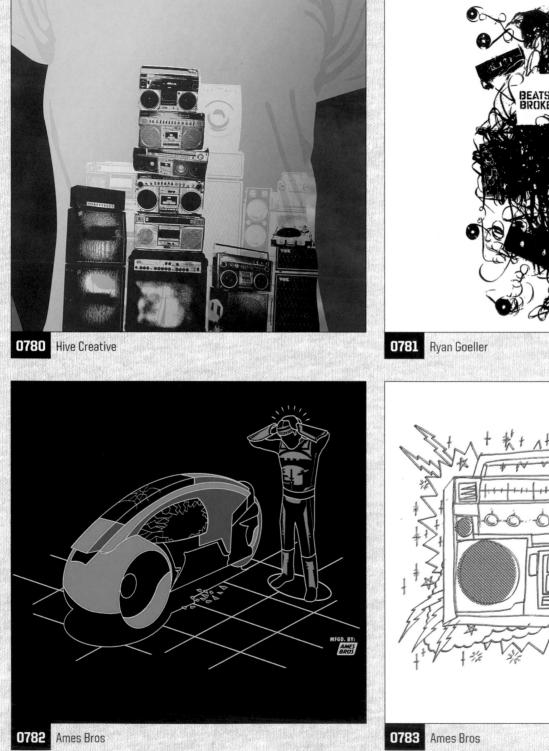

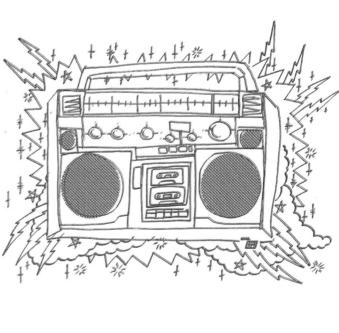

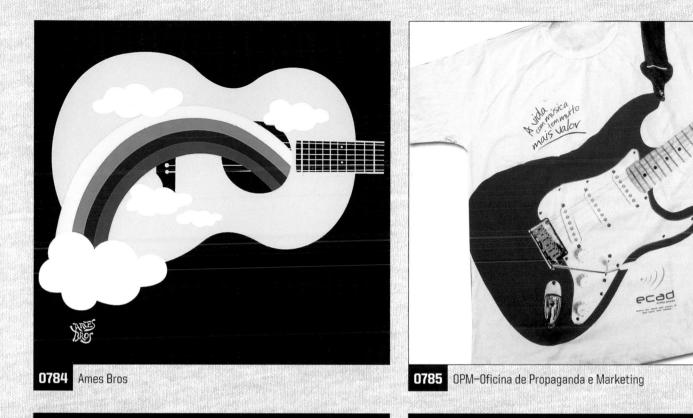

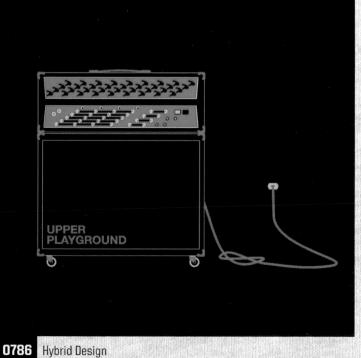

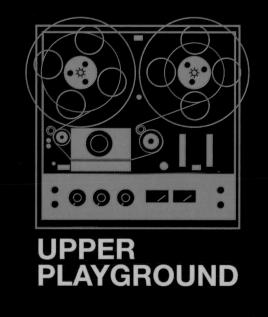

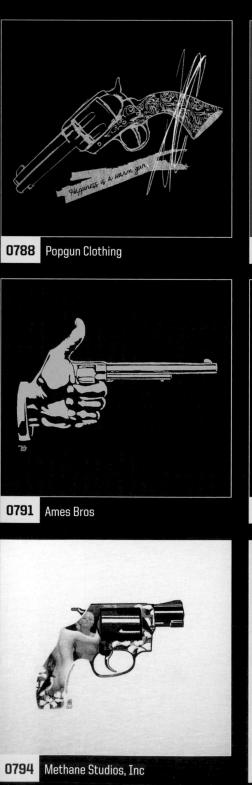

0792 Giant Robot

0795 Ames Bros

0789

Ames Bros

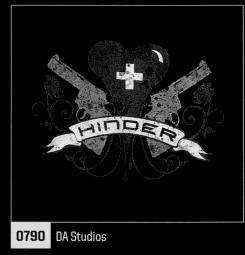

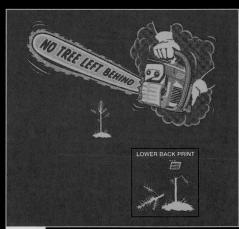

0793 Ames Bros

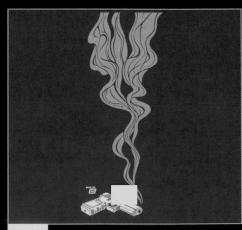

0796 Ames Bros

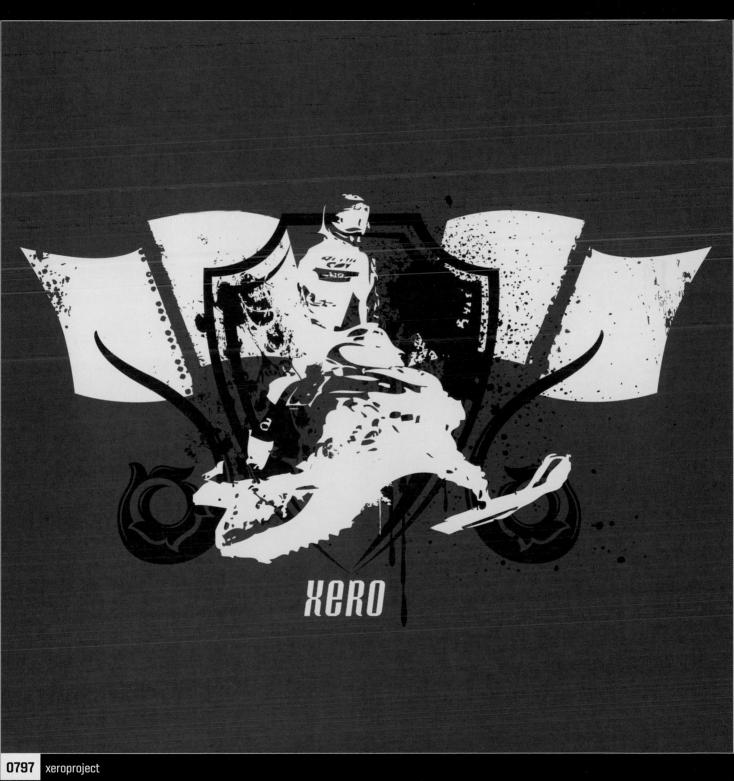

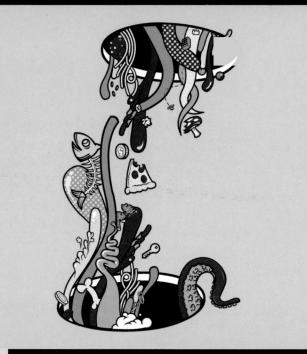

0798 Threadless

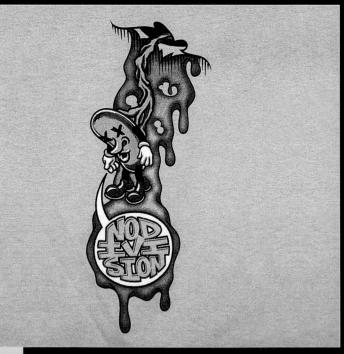

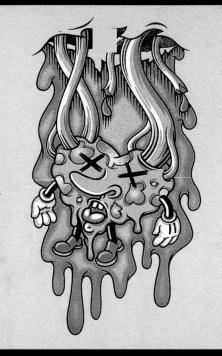

0799	Nodivision Design Syndicat
------	----------------------------

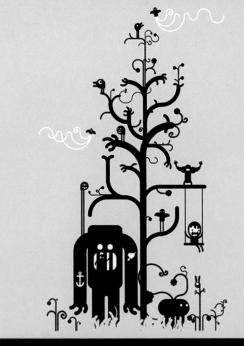

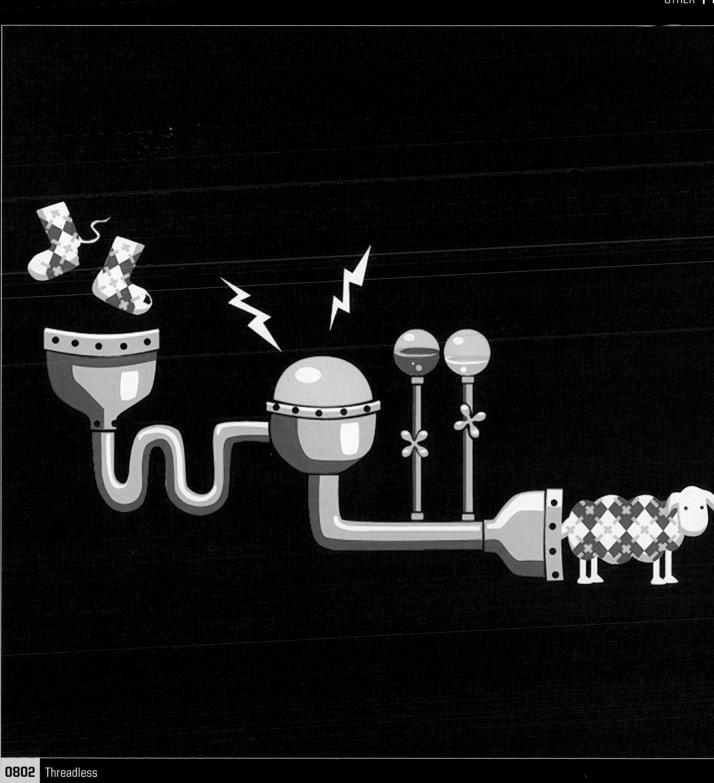

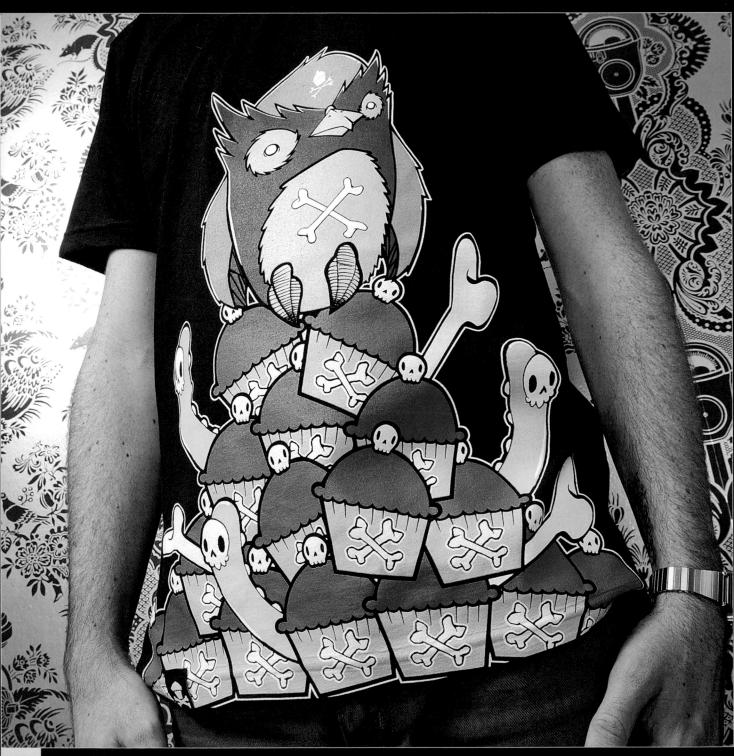

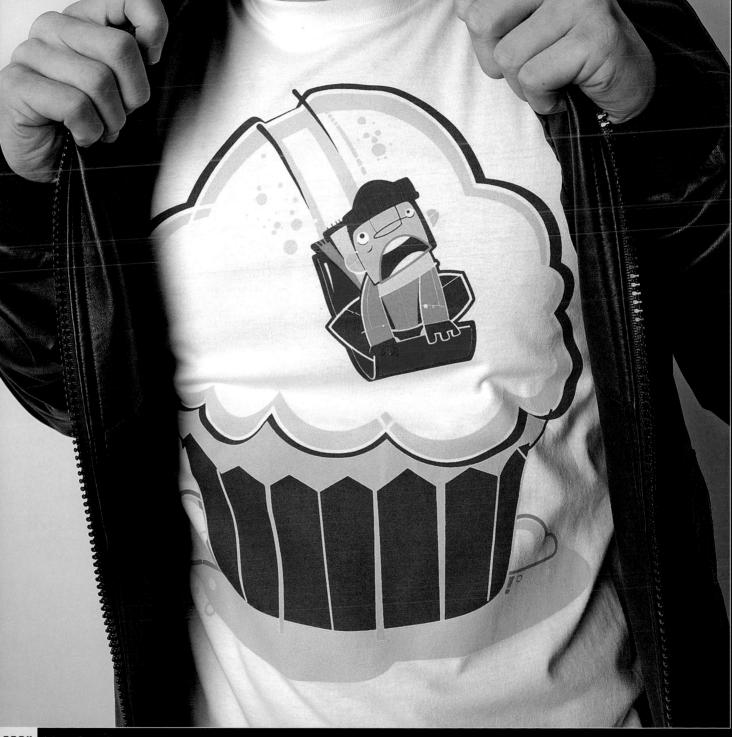

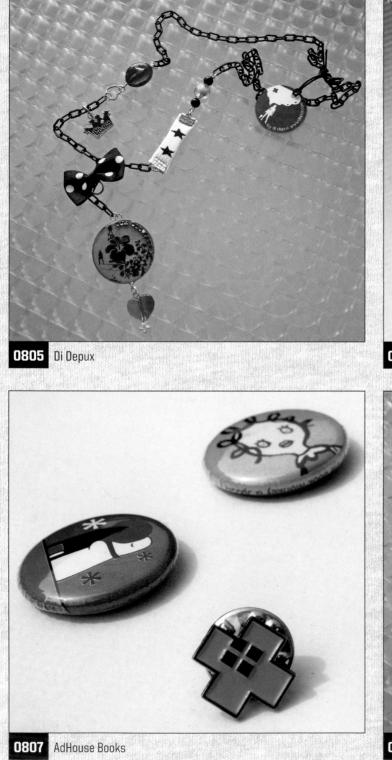

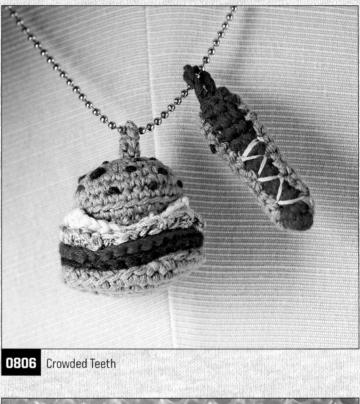

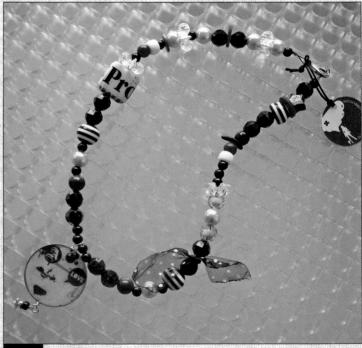

O8O8 Di Depux

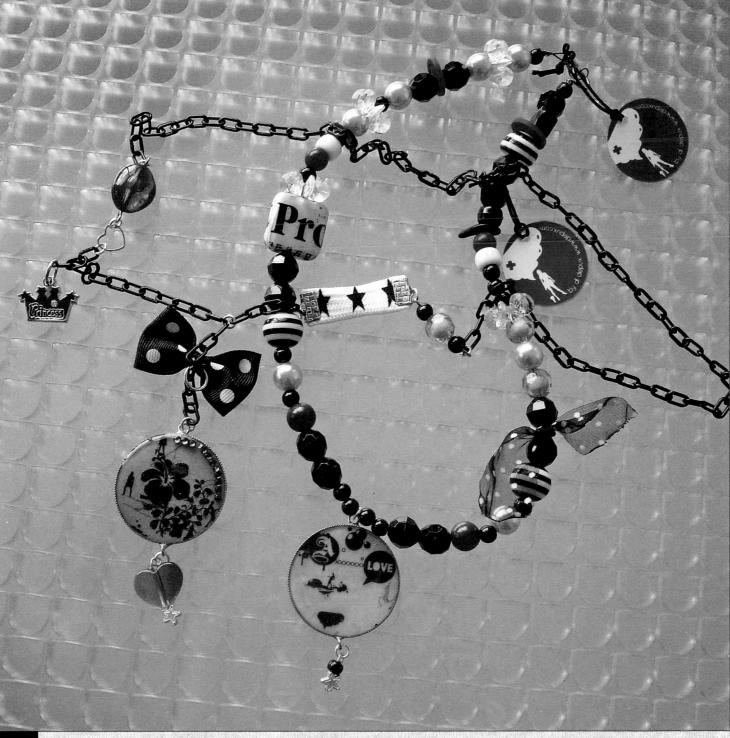

```
0811 Jonathan Wye, LLC
```

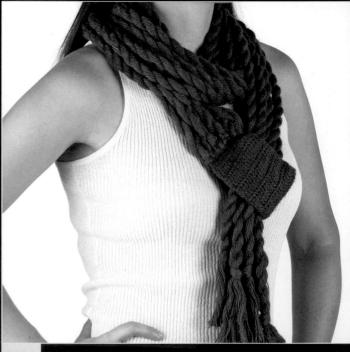

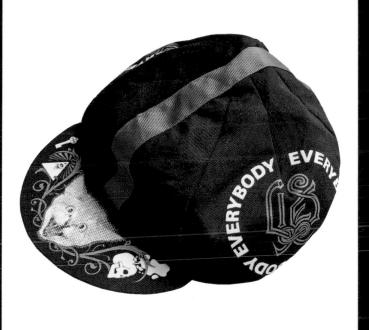

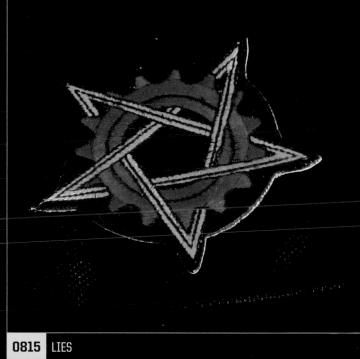

0814 LIES

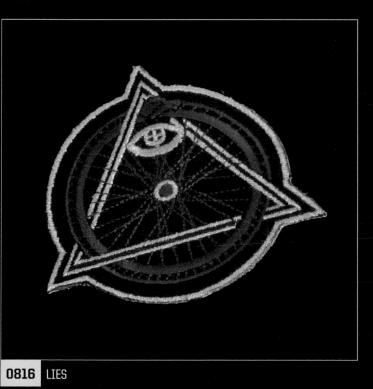

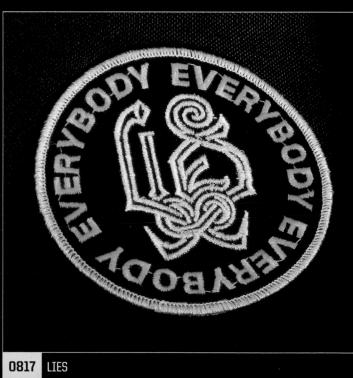

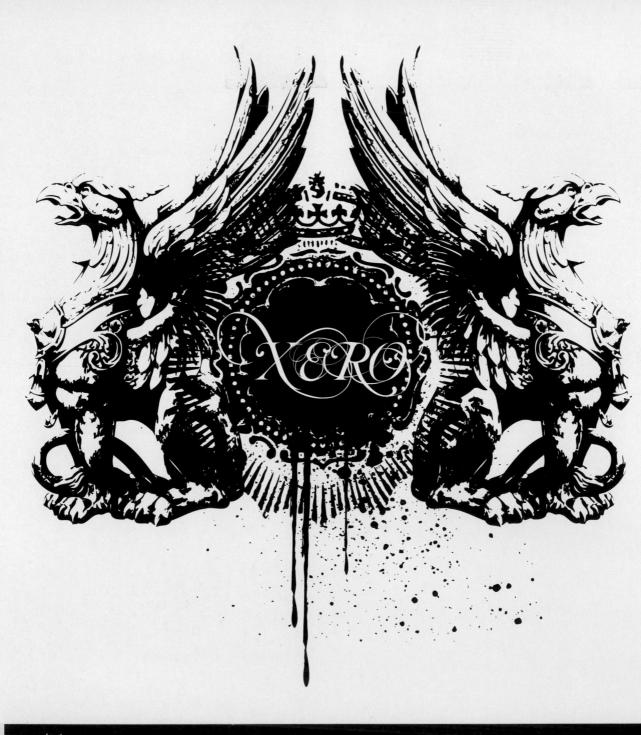

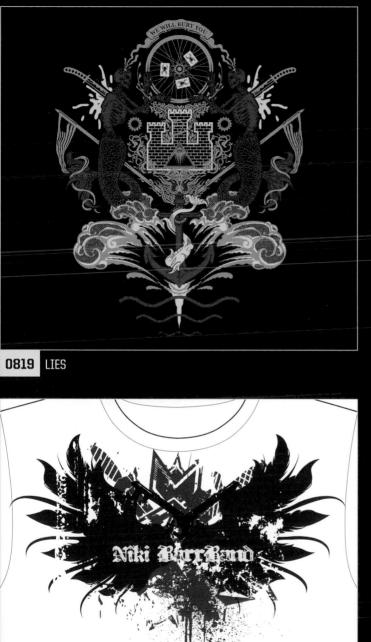

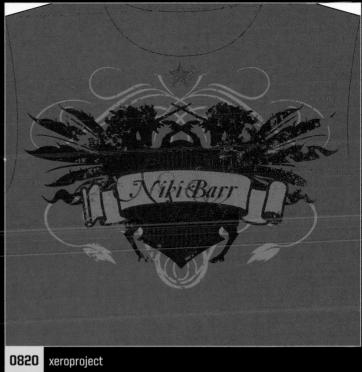

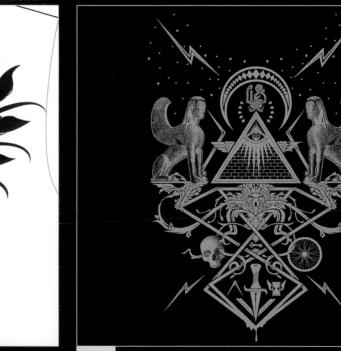

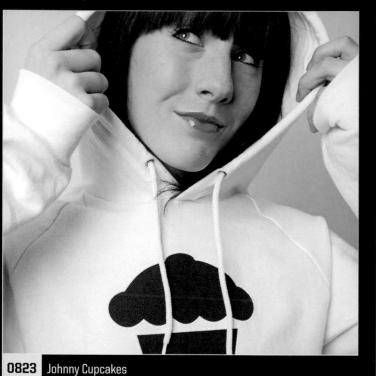

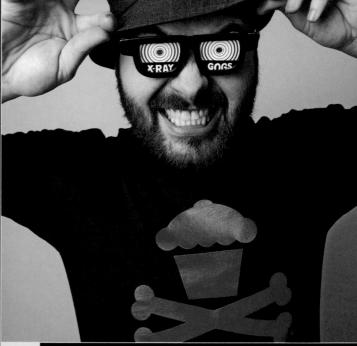

0824 Johnny Cupcakes

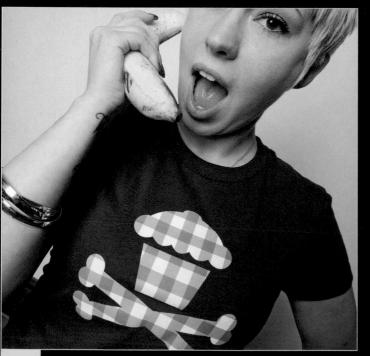

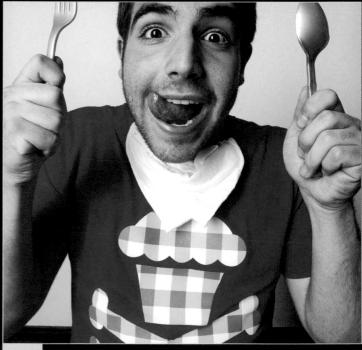

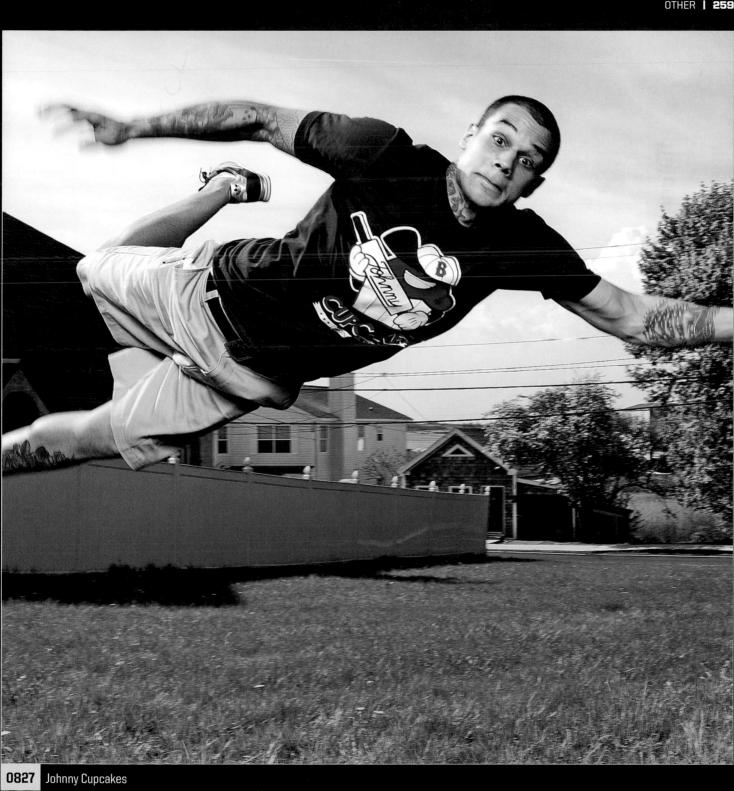

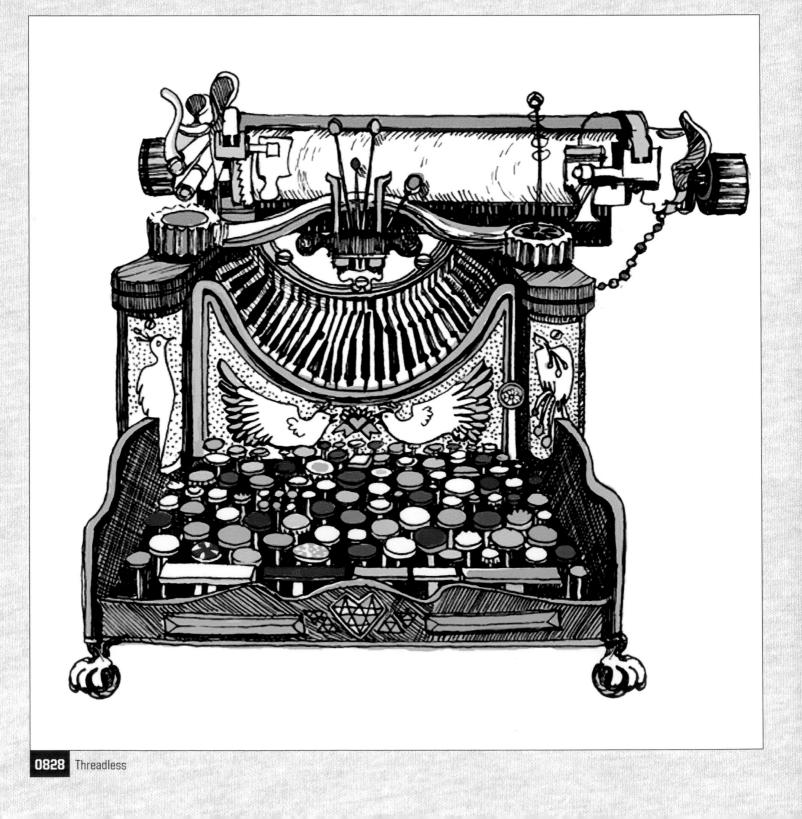

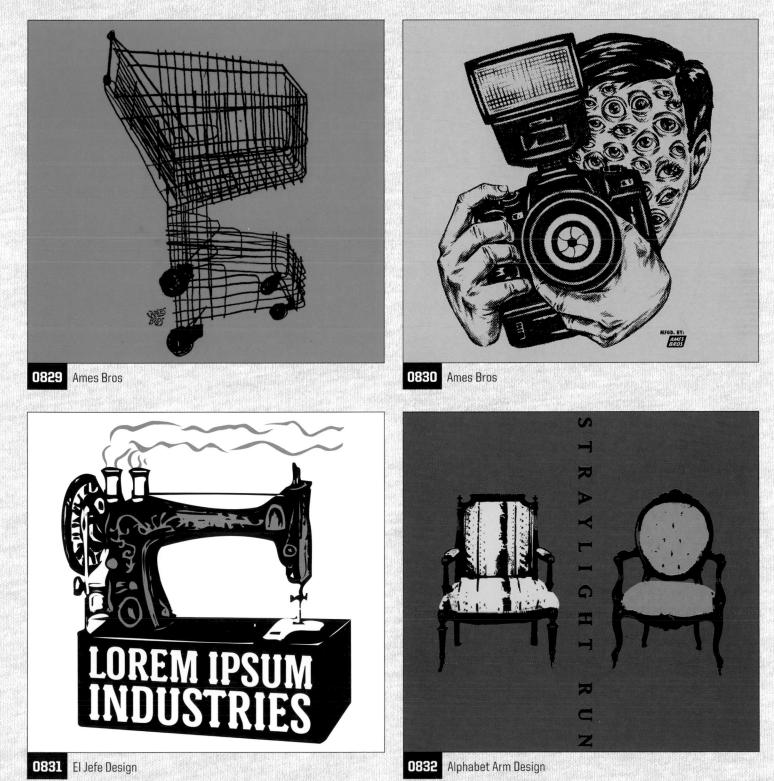

0839 Hybrid Design

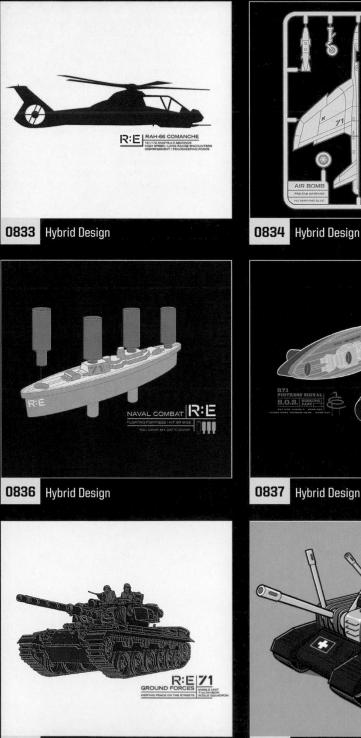

FIRECRACKER ARMY 0841 Hybrid Design

R:E

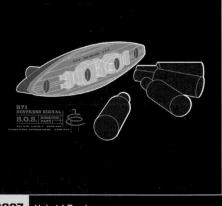

R:E

Hybrid Design

0840 Threadless

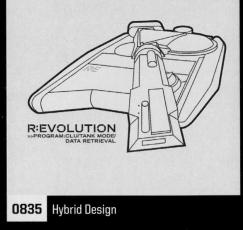

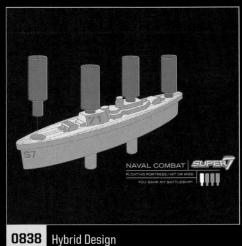

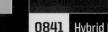

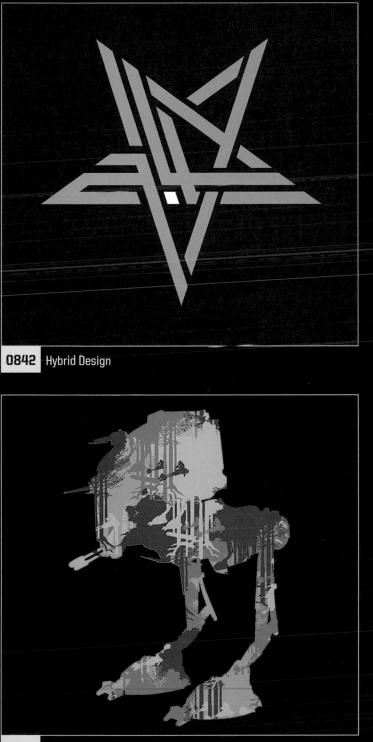

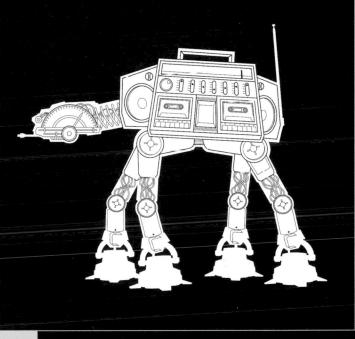

0843 Hybrid Design

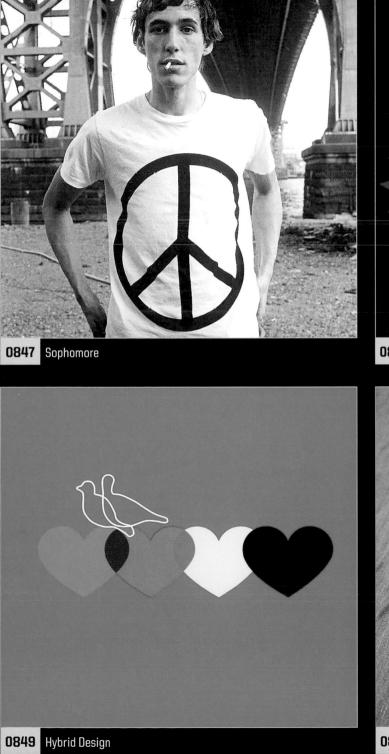

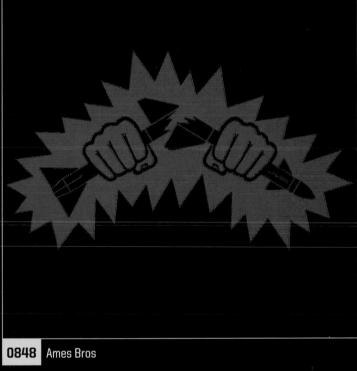

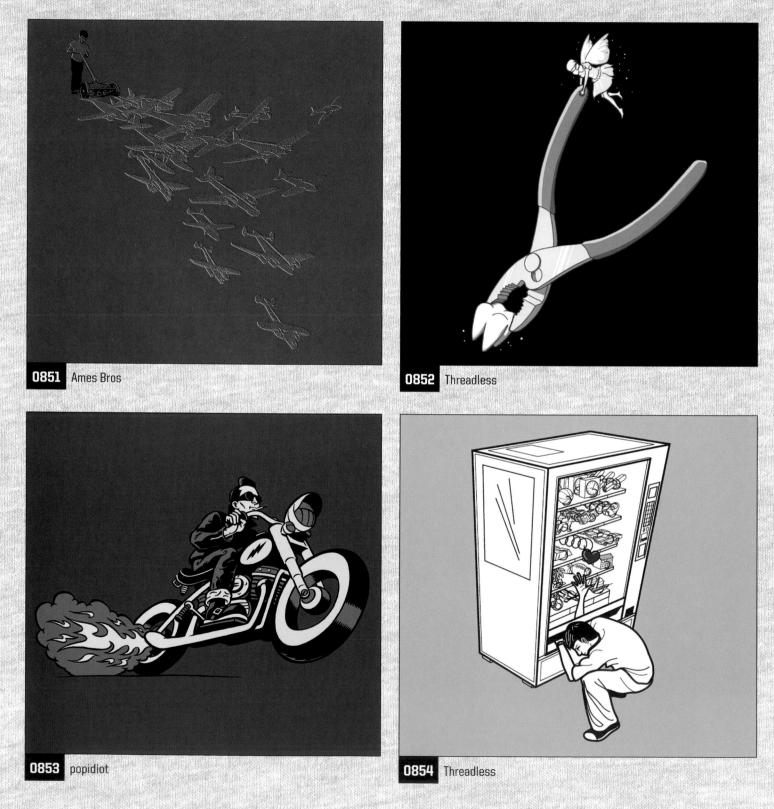

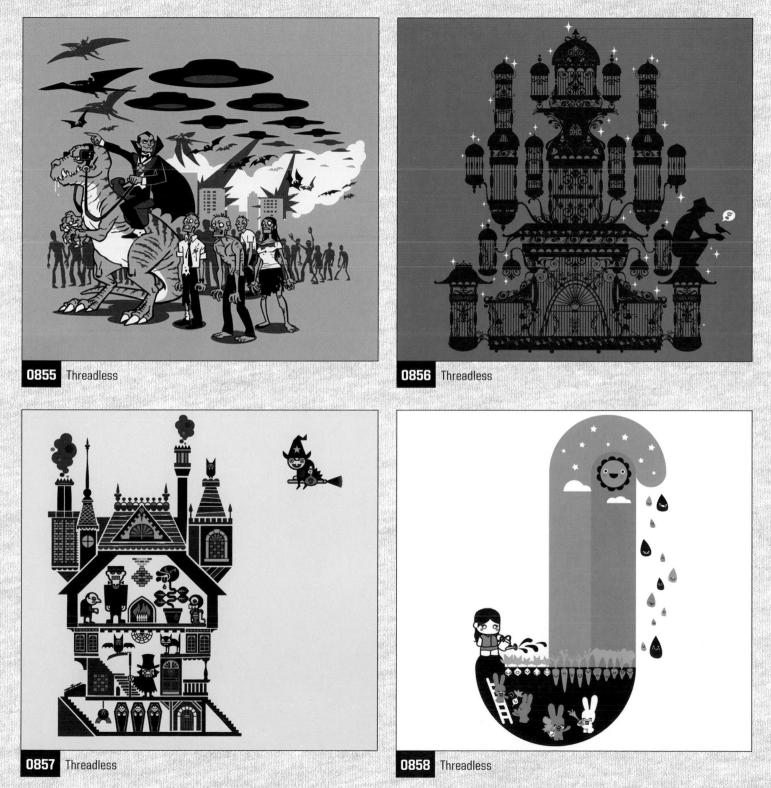

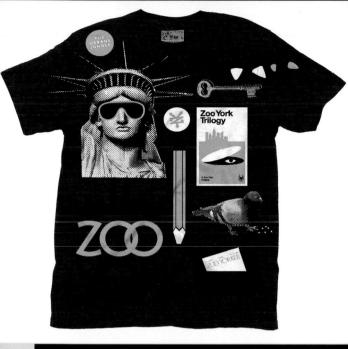

Marc Ecko Enterprises

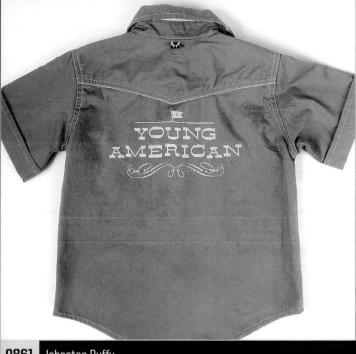

Johnston Duffy

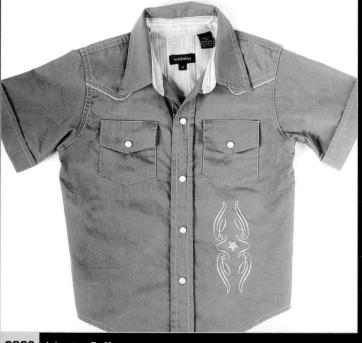

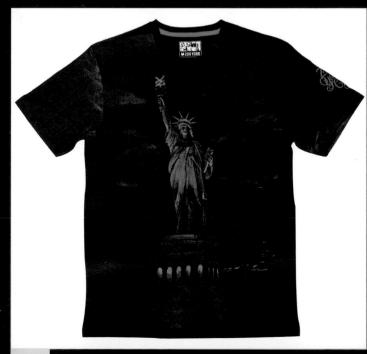

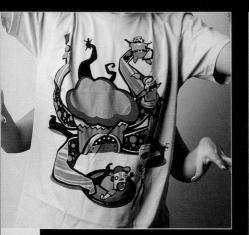

Johnny Cupcakes

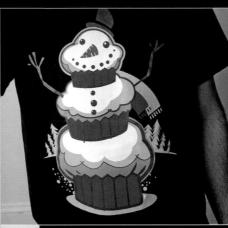

Johnny Cupcakes

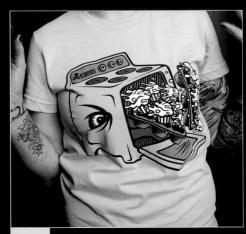

Johnny Cupcakes

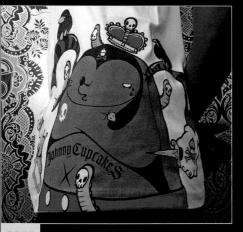

Johnny Cupcakes

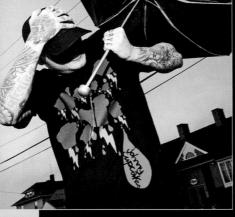

Johnny Cupcakes

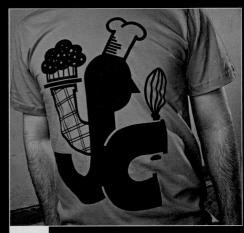

Johnny Cupcakes

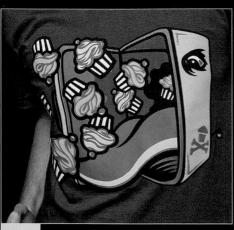

Johnny Cupcakes

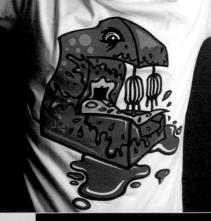

0871 Johnny Cupcakes

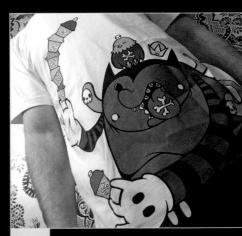

0872 Johnny Cupcakes

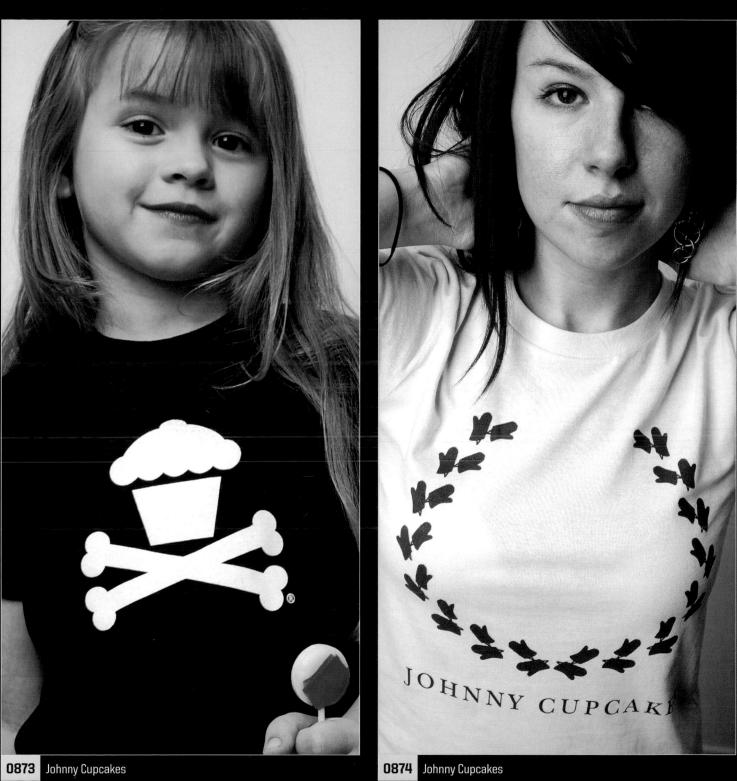

278 | 1000 GARMENT GRAPHICS

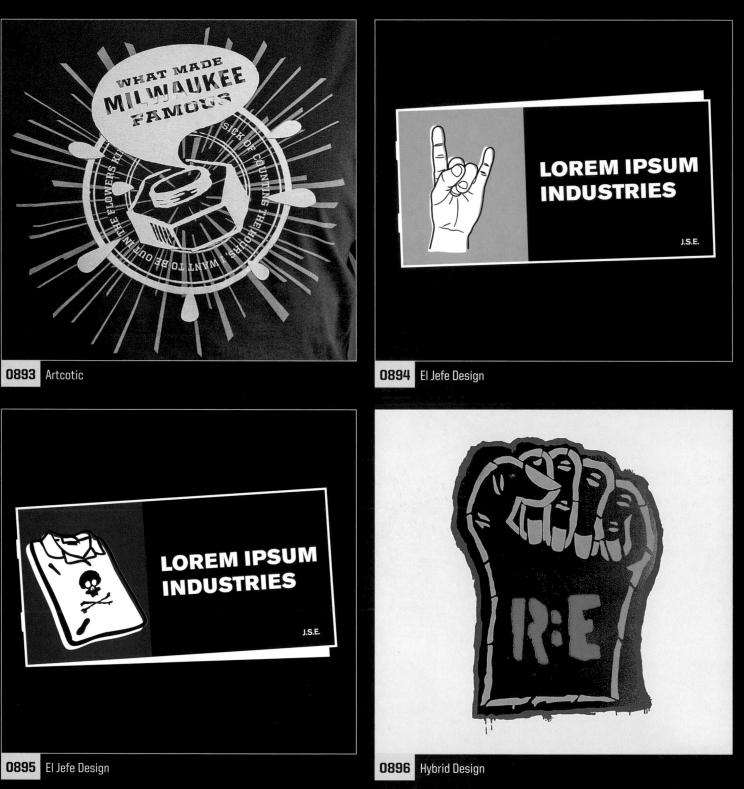

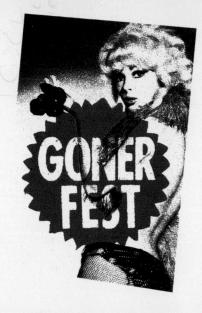

11 11m -DEATH CAB FOR CUTIE

0897 **Boss Construction**

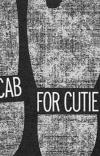

0898 Boss Construction

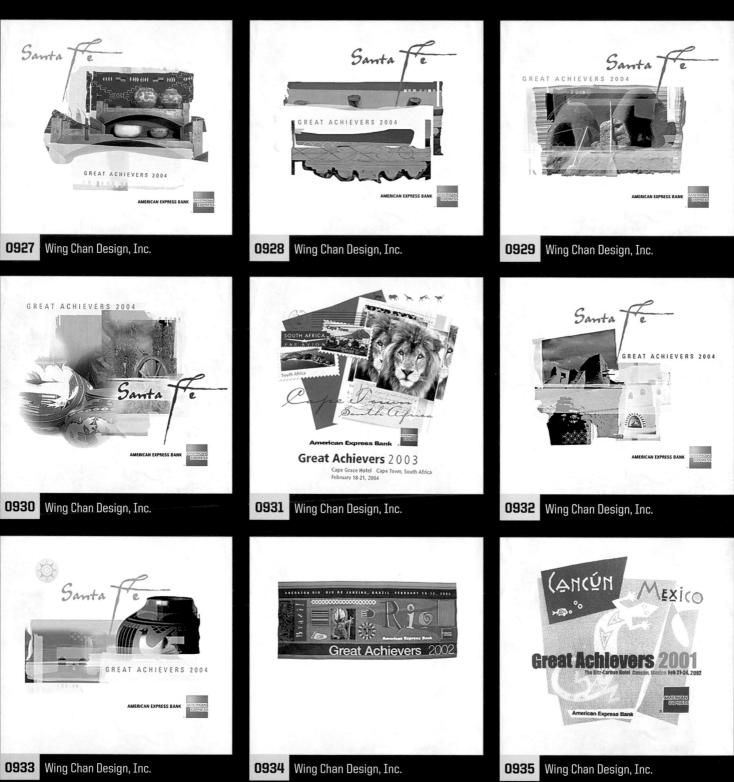

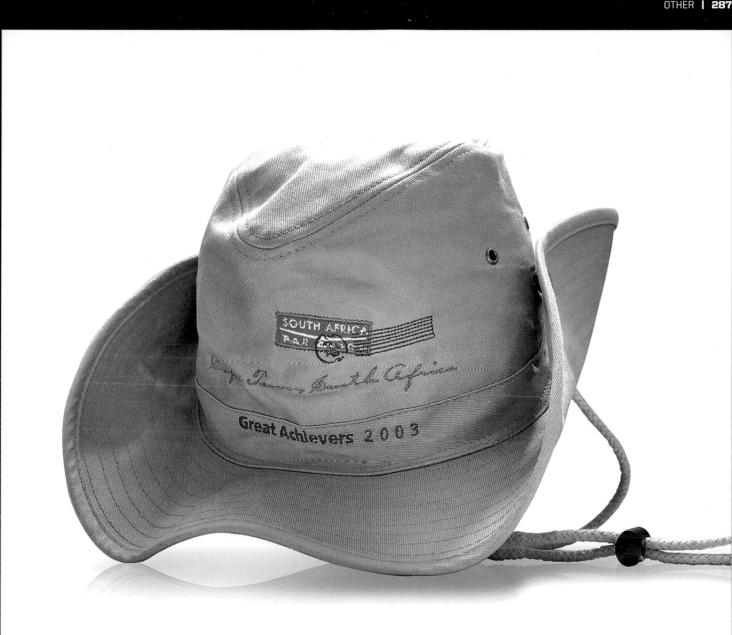

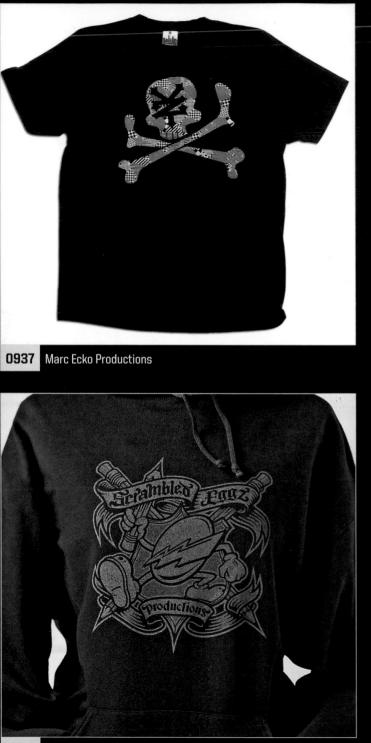

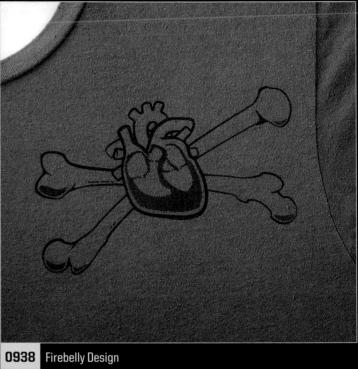

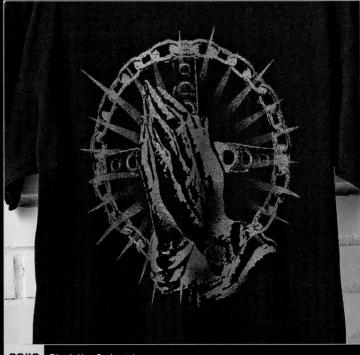

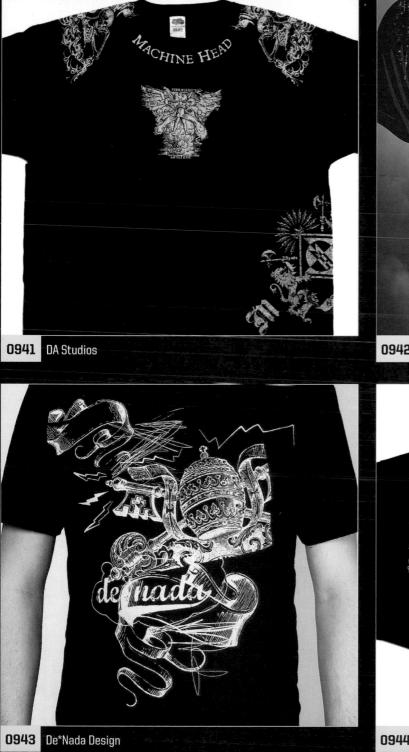

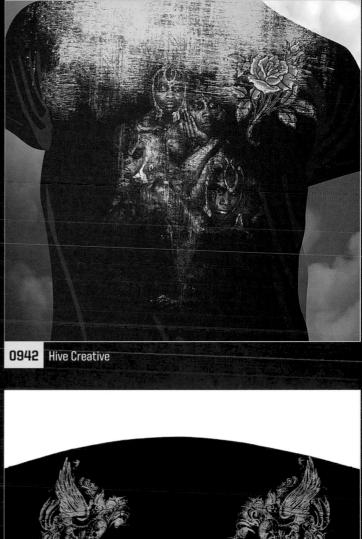

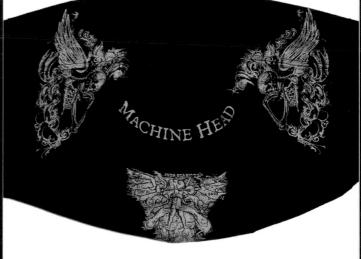

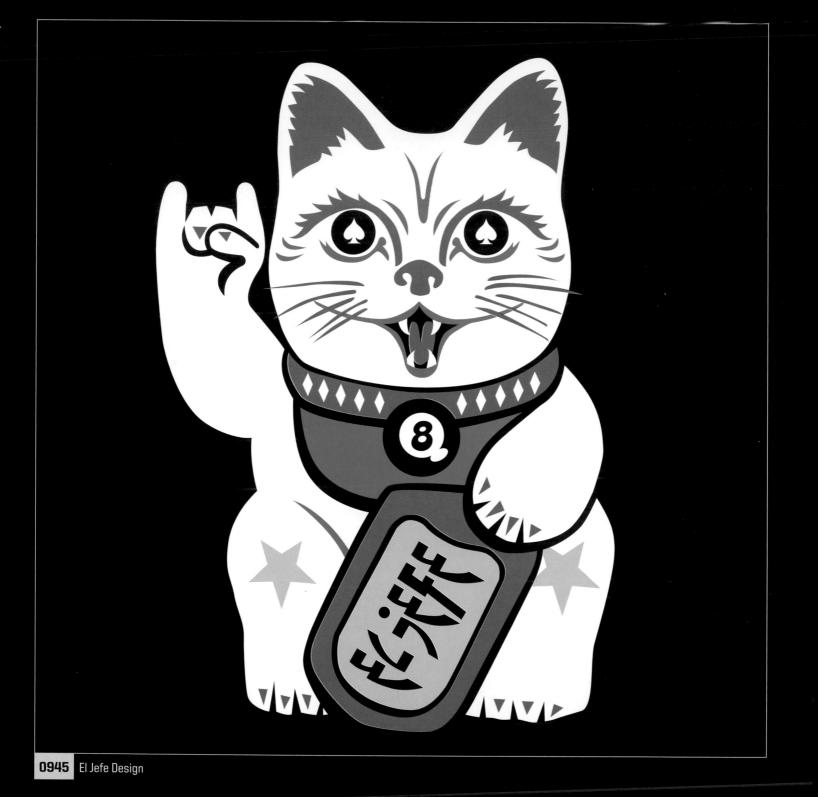

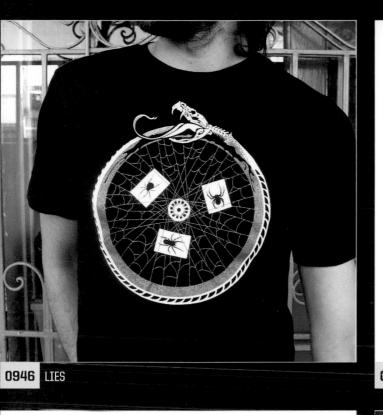

0947 Di Depux

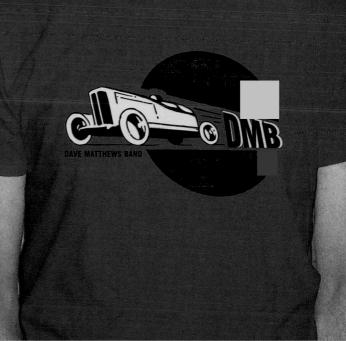

Deliver Now"

THE GLOBAL PROMI A WOMAN DIES GIVING BIRTH EVERY MINUTE OF EVE

A CHILD DIES EVERY THREE SECONDS OF EVE

HORE THAN **10,000,000** DEATHS PER YEAR. TOO HANY TO IGNORE.

I BELIEVE NO ONE SHOULHER LOSE A MOTHER, A W CHILD WHEN SIMPLE, PRNN. LIFE-SAVING SOLUTION I SUPPORT THE GLOBAL PROMISEINEINER NOW FOR WOMEN AND I

PAPPAS MACDONNELL 30 YEARS OLD AND STILL ADVENTUROUS

0952 Pappas MacDonnell, Inc.

0953 Johnston Duffy

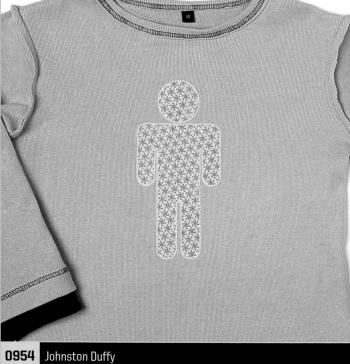

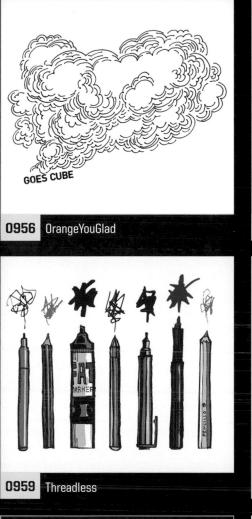

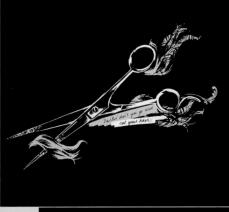

0957 Popgun Clothing

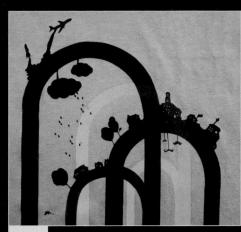

0958 Red Prairie Press

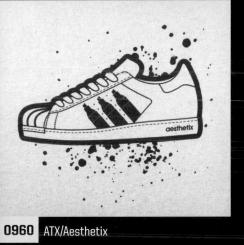

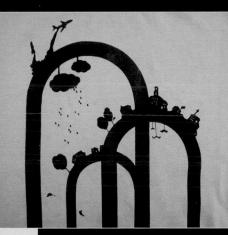

0961 Red Prairie Press

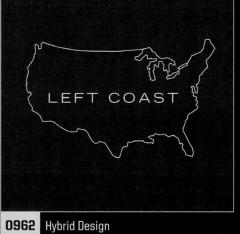

0963 Threadless

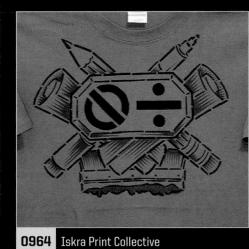

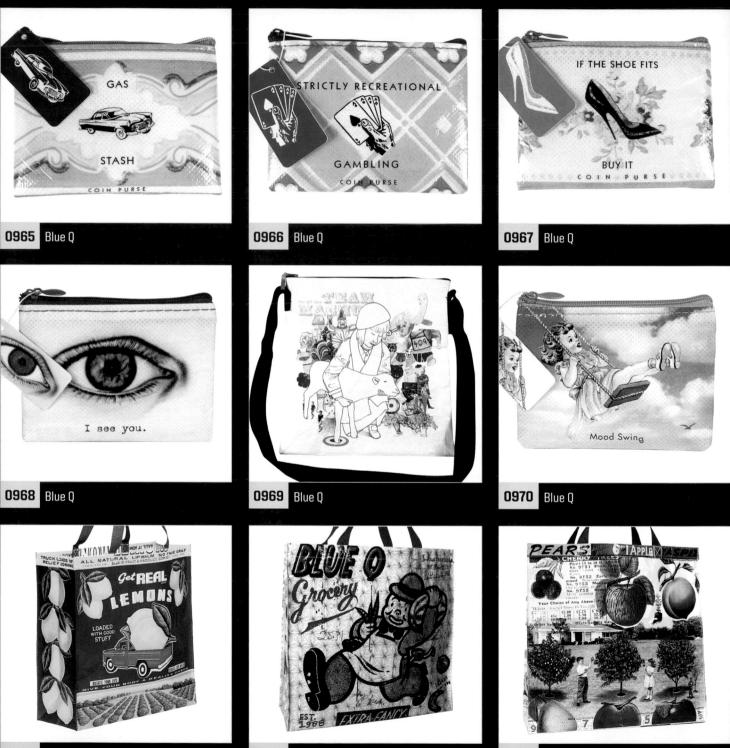

0971 Blue Q

0972 Blue Q

0973 Blue Q

other **| 297**

THE LAST CHEAP DRUG

COIN PURSE

0

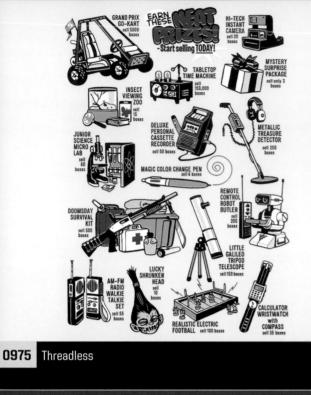

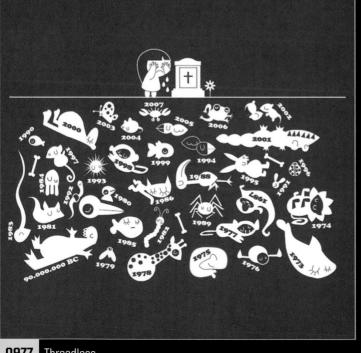

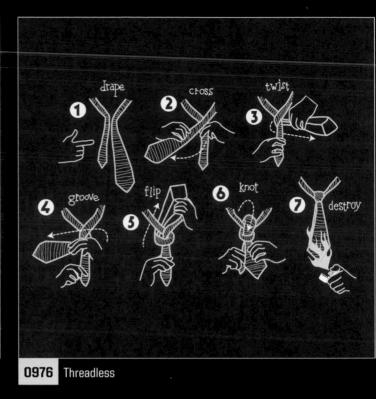

Super Terrific Animal Friendlies

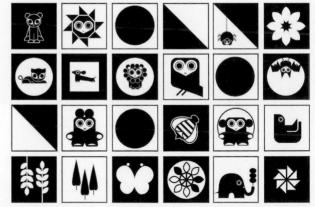

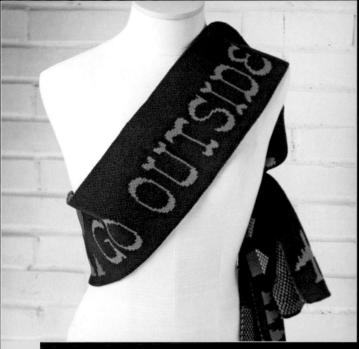

0979 Crowded Teeth

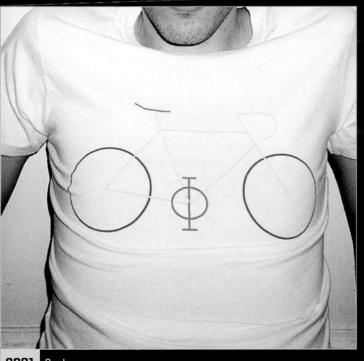

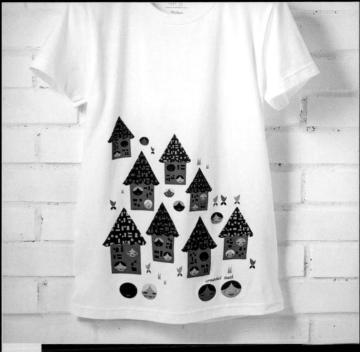

0980 Crowded Teeth

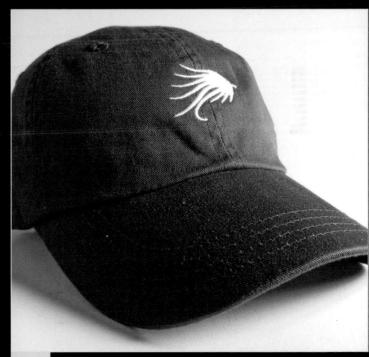

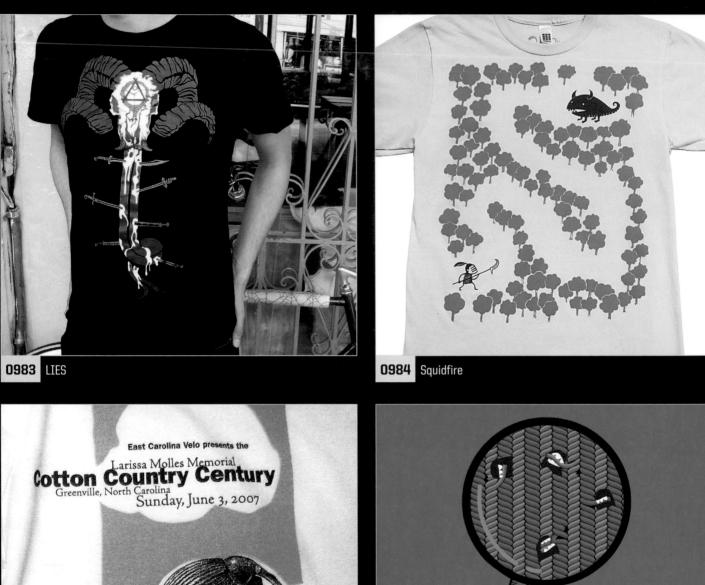

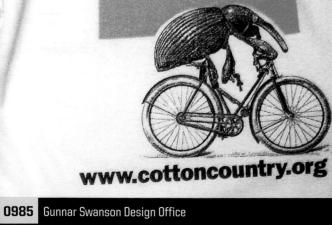

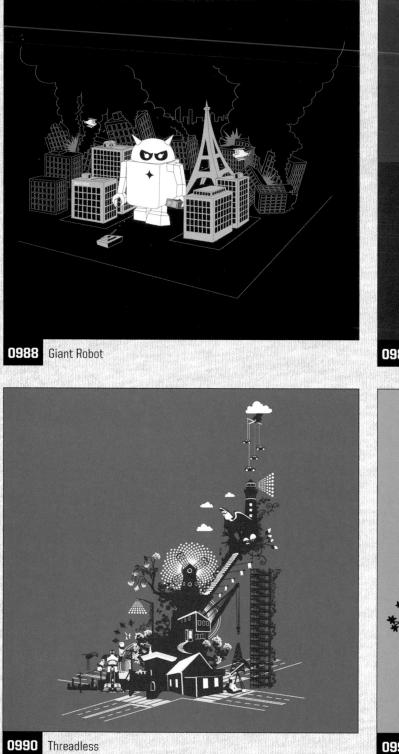

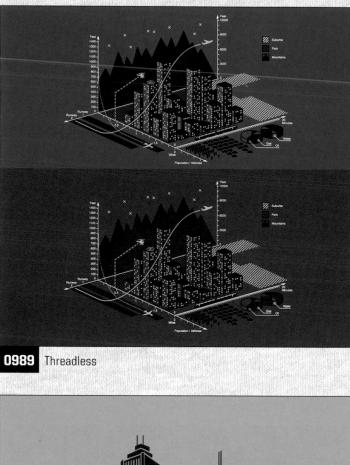

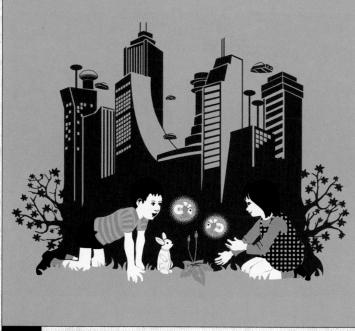

Willoughby Design Group

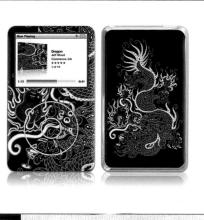

0993 The Faded Line Clothing Co.

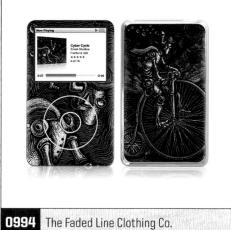

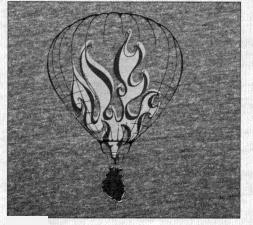

Firebelly Design

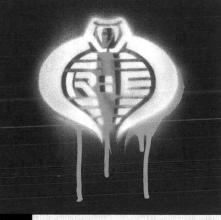

0996 Hybrid Design

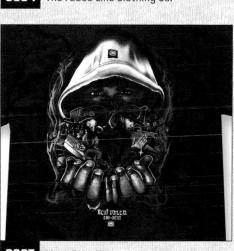

0997 Marc Ecko Enterprises

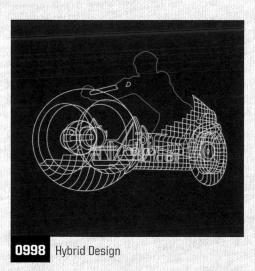

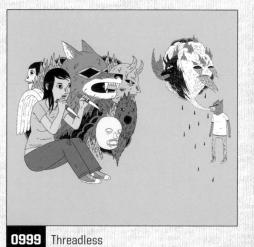

ADHOUSE BOOKS

Chris Pitzer 1224 Greycourt Ave. Richmond, VA 23227 USA 804.262.7045 pitzer@adhousebooks.com www.adhousebooks.com

0777, 0807, 0923 ART DIRECTOR: Chris Pitzer DESIGNER: Doug Fraser CLIENT: AdHouse Books

ADDICT LTD

Guy Stauber Unit 2, Muira Ind. Est. William St. Soton/Hants/SO14 5QH UK +44.23.8033.0344 guy@addict.co.uk www.addict.co.uk www.addict.co.uk

0056, 0596-0599, 0684, 0686-0687, 0689, 0758 ART DIRECTOR: Chris Carden-Jones DESIGNER: Chris Carden-Jones CLIENT: Addict

ALPHABET ARM DESIGN

Ryan Frease 500 Harrison Avenue Boston, MA 02118 USA 617.451.9990 info@alphabetarm.com www.alphabetarm.com

0071, 0073, 0076, 0133-0135, 0201, 0289, 0327, 0331, 0366, 0379-0382, 0400-0401, 0405-0409, 0417, 0440, 0531, 0539-0540, 0543, 0586, 0731, 0772, 0832, 0876-0877, 0888, 0949

ART DIRECTOR: Aaron Belyea DESIGNER: Aaron Belyea CLIENT: Alphabet Arm Design

AMES BROS

Barry Ament 2118 8th Ave., Suite 106 Seattle, WA 98121 USA 206.516.3020 barry@amesbros.com www.amesbros.com

0008-0009, 0012-0013, 0023-0024, 0027, 0036, 0038-0039, 0058, 0074-0075, 0085, 0087, 0090-0092, 0108, 0125-0126, 0147-0149, 0154, 0163, 0165, 0176-0177, 0179, 0188, 0190, 0193, 0197-0200, 0207-0208, 0223, 0226, 0230, 0254, 0267, 0288, 0317, 0326, 0335, 0337, 0344, 0359-0360, 0364-0365, 0371, 0412, 0414-0416, 0444-0447, 0449, 0458-0460, 0496, 0570-0572, 0670-0671, 0676, 0715, 0750, 0763-0764, 0782-0784, 0789, 0791, 0793, 0795-0796, 0829-0830, 0848, 0851, 0879, 0914-0915 **CLIENT**: Ames Bros Clothing

ARTCOTIC

Alex Lodermeier alex@artcotic.com www.artcotic.com 0007, 0010, 0093-0098, 0101, 0103, 0112, 0114, 0162, 0281, 0315, 0318, 0322, 0695-0696, 0889, 0893, 0905, 0921 **ART DIRECTOR:** Alex Lodermeier **CLIENT:** Artcotic

ATX/AESTHETIX

Jeremy Thompson P.O. Box 480093 Charlotte, NC 28269 USA 980.253.3410 jthompson@studioatx.com www.sup3rfr3sh.com 0431-0433, 0495, 0497, 0542, 0575, 0960 ART DIRECTOR: Jeremy Thompson DESIGNER: Jeremy Thompson CLIENT: SUP3RFR3SH

BANKER WESSEL

Jonas Banker Skeppsbrun 10 SE-111 30 Stockholm Sweden +46.8.224631 info@hankerwcssel.com www.bankerwessel.com

0218-0219, 0609-0613, 0648-0660, 0766 ART DIRECTORS: Ida Wessel, Jonas Banker DESIGNERS: Ida Wessel, Jonas Banker CLIENT: Banker Wessel

BLACK VAN INDUSTRIES

Arianne Gibbs 205 North San Mateo Ave. Ventura, CA 93004 USA 805.217.5367 agibbs@blackvanindustries.com www.blackvanindustries.com

0001-0005, 0049-0050, 0481-0484, 0940 ART DIRECTOR: Damon Robinson DESIGNER: Damon Robinson CLIENT: Black Van Industries

BLUE Q

103 Hawthorne Avenue Pittsfield, MA 01201 USA 800.321.7576 trevor@blueq.com www.blueq.com

0352, 0354, 0357, 0665, 0668 CREATIVE DIRECTOR: Blue Q DESIGNER: Haley Johnson Design

0062, 0518, 0521-0522, 0661 CREATIVE DIRECTOR: Blue Q DESIGNER: Fiona Hewitt

0063

CREATIVE DIRECTOR: Blue Q DESIGNER: Dragon

0065-0067 CREATIVE DIRECTOR: Blue Q DESIGNER: Misery Boutique

0242-0245, 0272-0277, 0462, 0467, 0738-0741, 0744-0745, 0965-0968, 0970, 0973-0974 CREATIVE DIRECTOR: Blue Q DESIGNER: Roy Fox

0247, 0270 CREATIVE DIRECTOR: Blue Q DESIGNER: Catalina Estrada

0248

CREATIVE DIRECTOR: Blue Q DESIGNER: Vinnie D'Angelo

0249, 0468

CREATIVE DIRECTOR: Blue Q DESIGNER: Modern Dog

0334

CREATIVE DIRECTOR: Blue Q **DESIGNER:** Michel Casarramona

0339

CREATIVE DIRECTOR: Blue Q DESIGNER: Saelee Oh

0463-0464, 0664, 0608 CREATIVE DIRECTOR: Blue Q DESIGNER: Louise Fili

0465

CREATIVE DIRECTOR: Blue Q **DESIGNER:** The Heads of State

0466, 0469, 0520, 0667 CREATIVE DIRECTOR: Blue Q DESIGNER: Ray Fenwick

0742

CREATIVE DIRECTOR: Blue Q **DESIGNER:** Charles Wilkin

0743

CREATIVE DIRECTOR: Blue Q DESIGNER: Niki Amano 0969 CREATIVE DIRECTOR: Blue Q DESIGNER: Team Macho

0972 CREATIVE DIRECTOR: Blue Q DESIGNER: Gary Taxali

BOSS CONSTRUCTION

Andrew Vastagh 3927 Moss Rose Drive Nashville, TN 37216 USA 615.975.1921 avastagh@gmail.com www.bossconstruct.com

0195

ART DIRECTOR: Andrew Vastagh DESIGNER: Andrew Vastagh CLIENT: Arma Secreta

0294, 0898-0899 ART DIRECTOR: Andrew Vastagh DESIGNER: Andrew Vastagh CLIENT: Death Cab for Cutie

0376

ART DIRECTOR: Andrew Vastagh DESIGNER: Andrew Vastagh CLIENT: Colour Revolt

0529, 0697

ART DIRECTOR: Andrew Vastagh DESIGNER: Andrew Vastagh CLIENT: Construct Clothing Co.

0730

ART DIRECTOR: Andrew Vastagh DESIGNER: Andrew Vastagh CLIENT: Morning State

0897

ART DIRECTOR: Andrew Vastagh DESIGNER: Andrew Vastagh CLIENT: Goner Records

0900

ART DIRECTOR: Andrew Vastagh DESIGNER: Andrew Vastagh CLIENT: Lausanne Collegiate School

CHRISTIANSEN : CREATIVE

Tricia Christiansen 511 2nd St., Suite 206 Hudson, WI 54016 USA 715.381.8480 tricia@christiansencreative.com www.christiansencreative.com 0132, 0441, 0490, 0512, 0515, 0524, 0537, 0544 **ART DIRECTOR:** Tricia Christiansen **DESIGNER:** Tricia Christiansen

CLIENT: The Purple Tree

CLAY MCINTOSH CREATIVE

Clay McIntosh 4530 S. Sheridan, Suite 202 Tulsa, OK 74145 USA 918.591.3070 clay@claymcintosh.com www.claymcintosh.com

0508, 0517

ART DIRECTOR: Clay McIntosh DESIGNER: Clay McIntosh CLIENT: OK Music Fanatics

CRAZE ONE. CLOTHING™/ NO COAST DESIGN™

Adam White 3800 North 22nd Street Lincoln, NE 68521 USA 402.570.4673 adam@crazeone.com www.crazeone.com 0349, 0373, 0498, 0901-0903 ART DIRECTOR: Adam White DESIGNER: Adam White CLIENT: Craze One. Clothing™

CROWDED TEETH

Michelle Romo 4416 Camero Ave. Los Angeles, CA 90027 USA 818.458.6558 michelle@crowdedteeth.com www.crowdedteeth.com 0268, 0324, 0361, 0806, 0850, 0909, 0979-0980 ART DIRECTOR: Michelle Romo DESIGNER: Michelle Romo CLIENT: Go Outside

DA STUDIOS

Deanna Alcorn 690 Fifth Street, #213 San Francisco, CA 94107 USA 415.348.8809 Deanna@dastudios.com www.dastudios.com 0040-0043, 0115, 0225, 0323, 0491-0492, 0622, 0790, 0941, 0944 **DESIGNER:** Deanna Alcorn **CLIENT:** Bravado International Group

DE*NADA DESIGN

Virginia Arrisueño 1549 3rd St. NW Washington, D.C. 20001 USA 202.361.6507 info@denadadesign.com www.denadadesign.com 0047, 0172, 0523, 0735, 0810, 0813, 0906, 0943

DEVETKA

Tanja Devetak Gornji TRG 1 Ljubljana 1000 Sluvenia 00.386.1.5195072 tanja.devetak@siol.net

0755-0756 ART DIRECTOR: Tanja Devetak DESIGNER: Tanja Devetak CLIENT: Devetka

DI DEPUX

Despina Bournele Meg. Alexandrou 18 Dafni-Athens 172 35 Greece +30.210.9755850 info@depux.com www.depux.com 0025, 0299, 0805, 0808-0809, 0947-0948

ART DIRECTOR: Despina Bournele DESIGNER: Despina Bournele CLIENT: Di Dupux-Despina Bournele

EBD

Lisa Wright 2500 Walnut St., #401 Denver, C0 80205 USA 303.830.8323 lisa@ebd.com www.ebd.com 0342, 0486, 0514

ART DIRECTOR: Ellen Bruss DESIGNER: Jorge Lamora CLIENT: The Lab of Art + Ideas

EL JEFE DESIGN

Jeffrey Everett 7623 Moccasin Lane Derwood, MD 20855 USA 301.461.6142 info@eljefedesign.com www.eljefedesign.com 0079, 0151-0153, 0279, 0532, 0534, 0569, 0583-0584, 0831, 0894-0895, 0945

ART DIRECTOR: Jeffrey Everett **CLIENT:** El Jefe Design

FIREBELLY DESIGN

Dawn Hancock 2701 W. Thomas, 2nd Fl Chicago, IL 60622 USA 773.489.3200 info@firebellydesign.com www.firebellydesign.com 0348, 0410, 0918, 0938, 0995

ART DIRECTOR: Dawn Hancock DESIGNER: Travis Barteaux CLIENT: Firebelly Design

FULLBLASTINC.COM

N. Todd Skiles 107 SE Washington St., #255 Portland, OR 97214 USA 503.227.2002 design@fullblastinc.com www.fullblastinc.com

0212-0213 ART DIRECTOR: N. Todd Skiles DESIGNER: N. Todd Skiles ILLUSTRATOR: Eric Sappington CLIENT: The Country Cat Restaurant + Bar

FUSZION

John Foster 901 Prince Street Alexandria, VA 22314 USA 703.548.8080 john@fuszion.com www.fuszion.com 0155

DESIGNER: John Foster **CLIENT:** John Guilt

0202 CREATIVE DIRECTOR: John Foster DESIGNER: The Carribean

0574 CREATIVE DIRECTOR: John Foster DESIGNER: Beauty Pill

0577

CREATIVE DIRECTOR: John Foster **DESIGNER:** Fulton Lights

0773

CREATIVE DIRECTOR: John Foster **DESIGNER:** Roofwalkers

GEYRHALTER DESIGN

Abbey Park 2525 Main St., Suite 205 Santa Monica, CA 90405 USA 310.392.7615 abigail@geyrhalter.com www.geyrhalter.com

0284, 0454

ART DIRECTOR: Fabian Geyrhalter DESIGNER: Fabian Geyrhalter CLIENT: Geyrhalter Design

GIANT ROBOT

Eric Nakamura P.O. Box 642053 Los Angeles, CA 90064 USA

310.479.7311 eric@giantrobot.com www.giantrobot.com

0077, 0189, 0566-0567, 0792, 0988 ART DIRECTOR: Eric Nakamura DESIGNER: Eric Nakamura CLIENT: Giant Robot

GIORGIO DAVANZO DESIGN

Giorgio Davanzo 501 Roy Street #209 Seatle, WA 00109 USA 206.328.5031 glorgio@davanzodesign.com www.davanzodesign.com

0411 DESIGNER: Giorgio Davanzo CLIENT: Giorgio Davanzo Design

GOOD NIGHT TV

Antonio Garcia 1400 W. Devon #322 Chicago, IL 60660 USA 312.238.8673 info@goodnighttv.com www.goodnighttv.com 0054, 0175, 0231, 0285, 0353, 0434-0437, 0636, 0734, 0891, 0904, 0916 **ART DIRECTOR:** The Team **DIRECTOR:** Good Night TV

GO WELSH

Craig Welsh 987 Mill Mar Road Lancaster, PA 17601 USA 717.898.9000 info@gowelsh.com www.gowelsh.com 0200, 0217, 0232-U235, 0238-0241, 0438 ART DIRECTOR: Craig Welsh DESIGNER: Mike Gilbert CLIENT: Blurt

GUNNAR SWANSON DESIGN OFFICE

Gunnar Swanson 1901 East 6th Street Greenville, NC 27858 USA 252.258.7006 gunnar@gunnarswanson.com www.gunnarswanson.com 0985 ART DIRECTOR: Gunnar Swanson DESIGNER: Gunnar Swanson CLIENT: EC Velo club

HERO DESIGN STUDIO

Ryan Besch 93 Allen Street Buffalo, NY 1/12O2 USA 716.858.HERO hero.design@mac.com www.heroandsound.com 0278, 0303-0304, 0320, 0332, 0403, 0775, 0890 ART DIRECTOR: Mark Brickey DESIGNER: Ryan Besch CLIENT: ear X-tacy Records

HIVE CREATIVE

Cade Bond 20A MacQuarle St. Pramran/Victoria/ 3181 Australia +613.9510.9744 cade@hive.com.au www.hive.com.au 0026, 0051, 0587-0590, 0780, 0942 ART DIRECTOR: Wayne Murphy DESIGNERS: Claire Dekker, Anne Hain, Craig Stapely CLIENT: Politix

HYBRID DESIGN

Suzi Nuti 540 Delancey St., #303 San Francisco, CA 94107 USA 415.227.4700 suzi@hybrid-design.com www.hybrid-design.com

0011, 0014-0019, 0022, 0080, 0104, 0150, 0178, 0183, 0185, 0187, 0192, 0252-0253, 0255, 0258, 0260-0263, 0310-0311, 0448, 0451, 0493-0494, 0562-0565, 0568, 0619, 0751-0752, 0762, 0765, 0786-0787, 0833-0839, 0841-0845, 0849, 0880-0887, 0896, 0926, 0962, 0978, 0996, 0998 ART DIRECTOR: Dora Drimalas DESIGNER: Dora Drimalas CLIENT: Upper Playground

INNOVATIVE INTERFACES

Dean Hunsaker 5850 Shellmound Way Emeryville, CA 94608

USA

510.655.6200 dhunsaker@iii.com www.iii.com

0402 ART DIRECTOR: Gene Shimshock DESIGNER: Dean Hunsaker

CLIENT: IUG (Innovative User Group) members

ISKRA PRINT COLLECTIVE

Matthew Stevens 47 Maple St. Burlington, VT 05401 USA 802.864.5884 hello@iskraprint.com www.iskraprint.com 0048, 0136

ART DIRECTOR: Michael Jager DESIGNER: Allison Ross

0099, 0166 ART DIRECTOR: Michael Jager DESIGNER: Tyler Stout

0196, 0485 ART DIRECTOR: Michael Jager DESIGNERS: Leo Listi, Matthew Stevens 0487 DESIGNER: Michael Jager

0488

ART DIRECTOR: Michael Jager DESIGNER: Steve Cousins

0489, 0536, 0698, 0964 ART DIRECTOR: Michael Jager

0513, 0694

ART DIRECTOR: Michael Jager DESIGNER: Malcolm Buick

0912

ART DIRECTOR: Michael Jager DESIGNER: Matthew Stevens

JOHNNY CUPCAKES

Johnny Earle 279 Newbury Street Boston, MA 02116 USA 866.606.CAKE info@johnnycupcakes.com www.johnnycupcakes.com

0045-0046, 0137-0142, 0167, 0338, 0345, 0439, 0547, 0635, 0736-0737, 0803-0804, 0823-0827, 0864-0875

JOHNSTON DUFFY

Martin Duffy 803 S. 4th Street, First Floor Philadelphia, PA 19147 USA

215.389.2888 martin@johnstonduffy.com www.johnstonduffy.com 0290-0291, 0525-0527, 0535, 0640, 0643, 0706, 0861-0862, 0953-0954 **ART DIRECTOR:** Martin Duffy

DESIGNERS: Andy Evans, Martin Duffy **CLIENT:** Wonderboy Clothing

JONATHON WYE, LLC

Jonathon Wye 723 Independence Ave. SE Washington, D.C. 20003 USA 202.368.4996 jonwye@jonwye.com www.jonwye.com 0052, 0229, 0173, 0699-0706, 0811 **DESIGNER:** Jonathan Wye

KIMIYO NAKATSUI

Kimiyo Natatsui 31-34 30th St. Long Island City, NY 11106 USA 646.867.5171 kimiyo.design@gmail.com 0533, 0638-0639, 0859

KRISTINA CRITCHLOW

Kristina Critchlow 84 Forsyth St., #3R New York, NY 10002 USA 203.219.5138 kcritchlow@kristonica.com www.kristonica.com 0591-0595, 0637 **DESIGNER:** Kristina Critchlow

LEIA BELL POSTERS & FINE ART

Leia Bell 221 East Broardway Salt Lake City, UT 84101 USA 801.634.7724 goprintgo@yahoo.com www.leiabell.com 0250, 0298, 0340

DESIGNER: Leia Bell **CLIENT:** leiabell.com promo

LIES

Caleb Kozlowski 65 Hill St., Suite D San Francisco, CA 94110 USA 415.694.9461 info@everybodylies.net www.everybodylies.net

0030, 0814-0817, 0819, 0822, 0946, 0983 ART DIRECTOR: Caleb Kozlowski DESIGNER: Caleb Kozlowski CLIENT: LIES

LOYALTY + BLOOD

David Denosowicz, Maggie Doyle 209 Jackson Street, #1 Brooklyn, NY 11211 USA 718.809.1732 Ioyaltyandblood@gmail.com www.loyaltyandblood.com

0122, 0746, 0917 **DESIGNER:** Loyalty + Blood

LUCKY BUNNY VISUAL COMMUNICATIONS

Rich DeSimone 84 Fountain Street, Suite 306 Pawtucket, RI 02860 USA info@luckybunny.net www.luckybunny.net 0214-0215, 0287, 0333, 0530 **ART DIRECTOR:** Rich DeSimon

MARC ECKO ENTERPRISES

David Smith 40 West 23rd Street New York, NY 10010 USA 917.262.1237 davids@ecko.com

0106, 0113, 0174, 0295, 0392-0399, 0418-0430, 0470-0479, 0503-0507, 600-0608, 0632-0633, 0645-0647, 0681-0683, 0685, 0688, 0690-0693, 0717-0729, 0757, 0759-0761, 0779, 0860, 0863, 0937, 0997 **DESIGNER:** Marc Ecko Enterprises

METHANE STUDIOS, INC.

Mark McDevitt 158 Tuckahoe Path Sharpsburg, GA 30277 USA 404.226.6744 mark@methanestudios.com www.methanestudios.com

0034-0035, 0072, 0143, 0157, 0186, 0228, 0346, 0367, 0413, 0794, 0911 **ART DIRECTORS:** Robert Lee, Mark McDevitt **DESIGNERS:** Robert Lee, Mark McDevitt **CLIENT:** Methane

NASSAR DESIGN

Nelida Nassar 11 Park Street Brookline, MA 02446 USA 617.264.2862 n.nassar@verizon.net www.nassardesign.com

0573, 0578 ART DIRECTOR: Nelida Nassar DESIGNER: Nelida Nassar CLIENT: TSA The Stubbins Associates

NATEDUVAL.COM

Nate Duval 93 S. Maple St., Apt. 7 Westfield, MA 01085 USA 315.263.6770 nate@nateduval.com www.nateduval.com 0120-0121, 0123, 0156, 0328, 0355, 0370

DESIGNER: Nate Duval CLIENT: Nate Duval

NODIVISION DESIGN SYNDICATE

J.P. Flexner 210 Victoria Drive Montgomeryville, PA 18936 USA 410.251.4869 stop.nodivision@gmail.com 0037, 0501, 0799-0800

DESIGNER: Robb Leef

OPM-OFICINA DE PROPAGANDA E MARKETING

Daniela Genuino Av. Presidente Wilson, 228/10° andar Rio de Janeiro, RJ 22230-170 Brazil 55.21.2544.1174 daniela@opm.com.br/fabio@opm.com.br www.opm.com.br 0545-0546, 0548, 0785

ART DIRECTOR: Fábio Marinho DESIGNER: Daniela Genuino CLIENT: Petrobras

ORANGESEED DESIGN

Kristin Murra 901 N. 3rd St., #305 Minneapolis, MN 55401 USA 612.252.9757x205 kmurra@orangeseed.com www.orangeseed.com

0383-0391, 0553-0561 ART DIRECTOR: Damian Wolf DESIGNERS: Kevin Hayes, John Wieland CLIENT: Twin Cities Marathon, Inc.

ORANGEYOUGLAD

Tammy Duncan 423 Smith Street Brooklyn, NY 11231 USA 718.219.0672 tammy@orangeyouglad.com www.orangeyouglad.com

0171, 0956 DESIGNER: Tammy Duncan

PAPPAS MACDONNELL, INC.

Glenn Thode 135 Rennell Drive Southport, CT 06890 USA 203.254.1944 gthode@pappasmacdonnell.com www.pappasmacdonnell.com

0341, 0952 ART DIRECTOR: Glenn Thode DESIGNER: Greg Stewart CLIENT: Pappas MacDonnell, Inc.

POPGUN CLOTHING

Patrick Sullivan 321 W. 7th St., #106 Kansas City, MO 64105 USA 816.547.9263 info@popgunclothing.com www.popgunclothing.com

0280, 0788, 0957 DESIGNERS: Patrick Sullivan, Chris Evans CLIENT: Popgun Clothing

POPIDIOT

Kelly Alder 3306 Gloucester Road Richmond, VA 23227 USA 804.353.3113 kalder@comcast.net www.popidint.com 0107, 0109-0110, 0128-0131, 0158, 0316, 0325, 0853 ART DIRECTORS: Kelly Alder, Jessica Kantor DESTGNERS: Jessica Kantur, Kelly Alder

PRINT BRIGADE

CLIENT: popidiot

Chris Piascik 73 Fifth Street, Apartment 3 Cambridge, MA 02140 USA 203.815.9901 chrispiascik@gmail.com www.printbrigade.com 0378, 0442, 0499-0500, 0625, 0748-0749 **ART DIRECTOR:** Chris Piascik **DESIGNER:** Chris Piascik **CLIENT:** Print Brigade

PROJECT M

25 Congress Street Belfast, ME 04915 USA 207.338.0101 info@minesf.com www.minesf.com

0538, 0913 **CLIENT:** The residents of Hale County, Alabama

PURSES BY PANTS

Heather J. Davis 2059 N. Avers Avenue Chicago, IL 60647 USA 773.771.4182 davis@aadvert.com

0614-0618 **DESIGNER:** Heather J. Davis

REBEL8

Joshy D. 1661 Tennessee St., #2L San Francisco, CA 94107 USA 415.643.3933 www.REBEL8.com 0033, 0111, 0321, 0502 ART DIRECTOR: Mike Giant DESIGNER: Joshy D. CLIENTS: REBEL8

RED PRAIRIE PRESS

Rachel Bone 3438 Ash Street Baltimore, MD 21211 USA 443.622.1598 rachelbone@gmail.com www.redprairiepress.com 0146, 0216, 0256-0257, 0264-0267, 0283, 0286, 0343, 0369, 0549, 0958, 0961 ART DIRECTOR: Rachel Bone DESIGNERS: Rachel Bone, Phil Davis CLIENT: Red Prarie Press

RYAN GOELLER

Ryan Goeller 9801 Stonelake Blvd., #336 Austin, TX 78759 USA 512.750.1593 me@ryangoeller.com www.ryangoeller.com

0781 DESIGNER: Ryan Goeller CLIENT: Beats Broke

S DESIGN INC.

Sarah Mason Sears 3120 W. Britton Rd., Suite S Oklahoma City, OK 73120 USA 405.608.0556 sarah@sdesigninc.com www.sdesigninc.com 0511

ART DIRECTORS: Sarah Mason Sears, Cara Sanders Robb DESIGNER: Jesse Davison CLIENT: Schlegel Bicycle

SAYLES GRAPHIC DESIGN

Sheree Clark 3701 Beaver Ave. Des Moines, IA 50310 USA 515.279.2922 sheree@saylesdesign.com www.saylesdesign.com

0404, 0480, 0509-0510 ART DIRECTOR: John Sayles DESIGNERS: John Sayles, Bridget Drendel CLIENT: East Village

SCRAMBLED EGGZ PRODUCTIONS

Tom Watters 70 E. Main Street Marlton, NJ 08053 USA 856.596.6990x.203 tom@scrambledeggz.com www.scrambledeggz.com 0939

ART DIRECTOR: Tom Watters DESIGNER: JP Flexner CLIENT: Scrambled Eggz Productions

SHERIFF PEANUT

Norah Utley 1400 Elmwood Berwyn, IL 60402 USA 773.263.2665 info@sheriffpeanut.com www.sheriffpeanut.com

0078, 0082, 0767, 0769-0770 **ART DIRECTOR:** Norah Utley **DESIGNER:** Norah Utley

SIQUIS

Greg Bennett 1340 Smith Ave., Suite 300 Baltimore, MD 21209 USA 410.323.4800x127 greg@siquis.com www.siquis.com

0951 ART DIRECTOR: Greg Bennett DESIGNER: Greg Bennett CLIENT: Rehoboth Beach Film Society

SOPHOMORE

Christiane Miller 195 Chrystie St. New York, NY 10002 USA 212.477.7570 chrissie@sophomorenyc.com www.sophomorenyc.com

0550-0551, 0634, 0847, 0981

SPAGHETTI KISS

Michael S. Bracco 3022 Glenmore Ave. Baltimore, MD 21214 USA 443.562.3327 girlyboy17@hotmail.com www.spaghettikiss.com 0100, 0102, 0222 **DESIGNER:** Michael S. Bracco

SQUIDFIRE

Kevin Sherry 4401 Eastern Ave. Baltimore, MD 21224 USA 410.327.3300 jbr@squidfire.com www.squidfire.com

0081, 0117-0118, 0203-0204, 0209, 0236-0237, 0312-0314, 0363, 0368, 0776, 0925, 0984 ART DIRECTOR: Jean-Baptiste Regnard DESIGNER: Kevin Sherry CLIENT: Squidfire

STUDIO INTERNATIONAL

Boris Ljubicic Buconjiceva 43 Zagreb, HR-10000 Croatia +385.137.40404 boris@studio-international.com www.studio-international.com 0443, 0641-0642, 0644, 0732-0733, 0812, 0955, 1000 ART DIRECTOR: Boris Ljubicic DESIGNER: Boris Ljubicic CLIENT: VARTEKS

SUKSEED

Jason Yun 13151 Fountain Park Dr., 6306 Playa Vista, CA 90094 USA 626.833.2087 jyunbreakdown@yahoo.com www.jasonyun.com

0069 ART DIRECTOR: Jason Yun DESIGNER: Jason Yun CLIENT: Paradigm Industries

THE FADED LINE CLOTHING CO.

Brad Mastrine 1094 Hawk Ct. Louisville, CO 80027 USA 303.544.5804 mastrine@thefadedline.com www.thefadedline.com 0028, 0068, 0105, 0164, 0166, 0180, 0182, 0194, 0205, 0846, 0993-0994 **ART DIRECTOR:** Brad Mastrine **DESIGNERS:** Emer, Todd Slater, Jim Pollock, Jeff Wood

THREADLESS

Jeffrey Kalmikoff 4043 N. Ravenswood, #106 Chicago, IL 60613 USA 773.878.3557 jeffrey@skinnycorp.com www.threadless.com

0006, 0020-0021, 0031-0033, 0044, 0053, 0055, 0057, 0059, 0070, 0083-0084, 0086, 0088-0089, 0124, 0127, 0144-0145, 0159-0161, 0168-0170, 0181, 0184, 0191, 0210-0211, 0220-0221, 0224, 0227, 0251, 0259, 0269, 0282, 0292-0293, 0296-0297, 0300-0302, 0305-0309, 0319, 0329-0330, 0336, 0347, 0350-0351, 0356, 0362, 0372, 0374-0375, 0377, 0450, 0452-0453, 0455-0457, 0461, 0516, 0576, 0582, 0620-0621, 0623-0624, 0626-0631, 0669, 0672-0675, 0677-0680, 0707-0714, 0716, 0747, 0753-0754, 0768, 0778, 0798, 0801-0802, 0828, 0840, 0852, 0854-0858, 0878, 0892, 0907-0908, 0910, 0920, 0924, 0959, 0963, 0975-0977, 0986, 0989-0991, 0999 **DESIGNER:** Threadless

TOKIDOKI LLC.

Simone Legno 5645 West Adams Blvd. Los Angeles, CA 90016 USA 323.930.0555 simone@tokidoki.it www.tokidoki.it 0987

ART DIRECTOR: Simone Legno DESIGNER: Simone Legno CLIENT: tokidoki

TRADER JOE'S

Jessica Frease 117 Kendrick St., Suite 700 Needham, MA 02494 USA 781.455.7316 jfrease@traderjoes.com www.traderjoes.com 0919, 0922 ART DIRECTOR: Jack Killeen DESIGNER: Jessica Frease

CLIENT: Trader Joe's

T-SHIRT INTERNATIONAL, INC.

Greg Forsythe 3611 Bakerstown Rd., Suite 3 Bakerstown, PA 15007 USA 724.443.2717x103 gregf@tsisportswear.com www.tsisportswear.com 0358

ART DIRECTOR: Greg Forsythe DESIGNER: Greg Forsythe CLIENT: Lost Creek Outfitters

WILLIAM HOMAN DESIGN

William Homan 111 Marquette Ave., Suite 1411 Minneapolis, MN 55401 USA 612.869.9105 william@williamhomandesign.com www.williamhomandesign.com

0580-0581, 0982 ART DIRECTOR: William Homan DESIGNER: William Homan CLIENT: Galloup's Slide Inn

WILLOUGHBY DESIGN GROUP

Ryan Jones 602 Westport Rd. Kansas City, MO 64111 USA 816.561.4189 rjones@willoughbydesign.com www.willoughbydesign.com

0950, 0992

ART DIRECTORS: Ann Willoughby, Zack Shubkagel, Anne Simmons, Megan Semrick DESIGNERS: Jessica McEntire, Stephanie Lee, Nate Hardin CLIENT: Willoughby Design Group

WING CHAN DESIGN, INC.

Wing Chan 167 Perry Street, Suite 5C New York, NY 10014 USA 212.727.9109 wing@wingchandesign.com www.wingchandesign.com 0519, 0528, 0552, 0579, 0585, 0927-0936 **ART DIRECTOR:** Wing Chan **DESIGNER:** Wing Chan **CLIENT:** Songs for Children Charity

XEROPROJECT

Jamie Kashetta 513 Mirasol Circle, #203 Celebration, FL 34747 USA 407.566.8164 jamie@xeroproject.com www.xeroproject.com

0029, 0774, 0797, 0818 ART DIRECTOR: Jamie Kashetta DESIGNER: Jamie Kashetta CLIENTS: xeroproject

0116, 0119, 0820-0821 ART DIRECTOR: Jamie Kashetta DESIGNER: Jamie Kashetta CLIENT: niki bar band

0541, 0771

ART DIRECTOR: Jamie Kashetta DESIGNER: Jamie Kashetta CLIENT: light the sky

ABOUT THE AUTHOR ACKNOWLEDGEMENTS

957 F O

HUGH BAIRD COLLEGE LIBRARY AND LEARNING CENTRES

effrey Everett started El Jefe Design in 2003 while receiving his MFA in graphic design from the School of Visual Arts in New York City where, conveniently, his thesis project was starting a T-shirt company. Now located outside of Washington, D.C., El Jefe Design has had the pleasure of designing and illustrating for a wide variety of entertainment and nonprofit clients. The studio is known for creating award-winning posters for nationally touring music acts big and small. El Jefe Design has had work shown in magazines such as *Print, How,* and *STEP Inside Design* and won awards from the AIGA and The Art Directors Club. For more information, visit **www.eljefedesign.com.**

The author would like to thank the following people for their invaluable help in creating this book: Steven Heller, Anya Kholodnov, Jeffrey Wright, the hard workers at Rockport Publishers; my family and friends for supporting me through the long nights; and Maximilian for making it all mean something.